D0604537

THE ESSENTIAL
DARKROOM BOOK

THE ESSENTIAL DARKROOM BOOK

Tom Grill and Mark Scanlon

Amphoto
American Photographic Book Publishing
An Imprint of Watson-Guptill Publications
1515 Broadway, New York, NY 10036

Copyright © 1981 by Radial Press, Inc.
Photographs copyright © 1981 by Tom Grill.

First published in New York, New York, by American Photographic
Book Publishing: an imprint of Watson-Guptill Publications, a
division of Billboard Publications, Inc., 1515 Broadway, New
York, NY 10036.

All rights reserved. No part of this publication may be
reproduced or used in any form or by any means—graphic,
electronic, or mechanical, including photocopying, recording,
taping, or information storage and retrieval systems—without
written permission of the publisher.

Designed by Tom Grill.

Library of Congress Cataloging in Publication Data

Grill, Tom, 1944–
 The essential darkroom book.

 Includes index.
 1. Photography—Processing. I. Scanlon, Mark,
1945– II. Title.
TR287.G73 770'.28'3 81-12669
ISBN 0-8174-3837-8 AACR2
ISBN 0-8174-3838-6 pbk.

Manufactured in the United States of America
First printing, 1981

1 2 3 4 5 6 7 8 9/86 85 84 83 82 81

CONTENTS

THE ESSENTIAL DARKROOM BOOK

INTRODUCTION

Of all the creative excitement inherent in photography, few thrills surpass that of watching prints form in a darkroom tray. Even the most experienced darkroom maestro can still recall the excitement he or she felt standing for the first time under the surrealistic glow of a darkroom safelight and marveling at the miraculous appearance of an image.

As a photographer who does his or her own processing, you are a participant in a long ''do-it-yourself'' tradition that hark back to a time when photographers had no choice but to personally process the photographs they took. The luxury of taking a photo and processing it at leisure simply did not exist then. When the darkroom craft was in its infancy, the instability that characterized many of the light-sensitive materials often demanded that processing be performed immediately after an exposure had been made. Therefore, the field of photography was limited to those people who were as adept at chemistry as they were interested in taking pictures.

Eventually, more stable chemicals were developed, commercial labs were established, and it became possible to let a specialist handle the processing. As a result, photography began to appeal on a large scale to people who previously had been discouraged by the complexities of working with darkroom chemicals.

Considering the ready availability of inexpensive commercial processing laboratories, why then does do-it-yourself processing flourish among photographers and continue to gain new and enthusiastic practitioners? The answer is found in the tremendous personal satisfaction and pride they derive from being master of all facets of a photograph—from its conception as an image, through its capture on film, to its visual realization as a print or slide.

The *Essential Darkroom Book* is designed to help you develop the skills necessary for *you* to experience the same pleasures of do-it-yourself processing that so many others have enjoyed. However, darkroom processing involves not only skills but also decisions, some of which may have to be made even before you know enough about processing to be certain what your needs will be. For example, although fundamental principles of processing are the same both in black and white and in color, the two require somewhat different equipment. Traditionally, photographers have first purchased black-and-white processing equipment and later switched to color. However, if you are certain that you will eventually want to engage in color processing, the most economical approach in the long run may be to purchase the more expensive color equipment at the outset. You may thus avoid ultimately having to incur switch-over expenses.

Moreover, when you process color film or make color prints, further decisions await you. Different procedures and ''chemistries'' exist for developing slides, for developing negatives, and for making prints from each. When you walk into a photo supply store, you must know which proce-

A succession of decisions contribute to the way a photograph finally appears. The succession begins when an image is framed in the viewfinder of a camera, proceeds through the development process, and culminates when the image is manipulated and projected onto a sheet of printing paper.

The decisions that affect photographic images being handled by commercial processing laboratories are often made by machines. These machines are calibrated to produce "average" results and consequently, except in the case of laboratories which cater to the needs of professional photographers, commercial labs cannot produce the exceptional results that are easily within the reach of the home processor.

dures you will need supplies for, as well as which specific brands you want to purchase.

Because there is more to learning darkroom processing than simply following "recipes," we have designed the *Essential Darkroom Book*, not only to teach you skills, but also to provide you with information with which you can make decisions such as those described above. If you have never before processed film or made prints, we suggest that before you purchase a single item of equipment, you read this book to obtain a solid overview of darkroom processing. Because color processing has recently been simplified to the point where learning to process color materials is not much more difficult than learning to process black-and-white materials, you may decide to skip black-and-white processing all together. But you will not know if that is the best course for you unless you have some understanding of the differences between the two types of processing. By reading over the entire book you can decide, and once you have made your decision, you can go back and reread the information on specific chemistries and brands. Then, when you enter a store to outfit your darkroom, you will be an educated consumer who does not have to rely on a salesperson for advice.

If you have had some darkroom experience in the past, in all likelihood that experience was with black-and-white processing, and you now would like to learn about color. If that is the case, you may still want to review the black-and-white chapters first, since they are referred to in the color chapters.

Because of the enormous popularity and widespread use of the 35mm camera, the *Essential Darkroom Book* concentrates almost exclusively on 35mm film. Although some specific items of equipment and the quantity of chemicals involved differ when processing film in sizes other than 35mm, the same basic procedures apply to developing film and making prints no matter what the size. You should encounter few, if any, problems in transferring 35mm techniques to other film sizes.

As well as providing fundamental information about darkroom processing and equipment, the *Essential Darkroom Book* also presents you with advance information on the most recent and sophisticated technological aids available. Although some of these aids may be initially too expensive or complex to be practical, they are included so that you will be aware of their availability as you hone your skills and expand your ambitions.

We have arranged the book so that procedures common to many processes are, for the most part, described only once. However, we have occasionally included information in more than one location for clarity's sake. We trust you will find these repetitions a convenience as well as an aid to your understanding.

Our goal is to give you the knowledge you need to process film and make prints successfully—even on your first attempt. We are confident that once you have watched your first print materialize in a processing tray, you, too, will share in the feeling of satisfaction and pride that so many before you have enjoyed.

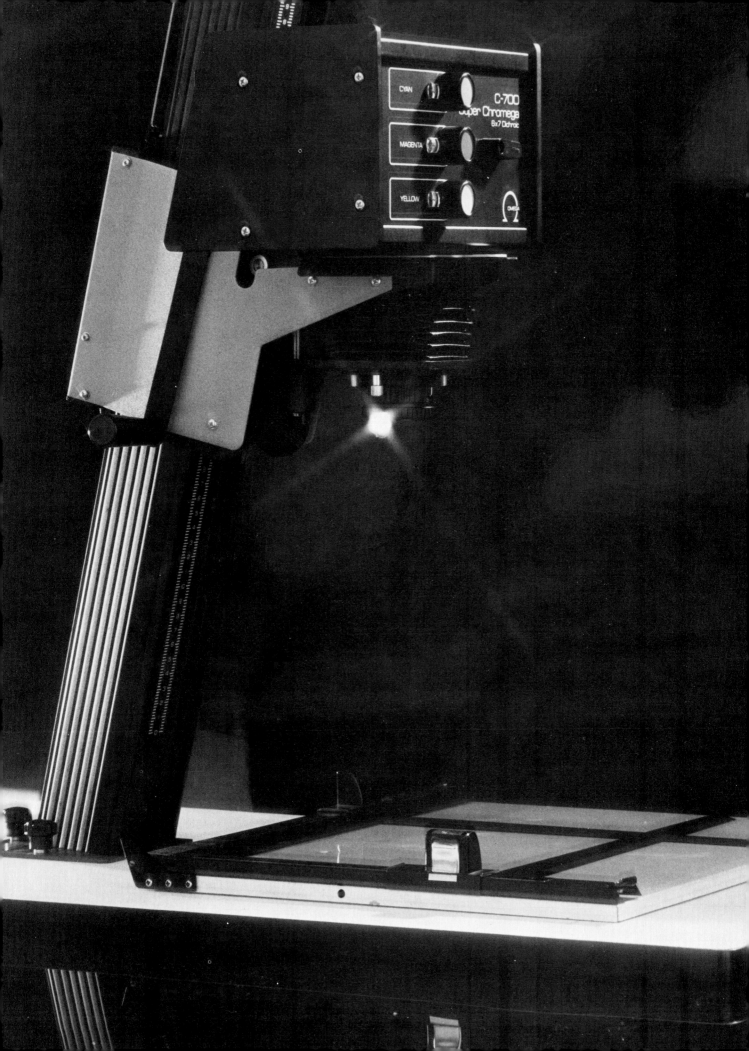

1. EQUIPMENT

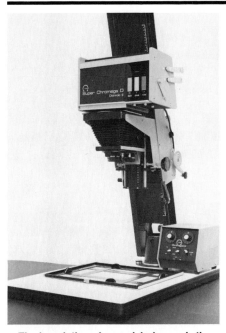

The foundation of a good darkroom is the enlarger. For casual processing, relatively inexpensive condenser enlargers are readily available which can often be obtained second hand. More expensive diffusion enlargers, such as the one with the dichroic head shown at left, are particularly useful for color printing, although image sharpness may suffer slightly.

The truly serious darkroom enthusiast for whom price is subordinate to image quality might opt for the unsurpassed quality obtainable from a large format enlarger, such as the one shown above. Although designed primarily to accommodate 4" x 5" (10 x 13 cm) negatives, such enlargers can be easily adapted to small format use with results that represent the ultimate in image reproduction.

Anybody can process film. Anybody can develop prints—in black and white or color. Although darkroom processing may seem mysterious or intimidating or impossible to learn, it is not. With surprisingly little effort, and without much special equipment, you can master the techniques quickly, and, sooner than you might imagine, you will begin producing results that are not simply good—but great.

Many photographers believe that they need elaborate facilities and expensive equipment to obtain quality results. In fact, elaborate equipment which does most of the thinking for you can prevent you from learning the fundamental principles that you must master if you are ever to become more than a technician in the darkroom. And some of the world's most highly regarded photographic prints were created in improvised darkrooms, using primitive or outmoded equipment. Certainly good equipment can be an asset, but rest assured that you can do without if you must. It is *darkroom discipline, correct technique*, and *careful attention to detail*, more than a fortune spent on expensive equipment, that are the hallmarks of a successful darkroom maestro. Although you should buy the best equipment you can afford, in the long run it is the care that you take to develop precise and proper habits that will be the primary criteria for your success.

Many products are commercially available to help with nearly every aspect of darkroom processing. All you really need in order to produce excellent results are a few essential items. Because the enlarger is always the center of activity, Chapter One begins with a description of enlargers and then deals in turn with additional items of equipment that you will need in order to establish a functioning darkroom. More sophisticated equipment is also described so that when you are ready to expand your darkroom, you can do so knowledgeably.

THE ENLARGER

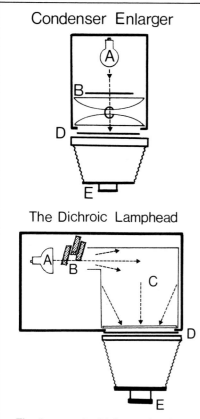

Condenser Enlarger

A
B
C
D
E

The Dichroic Lamphead

A
B
C
D
E

The two most widely used enlarger types are the condenser-head enlarger and the dichroic-head enlarger.

In a condenser-head enlarger (top photo), light from a tungsten bulb, A, passes through a heat-absorbing glass, B, and is focused by condenser lenses, C, onto a negative or slide, D. The light then passes through the negative or slide through an enlarger lens, E, and onto printing paper.

In a dichroic-head enlarger (lower photo) light from a quartz lamp, A, passes through three dichroic filters, B, which introduce the colors yellow, magenta, and cyan. The colored light then proceeds into a diffusion chamber, C, where the colors are mixed before being directed through a negative or slide, D. An enlarger lens, E, then projects the image onto printing paper. The amount of each color added by the dichroic filters depends on how far each filter is made to protrude into the light path.

Condenser heads produce sharp images showing high contrast and are especially well suited for black-and-white printing. Dichroic heads produce "softer" images of somewhat lower contrast than condenser heads and are well suited to printing in color.

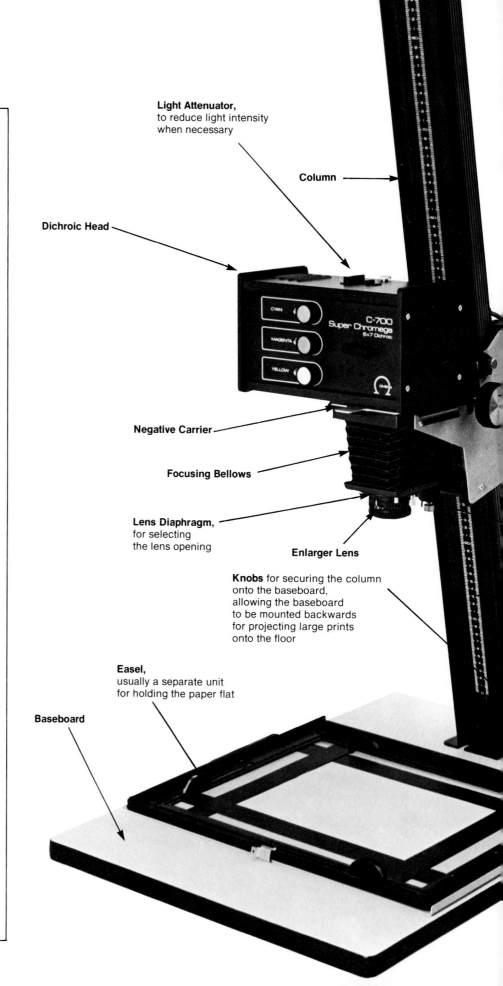

Light Attenuator, to reduce light intensity when necessary

Column

Dichroic Head

Negative Carrier

Focusing Bellows

Lens Diaphragm, for selecting the lens opening

Enlarger Lens

Knobs for securing the column onto the baseboard, allowing the baseboard to be mounted backwards for projecting large prints onto the floor

Easel, usually a separate unit for holding the paper flat

Baseboard

NEGATIVE CARRIERS

Film carriers are used to hold negatives and slides firmly within an enlarger. Carriers are sold in a variety of formats to accommodate different sizes of film. Some carriers merely support the edges of the film, others support the entire frame within a sandwich of glass. The glass holds the film perfectly flat but must occasionally be cleaned.

Focusing Knob

Enlargement Adjusting Knob, for raising or lowering the enlarger head on the column

Knob for attaching an additional filter carrier under the lens

Scale for measuring enlarger height

Timer, connected between the enlarger and the wall outlet

The enlarger head. The head of an enlarger is its most important and expensive component. There are three types of heads: condenser, diffusion, and cold-light.

Condenser heads. These heads use optical elements (lenses) to focus light from the enlarger lamp through the film negative and onto the printing paper (see illustration at far left). The primary shortcoming of condenser heads is their tendency to make more obvious the effects of dust, scratches, and any imperfections present in the negative.

Diffusion heads. These heads produce a "softer" (less focused) light than condenser heads, by either passing light through a diffusion glass or reflecting light back and forth in a mixing chamber (see illustration at far left).

Two types of lamp are available as light sources in condenser and diffusion heads. Condenser heads and the diffusion head that uses a diffusion glass both commonly contain a tungsten bulb, while the mixing-chamber diffusion head usually contains a quartz-halogen bulb. Both bulbs are suitable for use with black-and-white film, but the quartz-halogen bulb retains a more consistent color balance throughout its life and is therefore especially appropriate for color printing.

Cold-light heads. These heads employ a "cold" light source—usually a fluorescent lamp—to provide the softest, most even illumination of all. Cold lights have the unique advantage of producing so little heat that the negative or slide is in no danger of buckling when the lamp is on. Cold-light heads are expensive and therefore impractical for ordinary use.

The bellows. By expanding and contracting the bellows on an enlarger, you move the enlarger's lens up and down and thereby focus the projected image.

The lens. In order to obtain the best image possible, choose a lens of focal length approximately equal to the diagonal of a single frame of your film. (For 35mm film, you will want a lens of about 50mm focal length.)

Because of the bellows component, enlarger lenses do not contain a focusing mechanism and are therefore inexpensive when compared to camera lenses. Since the quality of the image your enlarger can produce is directly affected by the quality of its lens, purchase the best lens you can afford.

The column. In order to adjust the size of the image projected by the enlarger head, you adjust the position of the head by sliding it up and down a metal column. The longer the column, the greater the degree of magnification the enlarger can produce.

The baseboard. The enlarger baseboard serves as an anchor for the column and as the surface on which you work. To produce quality prints, the head, lens, and baseboard of your enlarger must all be in perfect alignment; otherwise, the image will be distorted and you will find it difficult, if not impossible, to focus all parts of the image at once.

Format. Each enlarger has a limit to the size of negative it can accommodate. Some enlargers can only accept negatives up to 35mm in size; others can accept negatives as large as 4"x5" (10x13 cm), 5"x7" (13x18 cm), and even 8"x10" (20x25 cm). In general, the larger the film format that the enlarger can handle, the more sturdily the enlarger is constructed. For most people, an enlarger that can accommodate a format as large as 2¼"x2¾" (6x7 cm) provides adequate versatility and strikes a reasonable compromise between sturdiness and bulk.

THE COLOR ENLARGER

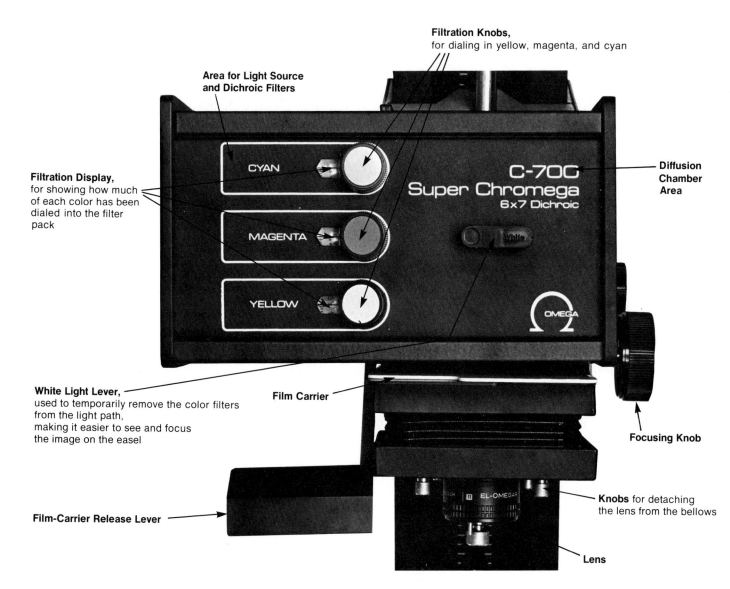

Filtration Knobs, for dialing in yellow, magenta, and cyan

Area for Light Source and Dichroic Filters

Filtration Display, for showing how much of each color has been dialed into the filter pack

CYAN

MAGENTA

YELLOW

C-70G Super Chromega 6×7 Dichroic

White

Ω OMEGA

Diffusion Chamber Area

White Light Lever, used to temporarily remove the color filters from the light path, making it easier to see and focus the image on the easel

Film Carrier

Focusing Knob

EL-OMEGAR

Knobs for detaching the lens from the bellows

Film-Carrier Release Lever

Lens

THE COLOR HEAD

Most enlargers suitable for black-and-white printing can be converted for color use; however, some convert more readily, and some produce better color prints than others. If you are certain that you will only be printing in black and white, then any high-quality condenser head with a good lens will be sufficient for your needs. If you think you may eventually want to try color printing, or if you want to start immediately with color, then you should be aware of the ways in which enlargers used for black-and-white printing differ from those used for color. You should also be familiar with the accessories you will need to have on hand when making color prints.

Heat-absorbing glass. In order to protect color filters, slides, and negatives from infrared radiation, color enlargers must pass light originating from the lamp through a heat-absorbing glass. Many enlargers contain heat-absorbing glass as original equipment, some enlargers are manufactured to accommodate it as an option, and some make no provision for such glass at all. If you ever wish to print in color, be certain your enlarger either contains heat-absorbing glass already or can at least accept it. (Heat-absorbing glass has no effect on black-and-white prints.)

Supplementary color filters. To print in color, you must place color filters between the enlarger's light source and the printing paper. The way enlargers accommodate such filters varies and can affect the quality of the final print.

1. *Filters under lens.* The most rudimentary method for adding filters is to attach a special filter holder to the enlarger lens. Since filters placed in such holders are inserted *between* the slide or negative and the printing paper, you must use high-quality, expensive color-compensating (CC) filters to minimize image distortion. Unfortunately, because CC filters are made of soft gelatin and are easily scratched, they deteriorate with use and must be replaced occasionally. The chief advantage of below-the-lens filters is that when used in conjunction with an ultraviolet filter (see below) and heat-absorbing glass, they permit you to print in color without purchasing a special enlarger head.

2. *Filter drawer.* Enlargers specifically designed to accommodate color filters contain a built-in filter drawer. Because such drawers are situated *above* the slide or negative, the image does not project through the filters and you can use economical color-printing (CP) filters made of acetate, instead of the more expensive CC filters.

Both types of enlarger require that you have an ample supply of CC or CP filters on hand (see p. 106). In addition, you will need to have an ultraviolet (UV) filter to screen out UV light emanating from the enlarger lamp.

3. *Dichroic heads.* Dichroic enlarger heads (which are a type of diffusion head) are designed specifically to make color filtration convenient and precise. Dichroic heads contain internal filters which add color to the light source in amounts you can easily control by

FILTER DRAWER

Most modern condenser enlargers have a drawer built into the enlarger head in which you can place color filters. The combination of filters placed in the drawer is referred to as the *filter pack.*

FILTERS UNDER THE LENS

Filter holders enable you to introduce filters below the lens of enlargers that do not contain a filter drawer built into the enlarger head. Some enlargers are sold with a filter holder already attached below the lens.

turning dials. Moreover, the dials are calibrated in density increments of one unit—unlike CC and CP filters, which are commonly available in increments no smaller than five units. As you might expect, dichroic heads are relatively expensive, but they are unsurpassed in precision and ease of use for color printing.

A 36-frame roll of film is approxi-

mately 4' (1.2m) in length and must be rolled into a shape convenient for darkroom processing. In order to insure that developing chemicals can circulate freely around all parts of the film, you coil it onto a reel and then insert the reel in a light-tight, leakproof developing tank. The chemical processes involved in film development then take place within the tank.

HEAT-ABSORBING GLASS

If you plan to use your condenser enlarger for color printing, you must be certain your enlarger contains a sheet of heat-absorbing glass to protect your negative or slide from heat damage. Most modern condenser enlargers are sold with the glass already installed, or they at least contain a slot to accept one. If your enlarger lacks a heat-absorbing glass you can probably order one from the manufacturer. The glass may be left in at all times since it has no detrimental effect on black-and-white printing.

REELS AND TANKS

METAL REELS AND TANKS

For durability and ease of cleaning, metal developing tanks and reels are unsurpassed.

Tanks are sold in various capacities, ranging from single-reel tanks to tanks that can handle ten or more reels at once. Since you must fill a tank completely with chemicals regardless of how many rolls of film you are processing, you may want to keep a few different tank sizes on hand.

Some photographers who do a substantial amount of processing store their chemicals inside extra tanks and then place loaded film reels directly into the chemicals. This method saves time and, in the case of multi-reel tanks, allows all the reels to begin development almost simultaneously.

Two different sizes of metal reels are shown above. Be sure the tanks and reels you purchase fit the film size you are using.

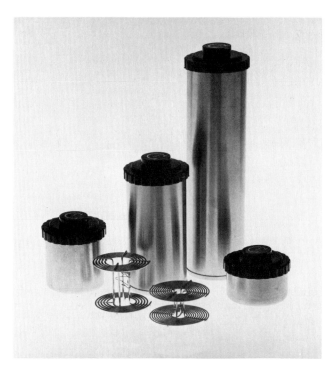

PLASTIC REELS AND TANKS

This inexpensive tank, reel, and thermometer kit is almost a complete film-processing darkroom in itself. The reel adjusts to handle more than one film size and possesses a rachet device to make film loading simple. However, tanks of this type can handle only one roll at a time, and for reasons discussed in the text, plastic tanks and reels are better suited for developing an occasional roll of film than for serious and frequent use.

If you want to try your hand at film developing to see if you enjoy it, but want to keep your initial investment to a minimum, plastic processing tanks and reels may be worthwhile.

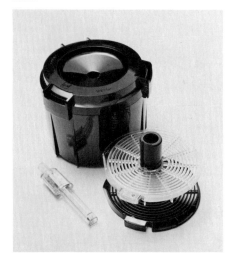

REELS

Metal reels. Stainless steel reels are designed for durability and ease of cleaning. Mounting film on metal reels can be a somewhat tricky procedure at first, but once you have mastered the technique, metal reels are the most convenient type available. Although metal reels are comparatively expensive, they last so long and are so easy to clean and dry that they are worth the extra cost.

Plastic reels. To make loading film onto reels easier and to offer a less expensive alternative to metal reels, some manufacturers produce reels constructed of plastic. Initially, plastic reels may seem easier to load, but the many grooves characteristic of the reels make cleaning and drying them a slow process. With practice, you will be able to load both metal and plastic reels with equal ease, so buy plastic reels only if you truly cannot afford metal ones.

TANKS

Metal tanks. As is the case with reels, stainless steel tanks are both more durable and more expensive than their plastic counterparts. Since the temperature of the chemicals in a tank must sometimes be adjusted by immersing the tank in a water bath, metal tanks have the advantage of transmitting temperature changes quickly.

Plastic tanks. Plastic tanks cost only one-quarter to one-third the price of metal tanks, but they are far more likely to crack or break. Moreover, most plastic tanks can hold only one reel of film at a time, whereas metal tanks allow you to process as many as ten reels at once.

Hybrid tanks. Sometimes metal tanks with metal tops leak slightly around the rim. Because plastic can establish a better seal than metal, hybrid tanks consisting of a metal tank with a plastic top combine the best features of both.

SAFELIGHTS

Visible light consists of a broad range of colors. Because some films and printing papers are not affected by certain of those colors, you need not operate in total darkness. You can use a "safelight" to provide dim illumination that will not ruin the light-sensitive material with which you are working.

Safelight colors. The correct safelight color to use varies from film to film and paper to paper. For most black-and-white papers, a light amber bulb (coded OC by Kodak and 902 by Ilford) is standard. Always check the instructions provided by a material's manufacturer before you assume that it can be viewed under a particular safelight (or any safelight at all, for that matter).

Intensity. Even a safelight of the proper color can affect a film or paper if it is located too close or is too strong. As a rule, the light source should never be closer than 4 ft. from any light-sensitive material, and the bulb should be no stronger than 15 watts.

Duration of exposure. Some papers and most film can only be exposed to a safelight for a limited time without a chemical change taking place. Check the manufacturer's instructions, and follow them carefully. Although some manufacturers claim that their color printing paper can be viewed under an amber light or that their panchromatic black-and-white film can be viewed under a dark green light, not all films and papers have these qualities. In any event, the illuminations recommended in the instances above are so dim that they are of little help.

Selection. Safelights are sold in a variety of designs, sizes, and prices. Base your selection on the size and configuration of your darkroom, and on the type of illumina-

tion—spot or general—that you want. Dome lights are best for spot lighting; flat, round, and two-sided lights are best for large areas. Recently, coated bulbs that simply screw into a conventional light socket have been improved to the point where they are now a reasonable and economical source of general safelight illumination. If you think you will need more than one safelight color, safelights with changeable filters are available.

These sections of your darkroom that do not involve the use of chemicals constitute its "dry side." In addition to your enlarger, the items you should consider buying in order to outfit your darkroom's dry side properly are discussed below.

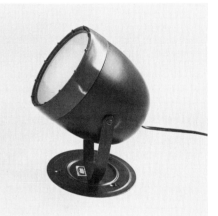

THE BULB SAFELIGHT

Not all safelights are expensive. For example, the bulb to the left constitutes an entire safelight. It screws into a regular lamp socket and casts illumination equally in all directions. Bulb safelights are especially convenient when you want to set up a temporary darkroom using existing light fixtures.

THE DOME SAFELIGHT

Dome safelights such as the one shown above allow you to direct light onto a specific area, such as a developer tray or the area where you store your paper. By concentrating light, dome safelights help prevent stray light from interfering with your ability to see and focus the image projected by your enlarger. An added advantage is that many dome lights accept filters, so they can be adapted for use with more than one type of paper.

SAFELIGHT FILTERS

Safelight Filter Color	Kodak Code	Use For
Light amber	OC	Most b/w printing papers
Amber	#13	Ektacolor 74 RC paper
Dark amber	#10	Panalure
Green	#3	b/w panchromatic films

DRYSIDE EQUIPMENT
Easels

EASELS

If you lay a piece of paper on your enlarger's baseboard while making an exposure, the paper's natural tendency to curl will ruin the image you are attempting to reproduce. By holding the paper flat, an easel assures you that the image will be undistorted, in sharp focus, and will not move during the exposure. A variety of easels is available.

Fixed-size easels. Fixed-size easels accept paper of a single size (4"x 5", 5"x 7", etc.) and are most useful for printing many copies of the one size quickly. They are inexpensive and automatically produce a ¼" (.6 cm) border around the print.

Borderless easels. Borderless easels enable you to print on an entire sheet of paper without wasting any space on a border. These easels are moderate in cost.

Adjustable-border easels. Easels with adjustable borders are available in two types. The most expensie type is adjustable on all four sides and allows you to produce an image completely surrounded by a border of any size. The less expensive ''corner-adjustable'' type has only two sides that are movable. Corner-adjustable easels allow you to crop your photo to any size by changing the position of two sides, but the size of the border can only be changed from about ⅛" to ½" (.3 to 1.3 cm).

Multiprint easels. Multiprint easels contain several openings of varying sizes which enable you to print more than one image on a single sheet of paper.

Selecting an easel. When deciding on which easel to buy, select one that will accommodate the largest sheet of paper you expect to use. Judge an easel by how securely it holds a sheet of paper and how easily you can load it in the dark. A good easel will greatly simplify your printing labors.

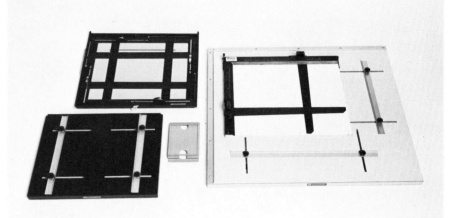

1. *Four-blade, fully adjustable easel.* Fully adjustable easels permit you to crop a photo from all four sides, thereby allowing you to center the image on your paper regardless of how wide you make the borders.

2. *Borderless easel.* Borderless easels hold printing paper firmly but do not form a border on the print. The sliding paper guides on the left and right adjust to accommodate different paper sizes. The easel shown here has been painted black to make it nonreflective.

3. *Simple easel.* The simplest type of easel accepts only one size of paper and produces only one border size. These easels are useful for making many identical prints from the same negative or slide.

4. *Two-blade adjustable easel.* Two-blade adjustable easels permit unlimited cropping along two edges, but the other two edges can only be varied from about ⅛" (.3cm) to about ⅜" (.9cm).

5. *Large adjustable borderless easel.* The borderless easel holds the printing paper on only two edges. Oversize prints need to be held on all four edges to keep the paper flat. Paper slipped into the upper left corner of the large adjustable borderless easel is held along two edges by fixed rails and along the remaining two edges by movable rails.

TIMERS

If you are to obtain consistent results from print to print, you must have a device that will turn your enlarger on and off accurately during exposures. Enlarger timers range from the simple to the sophisticated.

Mechanical timers. Mechanical timers are the least expensive timers available and are certainly adequate for most darkrooms.

Digital timers. Digital timers employ electronic circuitry to produce extreme, and usually unneeded, accuracy. Some digital timers are designed to turn off the darkroom safelight automatically while you focus the enlarger image (making it easier to see the image on the easel); others can be set to signal when to begin ''dodging'' or ''burning in'' (see p. 76).

Programmable timers. Some timers can be set to produce a sequence of different time intervals. A programming capability is rarely useful when exposing prints but can be very handy when developing either film or prints.

Selecting a timer. When selecting a timer, your main consideration should be that it repeats the same time interval accurately. If your budget permits, look for a timer that can be preset to repeat the same interval over and over.

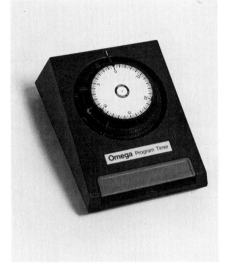

PROGRAMMABLE TIMERS

Because darkroom processing usually involves a series of timed steps, programmable timers have been developed which can be preset to time each step sequentially.

In the timer at left, pins have been inserted at the appropriate locations for the requirements of the Cibachrome process. As the dial turns and a pin reaches the twelve o'clock position, a bell rings and the timer stops. Timing does not begin for the next step until the bar along the bottom edge of the timer is depressed.

On this model, a processing-drum motor can be plugged into the timer so that the timer also controls the motor.

VOLTAGE REGULATORS

Household electrical current fluctuates enough from second to second to affect the intensity of light emanating from your enlarger lamp. These fluctuations usually have little noticeable effect on black and white prints, but with color prints, even minor variations in exposure can produce significant color shifts. Therefore, to smooth out voltage variations, color printing usually calls for a voltage regulator to be attached to your enlarger. Many dichroic enlarger heads are sold with a voltage regulator already installed, but you should check to be certain, in the event you find yourself obtaining inconsistent results in your color prints.

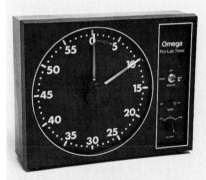

ELECTRICAL TIMERS

The type of timer shown at left is the "workhorse" of electrical darkroom timers. The enlarger and darkroom safelight can be connected into this type of timer so that all on-off functions are controlled by the timer. The large, luminescent dial is easy to read in the dark, and depending on how the timer is set, it can produce audible ticks or ring a bell when a timing period expires.

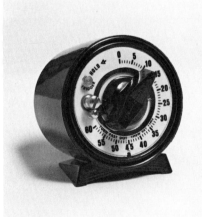

MECHANICAL TIMERS

The simple mechanical timer shown above is inexpensive but perfectly adequate for most common darkroom needs. The timer contains some electrical circuitry which permits it to turn the enlarger on and off.

DRYSIDE EQUIPMENT
Continued

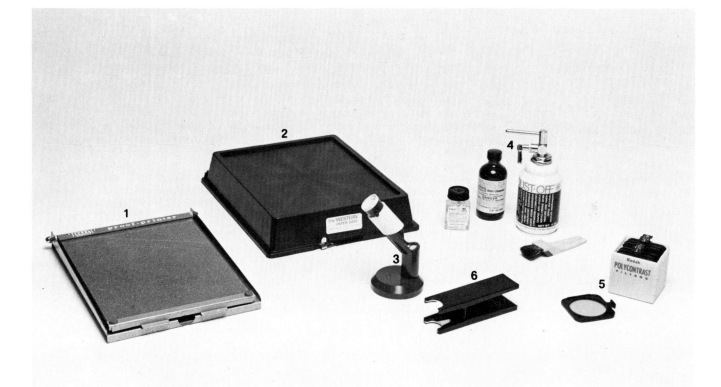

1. **Contact printer**
2. **Paper safe**
3. **Grain focuser**
4. **Cleaning aids:**
 Edwal No Scratch
 Kodak Film Cleaner
 Dust-Off Compressed Air
 Anti-static brush
5. **Polycontrast filters**
6. **Film-cassette opener**

ISO RATINGS
Recently, the International Standards Organization established a new convention for designating film-speed ratings. Instead of the designation "ASA 400/27 DIN," for example, a film box will now state "ISO 400/27°." During a transition period, film boxes will display both the old and new rating conventions.

CLEANING AIDS

Air guns. When you are making prints, every speck of dust adhering to the slide or negative will produce a noticeable spot on the print. The more you enlarge the print, the bigger the spot. The safest way to remove dust from slides and negatives is with an *air gun*. These guns, which are available in art supply stores and photo supply shops, use disposable cartridges as their source of compressed air.

Anti-static brushes. When a static charge builds up on a piece of film, dust is attracted. To reduce the charge, as well as to remove dust particles—especially stubborn ones that will not blow away—you should have on hand an anti-static camel's hair brush, which you lightly pass along the film's surface.

Film cleaners. To remove especially stubborn particles adhering to film, and to remove fingerprints and other spots, you should have available a commercial "film cleaner"—a solvent that you apply with a cotton swab.

Scratch-repair liquids. Occasionally, even with the best of care, a slide or negative may become scratched. A drop of Edwal No Scratch applied to the film may obscure the scratch and can be easily removed later with film cleaner.

CONTACT PRINTERS

In order to study the individual frames on a roll of negative film, you will need to produce a single, positive print made from one exposure of the entire roll. To do this, you cut the film into strips, arrange them on top of a sheet of 8"x10" printing paper, and expose this "sandwich" to light from your enlarger. *Contact printers* are designed to hold the strips of film motionless and flat against the paper while the exposure is being made.

You can make your own contact printer by hinging a piece of glass to an 8½" x 11" (22 x 28cm) or larger board by means of tape, or you can buy a commercially available version. The most expensive contact printer prints a space on which you can record comments or data next to each frame of film.

PAPER SAFES

Removing a single sheet of paper from the box-envelope combination in which paper is sold is time consuming and inconvenient. Therefore, you may wish to purchase a *paper safe* into which you can transfer as many sheets of paper as you wish. Some paper safes have shelves to accommodate more than one paper type at a time.

POLYCONTRAST FILTERS

As will be explained in greater detail in Chapter Four, each time you make a black-and-white print you will need to decide on the "contrast grade" of paper to use. Once you have made your choice, you can either use that grade of paper to make the print, or you can use a "variable-contrast" paper, the grade of which is determined by the *polycontrast filter* you place in the enlarger's light path. There are seven filters in a complete set, and many sets include a convenient holder for mounting the filters below the enlarger lens. Or, you can purchase polycontrast filters that fit in your enlarger's filter drawer. If your enlarger is fitted with a dichroic head, you can simply dial in the appropriate polycontrast filtration without needing to purchase a special set of filters.

FOCUSING AIDS

When correct focus is critical, you cannot rely on the naked eye. Special magnifiers are available that enable you to focus accurately. For maximum results, you must focus on a sheet of paper equal in thickness to the printing paper you will use.

FILM-CASSETTE OPENERS

Photo supply stores sell special film-cassette openers, but everyday bottle openers work perfectly well.

The sections of your darkroom where you use chemicals constitute your darkroom's "wet side." Items you should have on hand to outfit that side properly are discussed below.

WETSIDE EQUIPMENT

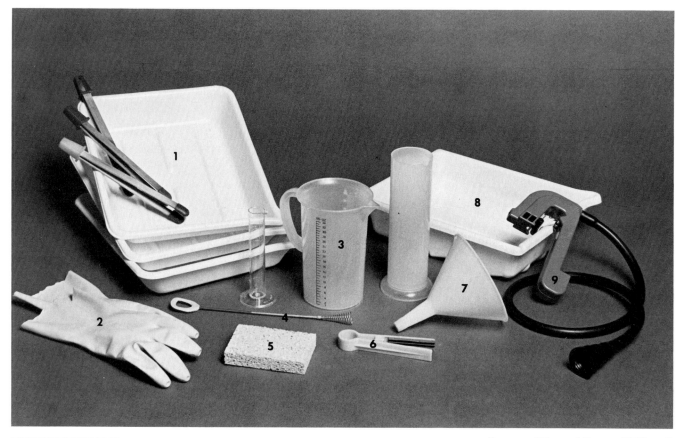

EQUIPMENT FOR THE DARKROOM WET SIDE

1. Trays and tongs
2. Rubber gloves
3. Selection of beakers
4. Stirring rod
5. Sponge
6. Squeegee tongs for film
7. Funnel
8. Washing tray
9. Siphon and connecting hose

TRAYS

Black-and-white prints are usually processed in flat, plastic trays. You will need three normal trays and one tray deep enough (4" is usually sufficient) to allow a thorough wash of many prints at once. Be sure the trays have ribs to prevent prints from adhering to the bottom of the tray. You can use 11"x14" trays for any print up to those dimensions, but if you process many prints smaller than 8"x10", you will find that 5"x7" trays make more efficient use of your chemicals. (If you will be processing color prints, you will also need a "drum." See page 118.)

GRADUATED BEAKERS

Graduated beakers are invaluable for mixing chemicals accurately. A small beaker (2–4 oz) (59–118ml) is useful for measuring small quantities; 16 oz (500 ml) beakers are handy for general use; and 32 oz (1 liter) and 64 oz (2 liters) beakers save you time when measuring large volumes. The beakers most suitable for darkroom use are made of metal or plastic (glass breaks too easily). If you buy plastic beakers, avoid those constructed of hard, brittle plastic. Many beakers are made of a softer plastic that is much more durable.

STORAGE BOTTLES

Once mixed, chemicals deteriorate—some quickly, some slowly. If you are to derive the maximum shelf life from your chemicals, you must store them carefully. The two criteria for a good storage bottle are that it excludes light and that air can be removed from it. (Both light and air speed the breakdown of chemicals.) Any clean, opaque, squeezable plastic bottle found

around the house will probably meet both criteria, although you can purchase expensive, commercially available versions, also. One type of specialized bottle, with sides that compress like an accordian, excludes light and air well but is difficult to clean because of the large surface area created by its pleats.

FUNNELS

Your darkroom counters will quickly become covered with puddles of chemicals unless you use funnels to transfer liquids from container to container. Pick up at least two different sizes of funnel. The best funnels contain a fine-mesh screen designed to trap sediment and solid impurities floating in the chemicals.

STIRRING RODS

Shaking chemicals to mix them introduces oxygen and speeds their deterioration. The stirring rods sold by camera stores are specifically designed for mixing darkroom chemicals. These rods permit deep and thorough agitation but do not roil the surface and thereby introduce air.

THERMOMETERS

Careful control of temperature is critical in darkroom processing; therefore, it is essential that you own a high-quality darkroom thermometer. One versatile thermometer includes a clip for securing it to the lip of a tray or bottle. Metal-clad thermometers can also double as stirring rods.

TONGS

Darkroom chemicals can be caustic, so you do not want your fingers to come in contact with them. Moreover, you must be careful not to contaminate one chemical with another. You therefore need a separate set of tongs for each of the three processing trays. Color-coded tongs are less likely to be immersed accidentally in the wrong tray and contaminate a chemical or ruin a print.

GRADUATE BEAKERS

Accurate measuring containers are indispensable in the darkroom. Small beakers are necessary for measuring small amounts of chemicals, while larger beakers are useful for mixing chemicals in bulk. Containers made of plastic are safe for most darkroom work, but beakers made of brittle plastic, which are slightly more accurate than ones made of pliable plastic, crack easily when dropped.

STORAGE BOTTLES

A wide assortment of storage containers is available. Try to match the size of the bottles you purchase to the quantities of liquids that they will contain because most chemicals deteriorate in the presence of air.

The accordian-type bottle at right allows you to remove air by collapsing the bottle as the chemical is used up. Due to the large surface area of the accordion pleats, however, these bottles are difficult to wash and dry. You can remove air just as well from most soft plastic bottles simply by squeezing the sides before screwing on the cap.

Some manufacturers provide special areas on which you can jot down the contents of the bottle and other pertinent information.

EXPOSURE, PRINTING, AND PROCESSING AIDS

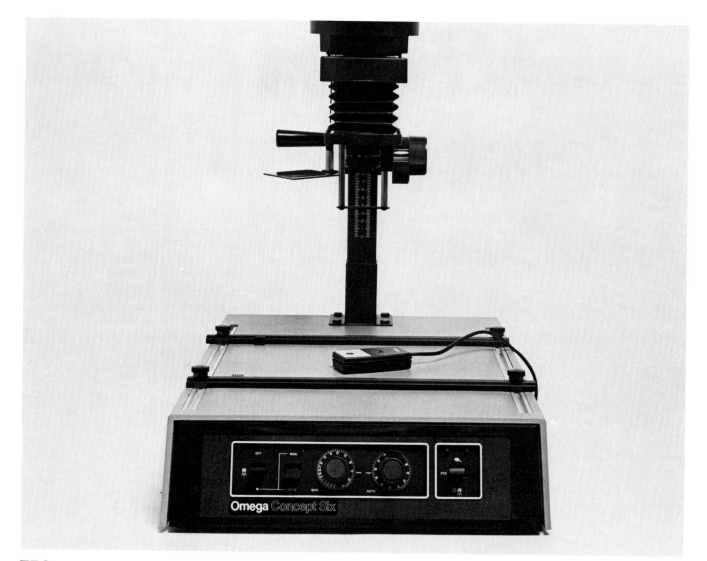

TECHNOLOGICAL AIDS

Modern advances in technology offer a mixed blessing: routine procedures can be automated, but the danger always exists that by relying too much on technology before understanding fundamental principles, you become slave to your equipment instead of its master.

The automated enlarger and enlarger meter described here can be of great help, but be sure you can work *without* them before you start with them.

The books shown are excellent resources that should be kept readily available in every darkroom.

THE AUTOMATIC ENLARGER

Some modern enlargers are built with sophisticated electronics which automate many procedures that formerly relied on trial and error. Enlargers like the one above can be programmed to analyze the light being projected by the enlarger head and indicate the best paper grade to use and the correct exposure time.

In all likelihood, automatic enlargers will one day be as prevalent as automatic cameras are today. Nonetheless, because the first step in programming an automatic enlarger is to produce a correct print without its help, an automatic enlarger will never relieve you of the need to understand fundamental darkroom principles. Therefore, you must be proficient in traditional darkroom skills in order to use and adjust the automatic enlarger effectively.

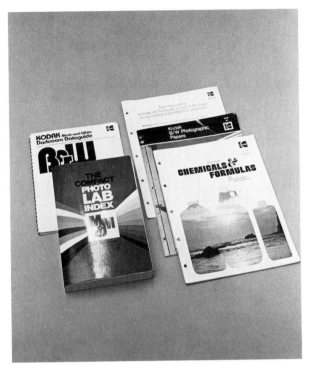

BOOKS

A good library of useful reference materials is a valuable darkroom resource. There is such a wide variety of films, papers, chemicals, and other supplies on the market that you will find the consolidated information in books far easier to refer to than the individual instruction sheets packaged with each product. In addition, some of the books, such as the *Kodak Darkroom Dataguide* shown to the left, contain useful charts, diagrams, and even mechanical calculators to help you make decisions quickly and accurately.

Some books are sold through book- or camera stores, others you can obtain directly from the manufacturer, free or at a nominal cost.

ENLARGER METERS

Some hand-held exposure meters designed for use with a camera can also be adapted to measure the light projected by an enlarger. Meters with an enlarger attachment both provide you with exposure information and aid in selecting a paper grade.

Although enlarger attachments themselves are relatively inexpensive, only the more expensive meters accept such attachments. Therefore, if you are contemplating buying a hand-held meter anyway, you may want to consider one with an enlarger capability, but it makes little sense to purchase such a meter solely for darkroom use.

DARKROOM ON A BUDGET

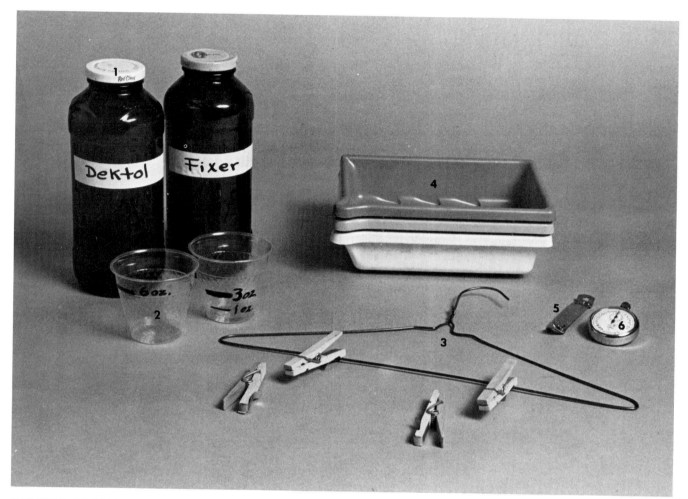

SAVING MONEY

Often you can save money by substituting inexpensive or home-made equipment for the manufactured items available through camera stores. If you substitute carefully, you will not in any way be compromising the quality of your results. Expensive darkroom aids can certainly make your task easier, but they do not necessarily make your prints better.

DARKROOM ON A BUDGET

1. Brown juice bottles
2. Plastic cups marked with commonly used measurements
3. Coat hanger with clothespins for turning a shower-curtain bar into a temporary negative drier
4. Small, plastic processing trays
5. Bottle opener for opening film canisters
6. Stopwatch with a sweep second hand

HOMEMADE CONTACT PRINTER

A piece of glass edged with tape and fastened to a cardboard or wood base makes a useful contact printer.

PLASTIC TANK

An inexpensive plastic tank like this one is packaged with its own thermometer. It is capable of developing one roll of film and adapting to different film sizes. As mentioned earlier, plastic processing kits are most suitable if you process film only occasionally.

2. THE DARKROOM

To the amateur photographer the term *darkroom* creates images of an elaborate and sophisticated arrangement of equipment—enlarger, sinks, trays, bottles, shelves. In actuality, modern processing equipment has made it possible for a darkroom to be quite simple. Now, the only irrevocable requirements for a darkroom are that it exclude light absolutely and that it provide the minimum amount of space necessary to accommodate an enlarger (and trays, if the ability to make black-and-white prints is desired).

For example, since light-tight printing drums make it possible to execute the entire chemical segment of color printing in the presence of light, you could set up your enlarger in a closet, load the drum there in darkness, and afterward move to a kitchen or bathroom for processing. Even running water can be foregone within the darkroom, as long as it is available nearby. Similarly, you can process film by transferring it from the cassette into a "daylight" tank within a light-tight changing bag. Once the film is safely in the tank, you can perform all subsequent processing steps under normal light.

Of course, improvised darkrooms and darkrooms that meet only minimum requirements are hardly ideal. Nonetheless, if you have a good enlarger and discipline yourself to follow careful processing techniques, unorthodox surroundings will not prevent you from producing high-quality prints. Many famous photographers have been forced to perform their processing tasks in makeshift quarters, yet have produced results of unsurpassed quality. If necessary, you can too. Usually all it takes for you to fashion a comfortable, efficient, and entirely adequate darkroom right in your own home is a little imagination and a moderate amount of work.

This chapter presents some principles and suggestions for effective darkroom design. Obviously it will only be in a custom-built darkroom constructed from scratch that you will be able to incorporate all the principles and tips. However, if you spend time studying, visualizing, and planning your darkroom, as well as sketching a few possible layouts to scale on graph paper, you should be able to include many—if not all—the recommendations here. In the long run, the time and effort you spend planning your darkroom down to the finest detail will be rewarded by ease of movement and quality of photography.

PRINCIPLES OF DESIGN

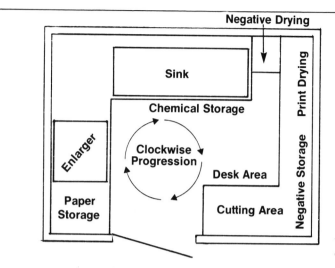

Negative Drying

Sink

Chemical Storage

Print Drying

Enlarger

Clockwise Progression

Negative Storage

Desk Area

Paper Storage

Cutting Area

SMALL DARKROOM DIAGRAM

Economy of motion is fundamental to efficient darkroom design. In addition, since you will be working in the dark much of the time, a well-planned darkroom will allow you to easily locate the materials you need without looking.

If possible, try to lay out your darkroom so that you always move in a single direction. In small darkrooms your motion will be basically circular. For example, while facing the enlarger in the design above, you would pick up the printing paper from your left, expose it, turn to your right to process it, turn again to your right to dry it, and turn yet another time to your right to trim the final print. The next turn would bring you back again to face the enlarger, where you would be set to repeat the process. By moving in such an orderly pattern, you will be less likely to lose your place in the middle of a process, and if you drop something in the dark, you will be able to find it easily.

LARGER DARKROOM DESIGN

In the best darkroom configuration, "dry" exposure operations are physically separated from "wet" processing operations. In larger darkrooms, the operations can be performed along opposite walls, although you must still be careful to lay out an efficient and logical sequence of movements.

The layout at right is adaptable to smaller or larger areas than shown. The advantage of long, wide counters and sinks is that they can accommodate oversize prints or special procedures that involve extra trays (e.g. printing for permanence, p. 78).

The darkroom shown uses a walk-in, light-trap entrance cubicle, painted black, instead of a light-tight door. Heavy dark curtains (symbolized by the two wavy lines) permit you to enter or leave the darkroom without admitting light. This method is especially convenient if more than one person will be needing access to the darkroom at one time.

LIGHTPROOF VENT

You will need a means for admitting fresh air into your darkroom which will provide the necessary ventilation without admitting light. To construct a lightproof vent:
1. *Cut hole* at least 1' (30cm) square in a door, wall, or window.
2. *Cover opening* on the outside with wire screening or slats.
3. *Surround inside borders* of the hole with wood strips that protrude 1" (3 cm) into the darkroom.
4. *Cut cover* for the vent from Masonite or plywood. Make the cover at least 4" (10 cm) wider than the hole in both dimensions.
5. *Attach strips of wood* along any two opposite edges of the cover. The strips should protrude 1⅞" (5 cm) from the surface of the cover.
6. *Attach additional strips of wood* along the remaining two edges of the cover. These strips should protrude only 1" from the surface of the cover.
7. *Paint inside of cover* flat black.
8. *Affix cover* over the hole so that the wood strips on the cover encompass the wood strips surrounding the hole. Because of the two narrower wood strips on the cover, air will be able to flow through the trap, but light will not (see diagram).

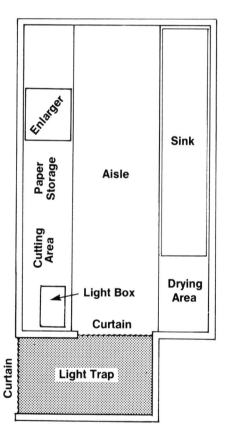

Enlarger

Paper Storage

Cutting Area

Aisle

Sink

Light Box

Curtain

Drying Area

Curtain

Light Trap

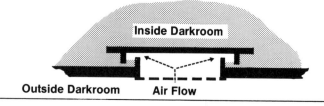

Inside Darkroom

Outside Darkroom Air Flow

Size. Big is not necessarily best. Unless you want to make huge enlargements, a 6' x 8' (1.8 x 2.4 m) floor space will be adequate, comfortable, and efficient. Even with counters built on three sides, an area this size will still allow you to have 30" to 36" (76.2 to 91.4 cm) of aisle space. If you forego a sink and also decide to use stackable trays, your darkroom could occupy as little as 3' x 4' (.91 x 1.2 m).

Light exclusion. Try to select a space with only one door and no windows. If windows are present, cover them with enough lightproof fabric or wood to block all light from entering. Caulk any room or window seams that admit light.

To block light from slipping around your darkroom door, construct a light baffle around the door's edges by attaching wood strips to the door *frame* in such a way that the strips overlap the door by about 1". To block light from entering under the door, staple a folded piece of fabric along the door's bottom edge. Adjust the size and placement of the fabric so that it makes good contact with the floor but does not bind when the door is opened and closed. Finish the job by adding a lock or latch to the door to prevent visitors from entering at the wrong time.

When you think you have blocked all leaks, stand in the room for 10 minutes with the lights out to accustom your eyes to the darkness, then carefully inspect every surface and seam for evidence of stray light.

Dry and wet areas. In a thoughtfully designed darkroom, there is a distinct separation of "dry" areas from "wet" areas. In the dry areas you perform all procedures that do not involve chemicals or water: film loading, paper loading, and enlarging. In the wet areas you perform procedures that do involve chemicals or water: developing and

washing. By creating distinct dry and wet sections in your darkroom, you minimize the likelihood of accidentally ruining a procedure by allowing chemicals or water to come in contact with items that should remain dry.

If your darkroom design includes only one counter, build a small partition to prevent liquids from running from the wet section onto the dry section.

Flow. Since you will be performing many procedures in total darkness, a good design will provide for a logical, efficient flow of motion as you progress from one procedure to the next. In a darkroom with counters on three sides, plan for a clockwise or counterclockwise progression. In a small darkroom with only one counter, the sequence should go from left to right or right to left.

Plumbing. The ideal is to have running water available right in your darkroom. If you are converting a spare bathroom, you may be able to use the sink already present; if at all possible, however, substitute a larger sink designed expecially for darkroom use.

Ventilation. You can improvise a rudimentary ventilation system by drilling a section of holes near the ceiling and another near the floor. To obstruct light, build a light trap over each section (see illustration). For more effective ventilation, a special electric fan that contains built-in light blocks can be purchased from a photo supply store.

Safelights. Many photographic papers can be viewed without harm under a safelight of the proper color. Locate a socket for your safelight, which should be built at least 4 ft. above the darkroom counters in a position where the illumination will not fall directly on your enlarger easel. (Direct light falling on the easel makes it difficult to focus and work with the pro-

jected image.)

Be careful to locate the safelight switch in a place where it cannot possibly be confused with the switch for the standard room light.

One way to obtain the most illumination from the least amount of safelight wattage is to paint the inside of the darkroom white. (As long as your basic darkroom construction is light-tight, there is no need to paint its walls black.)

COIN SAFELIGHT TEST

To double-check the reliability of your safelight, you can perform this simple test. Place a coin on top of a piece of unexposed enlarging paper that is positioned face up in the area of brightest safelight illumination in your darkroom. Allow the coin to sit for about 5 minutes, then process the paper normally. If the outline of the coin is at all apparent, then your safelight is too strong. Check the bulb, the filtration, and the distance of the light from the paper. Make adjustments and repeat the test until no outline is left on the paper.

DESIGN REFINEMENTS

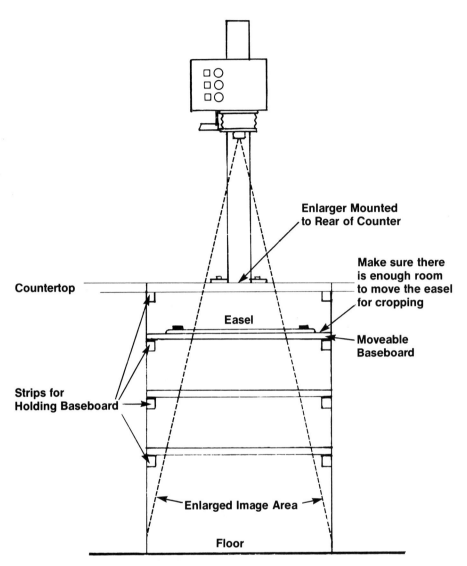

Enlarger Mounted to Rear of Counter

Make sure there is enough room to move the easel for cropping

Countertop

Easel

Moveable Baseboard

Strips for Holding Baseboard

Enlarged Image Area

Floor

ADJUSTABLE ENLARGER BASEBOARD

If you frequently need to produce enlargements exceeding the capacity of your enlarger, you can remount the enlarger column onto a customized counter that allows adjustments in the height of the baseboard.

The diagram above shows how the enlarger image (dotted line) becomes progressively larger as the baseboard is lowered to the floor. Wooden slats support the baseboard at various intermediate levels of enlargements. When constructing such a device, be sure to cut the top opening large enough so that it does not interfere with the image formed at the lower baseboard level. The distance from the enlarger to the bottom level will have to exceed 1 yd (.9m) to produce a 20"x24" (51×61 cm) print from a 35mm negative.

Once you have decided on a location for your darkroom, established its floor plan, arranged for any plumbing and electrical work that will be needed, and determined a logical plan for movement, you can refine your design for maximum efficiency and utilization of space.

ENLARGER MOUNTS

In a standard darkroom setup the enlarger is mounted on a counter, and the size to which photographs can be enlarged is limited by how high above the counter you can raise the enlarger head. A more versatile alternative is to mount the column along which the enlarger head travels directly onto the countertop rather than onto a baseboard, as is normally done.

If you construct the countertop so that you can lower the portion that serves as the enlarger's easel, you will then be able to make extreme enlargements. Take care when constructing such an apparatus to make certain that the adjustable portion of the counter remains completely parallel to the film plane in all positions; otherwise, the projected image will become distorted, and focusing will be difficult or impossible. Also, to make certain that the enlarger head will not vibrate and thus blur the image, securely brace the top of the column to the wall with wire.

ENLARGER ACCESSORIES

Try to locate all enlarger controls and tools as close to the enlarger as possible. If space is at a premium, mount a pegboard on the wall behind the enlarger to accommodate dodging tools, filters, and other accessories. An excellent location for paper storage is under the counter and near the enlarger, in drawers or on shelves. If you have room, you can locate a paper safe close-by.

MISCELLANEOUS ACCESSORIES

Changing bag. Even though you have taken great care to make your darkroom light-tight, you may wish to store a changing bag near the dry area of your darkroom. Then, if something goes wrong while you are loading film in the dark, you can quickly transfer the film to the changing bag and turn on the lights to deal with the problem.

Additional light. In order to evaluate your results while your prints are still in the fixer, you may want to mount a normal light above the fixer tray.

Study area. If sufficient counter space is available, you may wish to arrange a final prep-and-study area at one end of your darkroom. It would contain a light box for viewing negatives and slides as well as equipment for cutting and mounting prints and maintaining records.

BUILDING YOUR OWN FIBERGLASS SINK

You can easily and inexpensively make a sink of the exact dimensions you need out of Fiberglass. The first step is to construct a wood frame with a plywood bottom that slants toward the drain end of the sink. Be sure to seal all joints in the sink with bathtub caulk. To cover the frame with fiberglass, you will need polyester resin, Fiberglass cloth, a mixing bucket, and one or more paint brushes with which to apply the mixed resin. Work in a well-ventilated area using brushes you can throw away afterwards. To cover the wooden frame with fiberglass:

1. *Cut Fiberglass cloth* to fit the frame.
2. *Set cloth aside.*
3. *Mix enough resin* to coat the inside of the frame.
4. *Brush resin on all surfaces* that will later be covered with the Fiberglass cloth.
5. *Position cloth* over the wet frame. *(Note: Work fast. The resin dries very quickly.)*
6. *Smooth cloth* over the form and allow to dry for 15 minutes.
7. *Mix enough resin* to cover the cloth.
8. *Apply a coat of resin* over the Fiberglass.
9. *Allow resin to dry, then repeat previous step.*
10. When the Fiberglass is thoroughly dry, *cut a drain opening* in lower end and install drain plumbing.

The completely finished sink is shown on the next page.

A MODEL DARKROOM

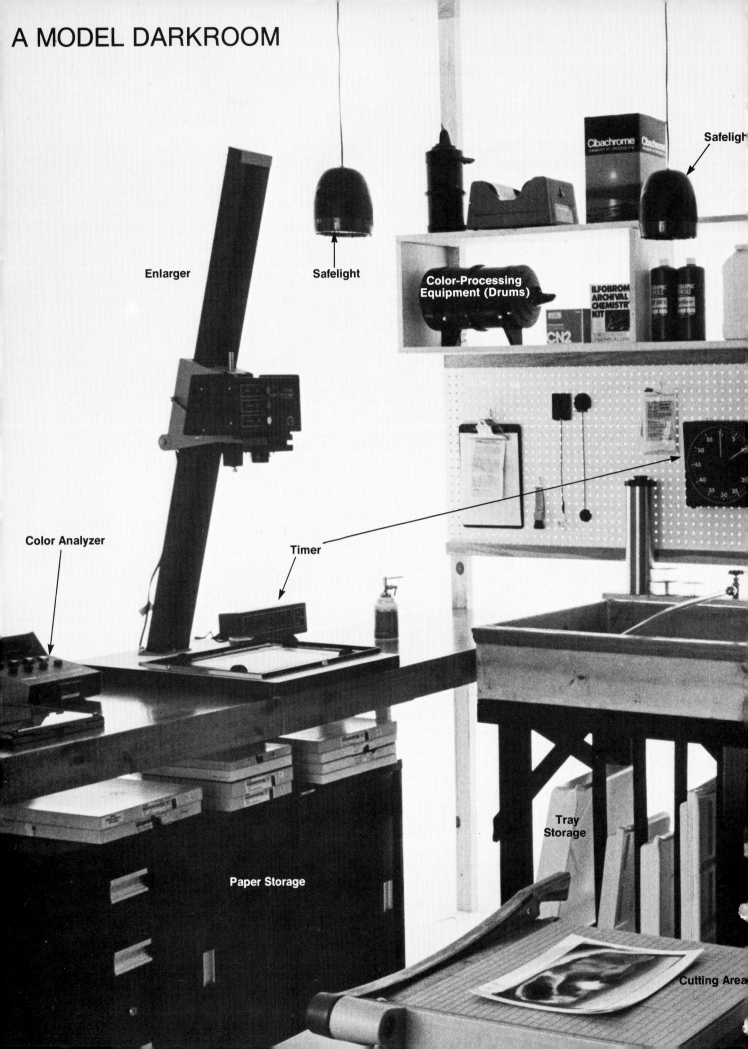

Enlarger

Safelight

Safelight

Color-Processing Equipment (Drums)

Color Analyzer

Timer

Tray Storage

Paper Storage

Cutting Area

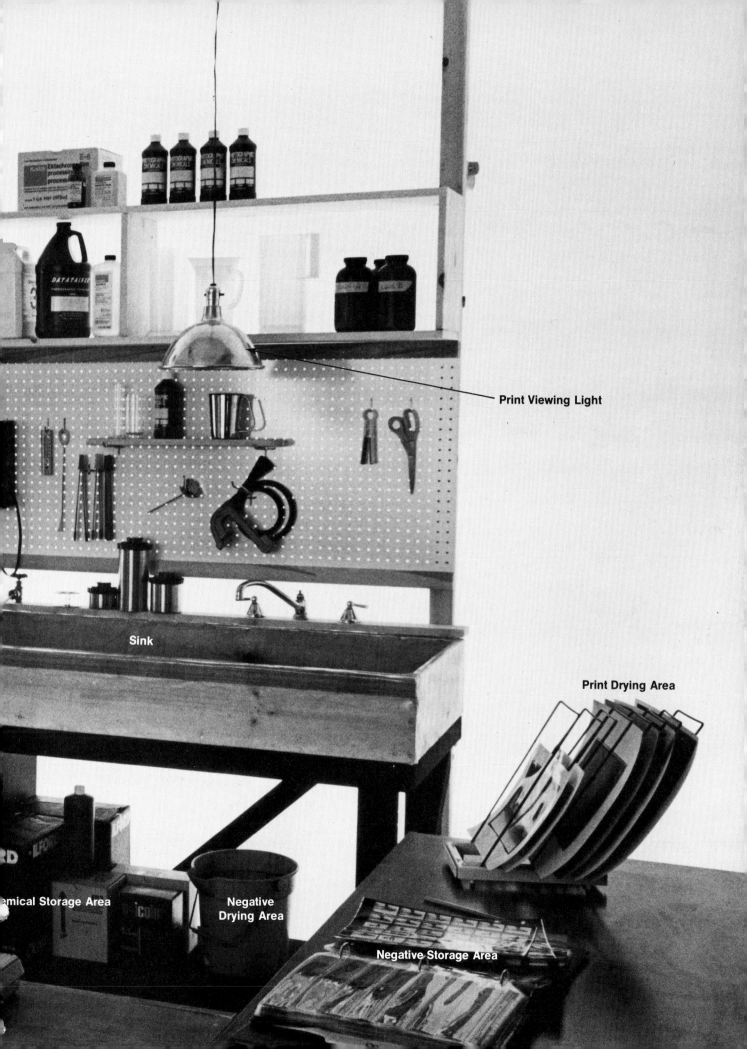

Print Viewing Light

Sink

Print Drying Area

Chemical Storage Area

Negative Drying Area

Negative Storage Area

3. THE BLACK-AND-WHITE NEGATIVE

**MATERIALS FOR PROCESSING
BLACK-AND-WHITE FILM**

Processing black-and-white film requires very little space, a minimum of equipment, and only a small amount of time. The chemicals and equipment pictured above are sufficient to completely process a roll of film.

The *Negative* lies at the very heart of black-and-white processing. Although techniques exist to help "rescue" a deficient negative, the more adept you are at producing high-quality negatives, the more successful you will be in the darkroom.

The manufacturers of darkroom equipment and supplies have a vested interest in your success and therefore make their products as foolproof as possible. On most occasions, you will obtain excellent negatives simply by following the manufacturers' instructions carefully. However, you must not consider their recommendations to be infallible; you must be prepared to deviate from normal procedures when you feel that circumstances so dictate.

As your skills improve, you will no doubt want to try to exert some creative control over the images you produce in the darkroom. By all means experiment, but be cautious. Initially, at least, try to deviate from standard procedures only when you have a specific goal in mind, such as adjusting contrast. Then evaluate your results by how closely you came to reaching your goal. Otherwise, the results of your experiments are likely to be difficult to interpret and hard to reproduce.

As you become adept in the darkroom, you will begin to realize that you cannot divorce the *taking* of a photograph from the *processing* of it. The two either complement or interfere with each other. Once you understand how to use this interrelationship to best advantage, you will be on the road to achieving your full potential as a photographer.

Tone. A *tone* in a black-and-white photograph is a shade of gray. Any two shades of gray that are distinguishable represent two different tones. Almost every scene you photograph will contain a range of tones, as will every negative. Since the human eye can perceive a broader range of tones than can be recorded on film, you must learn to recognize when the range of tones in a scene exceeds your film's ability to record them, and then how to compensate in the darkroom (p. 54).

Since light meters respond to tonal differences, you can use a light meter to measure the tonal range of a scene. The technique is to hold your meter (either a meter built into your camera or a hand-held one) close to the darkest and then the lightest tones in a scene. The difference between the readings you obtain from the two tones represents the *range* of tones contained in the scene.

Try to become an expert at evaluating tones by eye, even though the most accurate method will always be to use a meter. In most circumstances, being able to approximate the tonal range of a scene or negative will be sufficient for your needs.

CHARACTERISTICS OF FILM

PEBBLES

The best darkroom results are obtained when you match a thorough understanding of films with just as thorough an understanding of darkroom chemicals and processes. The photo above was taken on a fine-grained film which was then under-developed slightly to lower contrast and provide a very sharp print.

How film works. The basis of contemporary photography involves the effect of light on a class of chemicals known as silver halides. These compounds display the unusual characteristic of turning black after being exposed to light and chemical processing.

The production of a stable image on film involves three primary steps: first, an emulsion of silver halide crystals suspended in gelatin and mounted on a firm but flexible triacetate base, the film, is *exposed* by allowing light to strike it and form a *latent* (undeveloped) *image*; second, the latent image is *developed* by means of specially formulated chemicals; and third, the developed image is *fixed* by means of additional chemicals which remove the silver halide crystals that were not struck by light in the first step. The end result is called a *negative* because every dark point on the film corresponds to a light area in the original scene, and every light point on the film corresponds to a dark area in the original scene.

Grain structure. The size of the metallic silver crystals contained in the emulsion layer of a processed film produces what is referred to as the film's *grain structure*. The larger the size of each crystal, the more noticeable it is. In large-grained films, clusters of developed silver crystals are readily apparent to the naked eye.

Resolving power. The ability of a film to show a distinct separation between two closely spaced lines within the same shade of gray is called its *resolving power*. In practical terms, the greater a film's resolving power, the sharper the image it will form. Grain and resolving power are directly related: the smaller the grain, the greater the resolving power and the sharper the image.

Sensitivity to light. Films are produced with varying degrees of sensitivity to light. The higher a film's *speed*, as designated by its ASA rating, the more sensitive it is to light. Moreover, hand in hand with film speed is film grain. The faster a film, or the higher its ASA rating, the larger the film's grain structure.

The ASA numbers are carefully calculated to facilitate film-speed comparisons. Thus, ASA 50 film re-

sponds twice as quickly to light as does ASA 25 film, but one-quarter as quickly as ASA 200 film.

The ASA rating assigned to a particular film by its manufacturer assumes that the film will be processed "normally." By changing development times, or by using special developers, you can use the film as if it has an effective ASA different from its rated ASA.

Color sensitivity. Films that respond equally to all colors in the spectrum are called *panchromatic*. Some special-purpose films are *orthochromatic*; that is, they respond normally to blue and green, but red comes out black in a print made from their negatives. *Infrared* film responds to light waves beyond the range of the visible spectrum. The often unpredictable results that are obtained with infrared film are sometimes used creatively to add novelty to an otherwise dull scene.

Choosing a film. Because of the differences in grain structure and resolving power among films of different ASA ratings, your selection of film must strike a balance between the amount of light in a scene and the amount of grain and resolving power you need or want. Although there are darkroom techniques that will increase the amount of grain shown by a developed negative, there is no way to improve upon a film's inherent grain structure. However, one of the advantages of processing your own film is that once you learn the applicable techniques, you will be able to exercise a substantial amount of control over the final appearance of the image on your negative, even if the film is exposed under less-than-ideal conditions. which results in a loss of detail in the negative and an increase in grain size due to the abnormally

Negative density. The result of developing film is a buildup of metallic silver on the negative in pro-

COMMON BLACK-AND-WHITE FILMS

Film	ASA	Grain* (C M F VF)	Characteristics
KODAK			
Panatomic-X	32	VF +	Useful where excellent sharpness (resolution) is necessary and slow speed is no drawback
Plus-X	125	VF	Excellent general-purpose film with wide latitude and medium speed
Tri-X	400	F	Good general-purpose film when shooting is mostly in low-light situations; speed can be pushed
2475 Recording	1000	C	Useful for extremely low-light situations
High Contrast Copy 5069	64		For making copies of b/w negatives no gray tones
ILFORD			
Pan F	50	VF +	Useful where excellent sharpness is necessary and slow speed is no drawback
FP-4	125	VF	Excellent general-purpose film with wide latitude and medium speed
HP-5	400	F	Good general-purpose film when shooting is mostly in low-light situations; speed can be pushed
FUJI			
Neopan SS	100	VF	General-purpose film
Neopan 400	400	F	Useful for low-light situations
AGFA			
Agfapan 25	25	VF +	Useful where excellent sharpness is necessary and slow speed is no drawback
Agfapan 100	100	VF	General-purpose film
Agfapan 400	400	F	Useful for low-light situations

*C—coarse, M—medium, F—fine, VF—very fine

portion to the amount of light that originally struck the film. The greater the buildup, the denser the negative is said to be. A properly exposed, properly developed negative is "optimally" dense. Overexposure of the film in the camera or overdevelopment in the darkroom produces too much density, heavy concentrations of metallic silver. Underexposure or underdevelopment causes reduced density and a loss in highlight detail. Optimal negative density, there-

fore, is important for producing high-quality prints.

Negative contrast. Reproduction of images in black-and-white photography depends on the contrast between different shades of gray. Negatives that contain many slightly different shades of gray between the extremes of black and white are referred to as having *low contrast*. Negatives that show few, and more obvious, gradations of gray are referred to as having *high contrast*.

CHEMISTRY AND EQUIPMENT

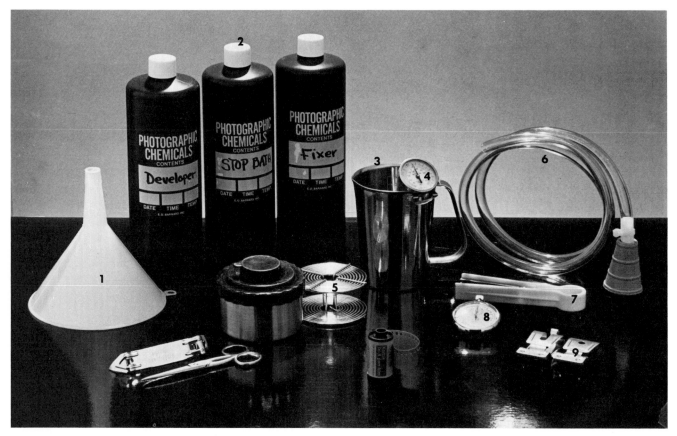

EQUIPMENT FOR PROCESSING BLACK-AND-WHITE NEGATIVES

1. **Funnel**
2. **Storage bottles**
3. **Graduated beaker for mixing and pouring**
4. **Thermometer**
5. **Processing tank and reel**
6. **Washing hose (optional)**
7. **Squeegee**
8. **Stopwatch or timer**
9. **Clips for hanging negatives**
10. **Film-cassette opener**
11. **Scissors**
12. **Film**

CHEMISTRY

All the chemicals you really need to develop film are a developer, a fixer, and some water. Additional chemicals and steps—stop bath, hypo clearing agent, and wetting agent—are optional refinements designed to save you time as well as to extend the life of your chemicals and film. The various chemicals you will be using are discussed below in the order that you will need them.

Developer. The developer converts exposed silver halide crystals into metallic silver, which produces the blacks and grays characteristic of black-and-white photography. Of all the chemicals involved in developing film, none is more important than the developer. Each developer has its own strengths and weaknesses, and each performs best under a particular set of circumstances. The developer you select will determine your film's effec-

tive speed (ASA), as well as your negative's grain and resolution. Moreover, you must match both the developer and the developing time to the conditions under which the film was exposed in order to achieve optimal negative density and contrast.

Stop bath. Once development is completed, you must remove the developer from the film's surface in order to prevent overdevelopment of the film and contamination of chemicals in later steps. One way to halt development is to use water, filling and emptying the tank twice within 30 seconds. Or, you can use a special stop bath mixture, which acts on the developer more quickly and more thoroughly than water alone.

The stop bath procedure is simple: you replace the developer in the tank with the stop bath solution, agitate for 15 seconds, and then discard the stop bath. (An in-

dicator-stop-bath solution can be reused until a change in color signals that the solution is depleted.)

Fixer. If you were to remove film from the developing tank immediately after the stop bath step, the photographs would appear "fogged" because of the remaining silver halide crystals which were not originally exposed to light and therefore were not converted to metallic silver by the developer. The fixer step dissolves these unexposed crystals, thereby removing the fog and making the film no longer light sensitive.

Fixing time varies between 2 minutes and 10 minutes depending on the type of fixer you are using. A rapid fixer will work in 2–4 minutes, while a regular fixer requires 5–10 minutes. Fixing time is also affected by how fresh the solution is. The older it is, the more time you must allow for the fixer to do its work.

Fixing time is somewhat arbitrary, but standard practice is to leave film in the fixer twice as long as is necessary to clear all visible fog. Should you find your film still fogged after removing it from the fixer, your fixer is either depleted or contaminated. To remedy the problem, you can fix the film again using fresh chemicals.

Hypo clearing agent. Any chemicals remaining on the film after processing is completed will continue to act and eventually will stain, fade, or completely destroy the photographic image. A thorough washing for 30 minutes under running water will usually eliminate chemical residues, but you can speed up the process and make it more reliable by inserting a wash with *hypo clearing agent* between two short water washes. Using a hypo clearing agent shortens the total wash time to 3–8 minutes.

Wetting agent. Due to normal surface tension, water forms beads on the surface of film. When the

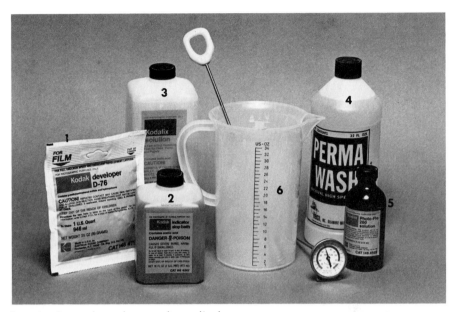

beads dry, minerals are deposited on the film and appear as spots. Solutions known as *wetting agents* prevent beads of water from forming by reducing surface tension so the water flows off the film more smoothly. Normal procedure involves soaking the film briefly in a wetting agent, such as Kodak Photo-Flo®, before hanging the film up to dry. (If you use a squeegee or sponge to remove excess liquid from the film before hanging it up, first moisten the squeegee or sponge with a wetting agent to minimize the likelihood of scratching the film's delicate emulsion layer.)

CHEMICALS FOR PROCESSING BLACK-AND-WHITE NEGATIVES

1. Package of developer (Kodak D-76)
2. Acid stop bath
3. Fixer (powder or liquid concentrate)
4. Perma Wash or hypo clearing agent to accelerate wash time
5. Wetting agent (Kodak Photo-Flo 200) to prevent water spots from forming on the negatives
6. Graduated mixing beaker and mixing rod
7. Thermometer for mixing and using chemicals

THE BLACK-AND-WHITE DEVELOPER

Significant differences exist among the various groups of developers: some work best for preserving the grain structure of fine-grained films, some are recommended for use only with properly exposed film, some are used to "push" underexposed film, some are most effective for increasing negative contrast, and some are best for decreasing negative density. In all likelihood your personal style of photography will cause you to find that most of your film can best be processed using one or two particular developers. Your strategy should be to identify your preferred developers, then master their use so completely that they become a standard against which you compare all others.

Black-and-white film processing is subject to a large number of variables. Although manufacturers offer guidelines for use of their products, no matter which developer you choose, you will need to experiment with time, temperature, and exposure.

Below are some explanations about different types of developers and some discussions on important aspects of developer selection. Find the category of developer that seems most likely to meet your needs, select a brand from that category, then completely familiarize yourself with that specific developer. Later you can experiment with other developers as your needs and desires indicate.

General developers. Most people find a good general-purpose developer such as Kodak D-76 or Ilford ID-11 to be the mainstay of their darkrooms. General-purpose developers are proven formulas which produce negatives of normal contrast, reasonably fine grain, good overall sharpness, and proper density, using average development times. If necessary, you

Black-and-White Developers

Developer	Film speed increase (S—slight; N—normal; H—high; VH—very high)	Chemical form (P—Powder; L—Liquid Concentrate)	Grain (M—medium; F—fine; VF—very fine)	Dilution	Can be replenished and re-used	Speed of development (S—slow; N—normal; F—fast; VF—very fast)	Characteristics
KODAK							
D-76	N–H	P	F	1:1	Yes	N	One of the best general use developers
Microdol-X	N	P	VF	1:3	Yes	S	Very fine grain developer for producing extra sharp negatives; for best results use diluted
HC 110	N	L	M–F	Varies	No	S–F	General-purpose liquid; speed of developer depends on dilution
Versatol	N	L	M	1:19	No	F	Can be used to develop paper as well as film
DK-50	N	P	M	1:1	Yes	N–F	General use developer
D-19	N	P	N	None	Yes	N–F	For very high contrast development
ILFORD							
Microphen	N	P	F	1:1 1:3	Yes	S–N	Excellent fine-grain developer which gives an increase in film speed
Perceptol	N	P	F	1:1 1:3	Yes	S–N	Very fine-grain developer for producing extra sharp negatives; for best results, use diluted (similar to Microdol-X)
Id-11	N–H	P	F	1:1	Yes	N	One of the best general use developers (formula similar to Kodak D-76)
ETHOL							
Blue	H–VH	L	M–F	1:30 to 1:120	No	N–F	Very versatile, highly concentrated, single-use liquid which gives a full range of film-speed choices and development-time choices depending on dilution
UFG	H–VH	P or L	F	1:5	Yes	F	General-use developer extremely versatile with wide latitude for controlling contrast and density
TEC	H	L	M	1:15	No	N	Compensating developer for controlling contrast and density
TEC	H	P	M	1:14	No	N	Compensating developer in two parts for controlling contrast and density
90	H–VH	P or L	M–F	None 1:10 1:20	Yes	VF N N	Can develop in 1½ minutes if used full strength; slower when diluted
ACUFINE							
Acufine	H–VH	P	F	1:1 1:3	Yes	VF	Useful for greatly increasing film speed while maintaining good grain
ACU-1	H–VH	P	F	1:5 1:10	No	N	Useful for greatly increasing film speed while maintaining good grain
Diafine	VH	P	M–F	None	Yes	6 min.	Produces exceptionally high film speed; same development time for all films in a two-step process
BESELER							
UltraFin FD2	H	L	F	Varies	No	N	Compensating developer for controlling negative contrast and density while maintaining sharpness
UltraFin FD5	N–H	L	VF	1:15 1:30	No	N S	General purpose developer designed to give good grain and sharpness
UltraFin FD7	H–VH	P	N–F	None	Yes	S–N	General-purpose developer designed to increase film speed while maintaining good grain; can be used as a compensating developer to control contrast
EDWAL							
FG7	S–VH	L	F	1:1 1:2 1:3 1:15	Yes	VF	Very versatile, general-purpose developer; different dilutions and development times yield film speeds and contrasts tailored to specific usages
Super 12	S–VH	L	F	1:1 1:9	Yes No	N	Noncompensating developer which yields "snappier" contrast in negatives under flat lighting situations, such as available light
Super 20	H–VH	L	VF	None 1:1 1:7	Yes Yes No	N	Very fine grain developer which gives sharp negatives of normal contrast on slow-to-medium-speed films
Minicol II	N	L	VF	1:7	No	S	Compensating developer intended for achieving very fine grain, sharp negatives from slow-speed film

can use these developers occasionally to "push" underexposed films with acceptable results.

Fine-grain developers. If your regular practice is to shoot very slow film in order to obtain sharp, fine-grained negatives suitable for large blowups, then fine-grain developers such as Kodak Microdol-X, Ilford Perceptol, and Beseler Ultrafine FD5 will serve you well, as long as you do not mind the increased development times they require.

Versatile developers. If you shoot in a wide variety of situations—pushing fast film to its ASA limit one day and making fine-grained 16″x20″ (41x51 cm) blowups the next—consider using a versatile developer such as Ethol UFG, Edwal FG7, or Ilford Microphen. These products can accommodate a wide range of film speeds and contrasts. With practice, you can use these developers to obtain quality results over a broad range of conditions.

Contrast developers. Sometimes you may want to use your developer to increase contrast, for example, when a roll of film has been shot outside on an overcast day or when you want to photograph line drawings (such as diagrams and sketches). Contrast developers such as Kodak D-19 accomplish this by rendering all tones as either pure black or pure white.

Compensating developers. Each type of film responds to a limited range of tones. If the range of tones in a scene exceeds the range of tones your film is able to record, detail will be lost in the shadows and highlights of the photographic image. If you have exposed a roll of film under conditions such that you know the scene exceeded your film's tonal range, you can use a compensating developer to retain more of the highlight and shadow detail than would be possible using a standard developer. Examples of good compensating developers include Edwal FG7, Ethol TEC, Beseler UltraFin FD2, and Acufine ACU-1.

Dilution vs. replenishment. Each time you process a roll of film, the strength of the chemicals in your developer becomes somewhat depleted. Developers intended for disposal after one use are diluted with water before being used. Developers intended for reuse are used full strength, then replenished by the addition of more of the concentrate or of a special replenishment solution.

Disposable developers will yield better negatives with greater consistency than will reusable developers, but their processing times are longer. Unless short development times are very important to you, however, the quality and consistency you can achieve with disposable developers are worth the few minutes of additional processing time.

Shelf life. Every manufacturer specifies its product's shelf life, that is, the period of time after mixing during which the chemicals should continue to yield satisfactory results. Because the principal cause of chemical deterioration is interaction with oxygen (oxidation), the advertised shelf life of a chem- ical is attainable only if nearly all oxygen is removed from the storage container. You should store mixing chemicals in airtight plastic bottles that you squeeze firmly to force out extra air before capping. Most developers stored in this manner will keep for three to six months.

Development time. The degree of density to which a latent image is developed depends upon the strength and temperature of the developer, the amount of time during which the developer is allowed to act, and the amount of agitation applied to the developing tank. Manufacturers of developers and film usually package general instructions and time-temperature charts with their products; you can also consult a book of photographic tables and formulas to obtain this information. However, since the optical elements in your particular enlarger may affect contrast, you may need to experiment with increased or decreased development times in order to achieve the contrast quality you desire. (Condenser enlargers often require shorter development times, diffusion enlargers often require longer development times.) Be sure you understand the technique for proper agitation, (p. 47) before you attempt to develop a roll of film.

Development times in minutes for various films in Kodak D-76 diluted 1:1 or Ilford ID-11

	TEMPERATURE				
	65F/18C	68F/20C	70F/21C	72F/22C	75F/24C
Kodak					
Panatomic-X	8	7	6½	5¾	5
Plus-X	8½	7¼	6¾	6	5¼
Tri-X	11½	10	9¼	8½	7¼
Ilford					
Pan-F	10½	9	8	7	6
FP-4	10½	9	8	7	6
HP-5	14	12	1½	9¾	8

LOADING FILM

DEVELOPING REELS

In order to ensure that all parts of a roll of film are evenly immersed in the processing chemicals, you must roll your film onto processing reels designed so that the film's surfaces can be freely reached by the various chemicals involved. Since film incorrectly loaded on a reel usually develops unevenly (as happened to the film in the photos at the top of this page), you should practice loading with an expandable roll of film until you have mastered the technique. Otherwise, you will be likely to ruin part or all of the first few rolls of film you try to develop.

Loading metal reels. You can learn to load plastic reels easily by following the directions included with the reel. In order to learn to load a metal reel, you will need either an already developed roll of film or an unexposed roll to "sacrifice" for the sake of education. There are two secrets to loading film onto a metal reel: (1) you must "bow" the film the proper amount by squeezing its edges between your fingertips as you feed it onto the reel and (2) you must not allow the film to feed onto the reel at an angle. The photo directly above shows a reel being loaded improperly. The film is not being fed straight onto the reel, which will result in crushed film and uneven development.

The photos at right illustrate how to load film onto a metal reel. If you are left-handed, reverse the refer-

→ 34A → 35 → 35A → 36 → 36.

LOADING FILM ONTO A METAL REEL

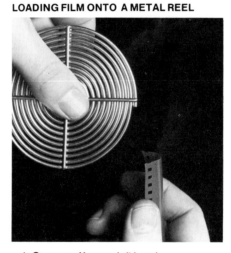

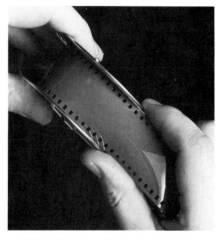

1. *Grasp reel* in your left hand.
2. *Check with left index finger* to make certain that the outer ends of the spiral wires that make up the reel point toward the film.
3. *Bow film* slightly by squeezing its edges between the fingertips of your right hand.
4. *Insert end of film* into the slot in the axle of the reel.
5. *Hold film in slot* with pressure from your left index finger.

6. *Place thumb and index finger* of your right hand against the edges of the reel. (Maintain a bow in the film.)
7. *Rotate reel counterclockwise* with your *left* hand. Allow the film to slide through your right thumb and finger against the reel.

8. *Continue rotating reel,* making certain the film feeds straight onto the reel and no kinks form, until all the film is loaded.
9. *Cut film spool* from the end of the roll (or detach the spool by removing the tape).
10. *Insert reel in tank.*
11. *Cover tank.*

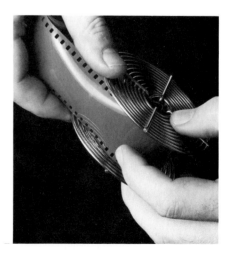

ences to right and left hands, and rotate the reel clockwise instead of counterclockwise. Practice first while looking at the reel, then practice in total darkness.

AGITATION TECHNIQUE

By keeping the chemical solution in motion, agitation replenishes depleted chemicals, resulting in even development and normal contrast (middle photo at right).

Effects of improper agitation. *Insufficient agitation* allows depleted chemicals to cling to the surface of the film, preventing full development and causing contrast to be too low (top photo). *Too much agitation* causes chemical reactions to take place too quickly, resulting in excessive density in the negatives and an increase in contrast (bottom photo at right). Also, overly vigorous agitation causes developer to surge through the film's sprocket holes, producing *surge marks* along the edge of the film.

Proper agitation technique. The agitation procedure described here will produce excellent results under most circumstances; however, always consult the manufacturer's instructions to determine if a special technique is recommended. (Note: Where air bubbles cling to the surface of the film, chemicals cannot approach close enough to the film for a chemical reaction to occur. By tapping the tank once or twice on a hard surface immediately after you pour a processing chemical into the tank, you will dislodge any air bubbles. Thereafter, follow the normal agitation procedure.)

Procedure. Unless the film's manufacturer recommends otherwise, firmly but gently turn the developing tank over and back each time an agitation step is called for. Practice for a few moments without film and with plain water in the tank until you have developed a smooth agitation rhythm. The over-and-back sequence should take about 2 seconds to complete.

No agitation.

Proper agitation.

Excessive agitation.

DEVELOPING BLACK-AND-WHITE FILM
Step-by-step

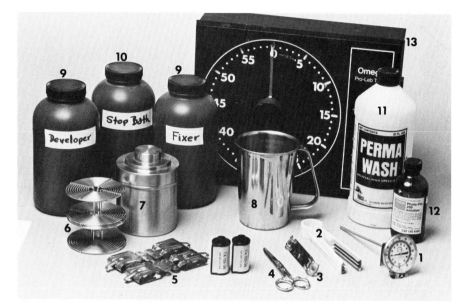

WHAT DO YOU NEED

1. Photo thermometer, *for determining the temperature of the chemicals you are using*

2. Squeegee tongs, *for removing excess water from film before hanging it to dry*

3. Bottle opener, *for opening film cassettes*

4. Scissors, *for snipping the ends of film*

5. Clips, *for hanging film while it drys*

6. Reels, *for holding film while processing takes place*

7. Tank, *for submerging film in chemicals within a lightfree environment*

8. Pitcher, *for pouring chemicals*

9. Developer and fixer, *chemicals necessary for developing film and removing unexposed silver*

10. Stop bath, *optional but very useful chemical used to halt action of developer thoroughly*

11. Hypo clearing bath, *optional but very useful chemical used to thoroughly remove fixer from film (e.g., Heico Perma Wash)*

12. Wetting agent, *optional chemical used to reduce surface tension of water to promote spotless drying (e.g., Kodak Photo-Flo)*

13. Timer, *to accurately measure duration of processing steps*

GENERAL INSTRUCTIONS

Determining development time. Packaged with each roll of black-and-white film you will find an information sheet that tells you how long to leave the film in the developer. All you need to do is measure the temperature of your chemicals, then look up the appropriate developing time for the type of developer you are using. Be sure that all your chemicals, including your wash water, are within about 5F (3C) of each other. The times required for chemicals other than the developer are listed on the bottles they come in or on separate instruction sheets.

Agitation. When you are performing an agitation step as part of an actual development sequence, for the first 15 seconds you should agitate continuously. Thereafter, you should agitate for only the last 5 seconds (i.e., for two complete tank inversions) of each 30-second period. At the end of the final 30-second period, do not agitate.

Using multi-reel tanks. Tanks which hold two reels can be handled in the same manner as single-reel tanks, but tanks which hold three or more reels should be agitated every 60 seconds instead of

every 30 seconds. If you want to develop a single roll of film in a multi-reel tank, be sure to fill the extra space in the tank with empty reels, and fill the tank completely with chemicals.

Mixing chemicals. Many darkroom chemicals must be mixed together or diluted before they can be used to process film. Consult the appendix for instructions on how to mix chemicals before you start to process a reel of film.

Pouring chemicals. Pour chemicals quickly and smoothly. Once a chemical is poured into the developing tank, be sure to tap the tank a few times on a hard surface to dislodge any air bubbles that may be clinging to the film. Start pouring chemicals out of the tank early enough so the tank is completely drained by the time the step should be completed.

Chemical depletion. If you are using a reusable chemical, you need to know when to replenish or discard it. To keep track of how many times a chemical has been used, you can make a small tick mark after each use on a piece of tape stuck onto the chemical's storage container.

Timing individual steps. The standard technique for timing individual steps is to start the timer at the same time you begin to pour a chemical into the tank. An alternative method, which is optional with small tanks but mandatory with large tanks (holding three or more reels) is to pour the developer into the tank *before* you turn the lights out to load the film into the reel. In this manner, when you place the loaded reel in the development tank, all of the film begins the development process at the same time. For subsequent steps, you should prepare a spare tank with the next chemical needed, so that when you turn the lights off and remove the

first tank's cover, you will only need to transfer the reel from the empty tank to the full one.

Opening the tank. Do not expose the film to ligt until after the film is fixed. Use the light-tight top on your tank for both pouring chemicals into the tank and pouring them out again.

Chemical contamination. It is surprisingly easy to contaminate one chemical with another. To prevent contamination, be sure your developing tank and reels are spotlessly clean and dry before you start to develop a roll of film; rinse your pitcher with water between uses; develop the habit of rinsing off your thermometer with water each time after you have immersed it in a chemical; always return chemicals to their proper bottles immediately after use; and clean up spilled chemicals promptly.

Organization. Assemble everything in the sequence you will need it. Develop a pattern of placement that is comfortable and efficient for you. Stick with it. Keep your work areas clean, uncluttered, and dry.

If you have practiced loading the film and agitating the tank and have assembled all the materials you will need (see photo), you are ready to begin. The photos on this and the following five pages will guide you through processing a roll of film from start to finish. The steps shown include use of a stop bath, hypo clearing agent (Perma Wash), and a wetting agent (Photo-Flo), all of which are helpful and strongly recommended, but which can be eliminated if necessary.

● 1. *Uncap film canister.* One end of each canister is flat, the other end has a stub of spool. Uncap the flat end.

● 2. *Trim off film leader.* The "leader" is the tapered end of a roll of film. The film will not feed onto the reel properly unless you remove the tapered section.

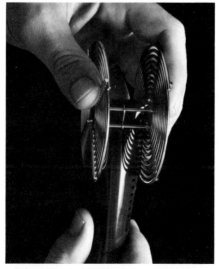

● 3. *Insert end of film in slot in center of the reel.* Remember to check that the reel spirals toward the film, and to gently squeeze the film to form a bow. Hold the film in the center slot with your left index finger.

● 4. *Roll film onto reel.* Keep the film straight, maintain a bow, and allow the film to slide between your right thumb and index finger. Run your left index finger along the film to check for kinks.

Execute steps preceded by a "●" in complete darkness.

• 5. *Cut spool away from end of film.* If you prefer, you can detach the spool by removing the tape that holds it to the film.

• 6. *Insert reel in developing tank.* If you are using a multi-reel tank but are developing only one reel of film, place the loaded reel in the bottom, and fill the remaining space with empty reels.

• 7. *Cover tank.* Once the tank's cover is on, you can turn on the lights.

8. *Pour measured amount of developer into pitcher and check temperature.* Use enough developer to completely fill the tank, even if you have only one loaded reel in a multi-reel tank.

KODAK Packaged Developers	SMALL TANK†—Agitation at 30-Second Intervals						
	65°F 18°C	68°F 20°C	70°F 21°C	72°F 22°C	75°F 24°C	65°F 18°C	
HC-110 (Dilution B)	8½	7½	6½	6	5	9½	
D-76	9	8	7½	6½	5½	10	
D-76 (1:1)	11	10	9½	9	8	13	
MICRODOL-X	11	10	9½	9	8	13	
MICRODOL-X (1:3)	–	–	15	14	13	–	
POLYDOL	8	7	6½	6	5	9	
DK-50 (1:1)	7	6	5½	5	4½	7½	
HC-110 (Dilution A)	4¼	3¾	3¼	3	2½	4¾	

NOTE: Do not use developers containing silver halide solvents.
*Unsatisfactory uniformity may result with development times shorte
†Usually one-quart size or smaller.

9. *Determine correct development time.* Consult instructions packaged with your film or developer, or refer to a darkroom manual. A 73 F (23C) temperature calls for a development time between 6½ minutes and 5½ minutes.

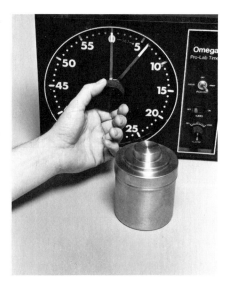

10. *Set timer.* The time indicated for this film in this developer at this temperature is 6 minutes.

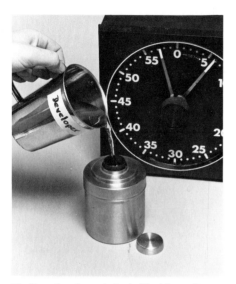

11. *Pour developer in tank. Start timer.* Remember that pouring and timing being simultaneously. If you are using a tank holding three or more loaded reels, consider the alternative method for pouring developer described on p. 18.

12. *Agitate tank continuously for the first 30 seconds.* Thereafter, agitate for the last 5 seconds of each 30-second interval. Do not agitate in the final 30-second interval.

13. *Drain developer from tank.* Remember to begin pouring early enough so that the tank is empty when the timer rings (about 10 seconds for single-reel tanks). Discard the developer or save it for reuse, as applicable.

14. *Set timer.* The correct time for this particular stop bath is 30 seconds.

15. *Pour stop bath into tank. Start timer.* If you are not using a stop bath, insert a 30-second water wash here.

16. *Agitate tank.* Agitate continuously.

DEVELOPING BLACK-AND-WHITE FILM (Continued)
Step-by-step

17. Drain stop bath from tank. Save the stop bath for reuse.

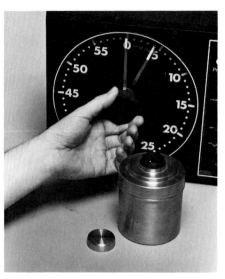

18. *Set timer.* The correct time for this particular fixer with this particular film is 4 minutes.

19. *Pour fixer in tank. Start timer.*

20. *Agitate tank.* Agitate continuously for the first 30 seconds. Thereafter, agitate for the last 5 seconds of each 30-second interval. Do not agitate in the final 30-second interval.

21. *Drain fixer from tank.* Save the fixer for reuse.

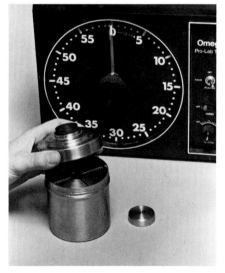

22. *Remove tank cover.*

23. *Wash film in running water.* A 1-minute wash is correct because a hypo clearing agent will be used. A water wash alone needs 20–30 minutes.

24. *Fill tank with hypo clearing agent. Agitate continuously.* Be certain you have diluted the clearing agent according to the manufacturer's instructions. The correct time to use with this particular brand of clearing agent is 1 minute.

25. *Wash in running water.* A 1-minute wash is sufficient.

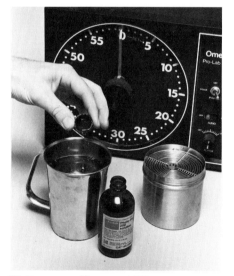

26. *Prepare wetting agent.* Dilute according to the manufacturer's instructions.

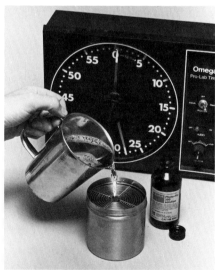

27. *Pour wetting agent solution into tank.* Allow the film to soak for 30 seconds. Do not agitate. Discard the wetting agent or save it for reuse, as you wish.

28. *Hang film to dry. Squeegee.* Premoisten the squeegee tongs with a wetting agent solution. Run the tongs along the film in one continuous stroke from top to bottom. Try to protect the film from dust. The film is dry when the emulsion side becomes concave rather than convex.

CONTROLLING DENSITY AND CONTRAST

Dense Negative

Normally Dense Negative

Weak Negative

If density in a negative is incorrect, detail suffers. Only in the middle photo above is detail sufficient to yield a good print. In the top photo, detail is obscured by excessive silver deposits, while in the bottom photo, not enough silver has been deposited to provide adequate detail.

If the proper exposure of the *darkest* tone in a scene requires an aperture that is no more than seven stops different from the aperture required for a perfect exposure of the *lightest* tone (at the same shutter speed), the film will be able to record all the tones contained in the scene. (Of course, the actual photograph must be exposed for the tone exactly between the two extremes.) If a scene contains a tonal range greater than seven *f*-stops, that is, if the scene is too "contrasty" for the film, detail will be lost in the shadow and/or the highlight areas. If a scene contains a tonal range substantially less than seven *f*-stops, the film's capabilities are being underutilized. Because of the nature of film developing, however, both these problems can be alleviated somewhat by manipulating negative density and contrast in the darkroom.

THE EFFECT OF DEVELOPMENT TIME

How development time affects density and contrast. When film is exposed to light, the conversion of silver halide to metallic silver is greatest where the largest amount of light hits the film; that is, the greatest amount of silver is deposited on the sections of the negative that correspond to the *highlights* in the original scene. Conversely, the least amount of silver is deposited on the areas of the negative that corresponds to *shadows* in the original scene.

When exposed film comes in contact with developer, a large amount of silver halide must be converted to metallic silver in the highlight areas, but far less silver halide must be converted in the shadow areas. Thus, shadows finish developing relatively quickly, whereas highlights take much longer. If development is cut short before the highlights are completely developed, they appear more gray in a final print than they were in the original scene. In other words, *underdevelopment reduces contrast* by reducing the range of tones (shades of gray) contained in the negative. If development is allowed to proceed *beyond* the time for an "optimal" negative, shadow density may increase a little, but highlight density increases substantially, causing an increase in overall contrast because the range of tones in the negative becomes wider. In other words, *over-development increases contrast*.

If a scene contains a tonal range which is greater than seven *f*-stops, underdeveloping the film will tend to reduce the tonal range (or contrast) on the negative so that the range falls within the film's recording capabilities. But since underdevelopment will reduce the negative's overall density, the original scene needs to have been overexposed to compensate. Therefore, if you are confronted with a high-contrast scene that exceeds your film's recording capability—an outdoor panorama under a harsh sun, for example—overexpose the scene by one *f*-stop, then underdevelop the film. The result will be a negative of correct density which preserves the shadow and highlight detail that would have been lost had the scene been exposed and processed normally.

Likewise, if you wish to photograph a low-contrast scene—a sailboat engulfed in fog, perhaps—underexposing the film followed by overdeveloping the negative will produce a properly dense negative showing a broader tonal range (more contrast) than the original scene. Control such as this is what makes darkroom processing much more than a routine exercise in direction-following.

OTHER FACTORS

The amount of contrast displayed by a final print will not only be affected by the original scene, the way it is exposed, and the way it is developed, but also by the camera lens, the enlarger light source, and the enlarger lens.

Making adjustments to improve negatives. If the contrast in your negatives is consistently too high or too low, try decreasing or increasing development time, respectively, to alleviate the problem. If this causes a problem with density, set your exposure meter to a lower or higher ASA rating, respectively, which has the effect of altering exposure. (The ASA rating assigned by the film's manufacturer applies under a "standard" set of conditions. Your equipment or conditions may invalidate the assigned ASA.)

Testing for proper negative contrast. A simple exercise will help you establish the best ASA rating and development time for your film-equipment-developer combination.

Load your camera with fresh film, and set your exposure meter to the film's assigned ASA. Next, photograph a gray scale available from photo supply stores, filling the film frame as completely as possible. Now reduce your ASA setting by one-half stop and repeat. Keep changing the ASA setting by one-half stop until you have taken photographs at two consecutive ASA settings on either side of the film's assigned ASA. Now, develop the film normally. The ASA setting at which the individual squares on the gray scale are distinct is the setting you should normally use with this film. You can repeat the test for the other films you regularly use, and keep a record of the new ASA settings for future reference.

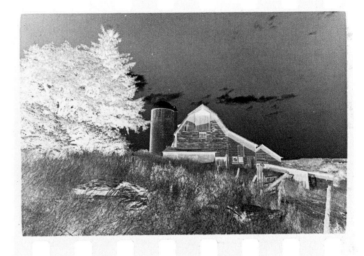

→ 22 → 22A

DEVELOPMENT TIME AND SUBJECT TONAL RANGE

If light meter readings reveal that a scene contains fewer or more than seven tones, you can "expand" or "contract" the scene's tonal range as suggested below.

If subject tonal range is:	Change development time by:
5 stops	+60%
6 stops	+25%
7 stops	no change
8 stops	−2.5%
9 stops	−5%

Being able to analyze contrast in a negative will help you learn to *control* contrast and to decide on the grade of paper to use to print a particular negative.

The negative at left, below, is too "contrasty." The difference between the lightest and darkest tones is extreme, and there is no detail in the darkest and lightest areas.

The negative at right, below, shows insufficient contrast. The gradations between tones are slight, and the frame appears dull overall.

The negative above demonstrates the way a negative *should* look. The range of tones is not extreme, but the subject is nonetheless clearly defined. Note especially that detail is excellent in both the darkest and lightest areas.

You will save yourself a substantial amount of printing paper as well as time if you quickly learn to identify and produce negatives showing correct density and contrast.

34A → 35 → :

High Contrast Negative

ETY FILM 5062 K

20 → 20A 1 8

Low Contrast Negative

55

PUSH PROCESSING

PUSH-PROCESSING
BLACK-AND-WHITE FILM

One decided advantage of home processing is that you are able to tailor film speed to your specific needs. Nowhere is that ability more valuable than in low-light situations when photographing living subjects. In order to take the above photo without resorting to artificial lighting, the ASA of the film was pushed to gain two stops of shutter speed. To compensate for having pushed the film, its development time was increased.

If you are faced with a situation in which there is insufficient light to allow you to take a picture at a fast enough shutter speed to prevent blurring, you may have to resort to "pushing" your film speed beyond its rated ASA. For example, suppose you are confronted by a situation such that even though you have set your lens to its widest aperture and are using ASA 400 film, you are still worried that the shutter speed you need for a correct exposure might permit a blurred image. If you set your exposure meter to ASA 800, the meter will indicate that a correct exposure is occurring at the next faster shutter speed. The net effect is that the image on the film is "frozen" by the faster shutter, and the film is underexposed by one *f*-stop. Had you

pushed the film to ASA 1200, you could have used a shutter speed one and one-half times faster than at ASA 400, and a push to ASA 1600 would have allowed you to use a shutter speed two times (two stops) faster than at ASA 400.

Push-processing. Because pushed film contains underexposed latent images, normal processing of such film produces negatives of less-than-optimal density. In order to improve density, you can either extend development time or use a special developer specifically intended for use in processing pushed film. (Of course, you must always push the *entire* roll of film, since you cannot push-process a few frames while processing the rest normally.)

Extending processing time. The more you have pushed a film (the more you have increased the film's ASA above its recommended rating), the more you need to extend processing time if you are using a standard developer. Although the extended development time improves negative density, it also causes increased graininess, loss of sharpness, loss of detail in shadows and highlights, and increased contrast. As you might expect, the more the film is pushed, the more noticeable these effects.

Using special developers. High-speed developers such as UFG, TEC, Acufine, Diafine, and UltraFin FD7 are formulated to minimize the image deterioration that occurs when pushed film is processed in standard developers. These special developers are excellent for preserving grain structure, shadow and highlight detail, sharpness, and contrast by controlling the clumping of metallic silver that otherwise occurs when film is pushed and push-processed.

Which to use. If you only occasionally resort to pushing film, there is little point in purchasing special developers. If you regularly push film, however, or if you have a roll of pushed film out of which you wish to squeeze every last drop of quality, then special developers are worthwhile.

Temperature and Film Speed for Some High Speed Developers

Film	Temp F	C	Developer: Rated ASA / Development Time in Minutes*				
			Acufine	Edwal FG7 (1:2)+	Ethol Blue (1:30)+	Ethol UFG	UltraFin
Tri-X	65	18	1200/7½	800/4	2400/8¼	1200/7	1600/19¼
	70	21	1200/6	800/3½	2400/6¾	1200/5¼	1600/15½
	75	24	1200/4¾	800/3	2400/5½	1200/4	1600/11¾
Plus-X	65	18	320/5	250/3½	400/3½	320/4	200/12¾
	70	21	320/4	250/3	400/2	320/3¼	200/11½
	75	24	320/3¼	250/2½	400/2	320/2¾	200/9
HP-5	65	18	1600/10	800/4	1600/11	1000/6¼	1600/19½
	70	21	1600/8	800/3½	1600/8	1000/5¼	1600/17
	75	24	1600/6¼	800/3	1600/5½	1000/4½	1600/14½
FP-4	65	18	200/5	250/4	320/3¾	320/4¼	250/17
	70	21	200/4	250/3½	320/3	320/3½	250/15¼
	75	24	200/3¼	250/3	320/2½	320/2¾	250/12
Kodak 2475	65	18	3200/8¼	2000/6	2400/12¾	3200/11¼	1000/19½
	70	21	3200/7	2000/5	2400/10	3200/9¾	1000/11
	75	24	3200/5½	2000/4	2400/8	3200/8½	1000/8½

*NOTE: Pushing film involves some risk. Actual times may vary depending on circumstances and equipment. Experiment first, then make adjustments based on your findings.

+ Ratio of developer to water.

Push Processing

To push ASA 400 black-and-white film in Kodak D-76 or Ilford ID-11, try altering development time as shown in the chart below. The increases are only approximate, and you may need to adjust the suggested percentages according to your own results.

To push	To ASA	Increase development time by
2 stops	1600	80%
1½ stops	1200	60%
1 stop	800	40%

REDUCTION AND INTENSIFICATION

Overexposed Negative

REDUCING A NEGATIVE

The negative shown above was over-exposed by three *f*-stops and processed normally. Treatment with Kodak Farmer's Reducer reduced the overexposed image to normal density, as shown below.

Often you can rectify minor density problems merely by choosing the correct grade of printing paper (as explained in the next chapter), but in extreme cases, two methods—*reduction* and *intensification*—exist for treating the negative itself before the print is made. These techniques, however, are best used only as a last resort,

REDUCING DENSITY

You can reduce negative density in two simple steps using Kodak Farmer's Reducer. The reducing kit contains two packets of chemicals, labeled "A" and "B," which each produce 1 quart of solution when dissolved in water. To reduce an overly dense negative (this process can be performed under normal room lights):

1. *Soak* the negative in water for 10 minutes.
2. *Mix* equal volumes of solutions A and B in a tray large enough to accommodate the negative you wish to treat.
3. *Immediately immerse* the negative in the mixture. The mixture has an active life of only 10 minutes.
4. *Watch* the negative closely; *do not overreduce*. Overreduced negatives are very difficult to restore.
5. *Remove* the negative as soon as reduction has progressed to your satisfaction.
6. *Wash* the negative in running water for at least 10 minutes.
7. *Dry* the negative.
8. *Repeat* the entire process, if necessary.

Reduced Negative

Underexposed Negative

Intensified Negative

INTENSIFYING DENSITY

A negative that lacks density is referred to as being *weak*. Kodak Chromium Intensifier restores density and improves contrast but at the same time adds significantly to the grain size of the film.

The intensifier kit contains two packets of powder: one mixes with water to form 16 oz (473 ml) of a bleach solution, the other forms 16 oz of a clearing bath. In addition, you will need to purchase Kodak Dektol developer and dilute it 1:3 (one part Dektol to three parts water). To intensify a weak negative (this procedure can be performed under normal room lights):

1. *Soak* the negative in water for about 10 minutes.
2. *Immerse* the negative in the bleach for 3–5 minutes, or until the entire image turns yellow.
3. *Rinse* in water.
4. *Immerse* the negative in the clearing bath for 2 minutes, or until the negative clears and the yellow disappears.
5. *Rinse* in water.
6. *Redevelop* the negative in Dektol (diluted 1:3) until a darker image reappears.
7. *Wash* for 10–20 minutes.
8. *Repeat* the entire process, if necessary.

INTENSIFYING A NEGATIVE

When a negative has been underexposed to the point where it is difficult to print (above, left), you may be able to salvage the negative by bleaching and redeveloping it in a process known as *intensification*. Although intensification will yield a more printable negative (above, right), grain will increase and quality will remain inferior to that of a negative that was properly exposed and processed in the first place.

4. THE BLACK-AND-WHITE PRINT

When you expose a frame of film but allow someone else or a machine to develop and print it, for all practical purposes your involvement in the creative process has ended with the camera's shutter snap. However, by processing and printing your own film, you assume a position of total control. You manipulate each facet of the craft until you achieve exactly the results *you* are seeking.

The mechanics of producing a high-quality print, while not very difficult to learn, require more than simply reproducing the image on a negative. With practice and determination, you can dramatically and creatively influence the appearance of a print—to an equal or even a greater extent than when you took the photograph originally. In other words, the negative is as much a starting point for creativity as the original scene. You will know you have achieved the highest level of darkroom mastery when you discover that the decisions you make regarding the way you take your photographs is influenced by the way you plan to process and print them.

The two phases of producing a print are: exposing the paper and processing it. The first phase is a "dry" procedure performed with the help of an enlarger, and the latter phase is a "wet" procedure in which chemicals in liquid form are required. Although you will need to combine the two phases once you actually start producing your own prints, we will discuss each phase separately.

The dry procedure, in which you expose the paper, is probably the most rewarding and exciting part of darkroom processing, perhaps because that is the phase in which you have the greatest creative influence. Although the selection of a printing paper can be an imposing task because of the bewildering array of paper available, the specific paper you initially choose is not critical as long as you come to know it well. Once you become thoroughly familiar with how that paper responds to exposure and processing, you will be able to switch to different papers with ease.

Unless you are planning to try archival printing, (see p. 78), the wet part of preparing prints varies little when using products from one manufacturer or another. Similarly, once you learn to process prints, the techniques are the same whether you are preparing a contact sheet, a test exposure, or a final print.

THE PRINTING SETUP

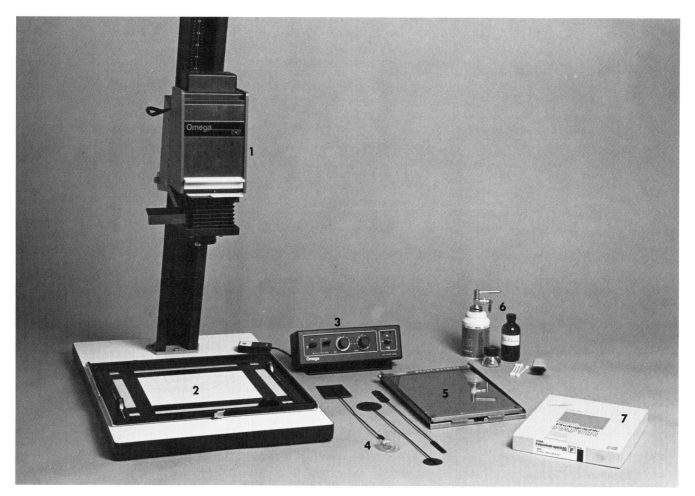

DRY-SIDE EQUIPMENT

1. **Enlarger**
2. **Paper easel**
3. **Enlarger timer**
4. **Dodging tools**
5. **Contact printer**
6. **Materials for viewing and cleaning negatives: compressed air, magnifier, negative-cleaning fluid, Q-tips, anti-static brush**
7. **Enlarging paper**

PREPARING TO PRINT

Most of the equipment (trays, tongs, thermometers, water, jars, etc.) that you need for black-and-white printing has already been described and discussed in the first two chapters. However, there are some other considerations you should have when you are making prints.

Chemicals. With some slight variations, the chemicals used to process prints are similar to those used to develop film. *Indicator stop baths* are normal stop baths with a chemical that changes color and thereby indicates when the stop bath is exhausted and needs to be replaced. *Fixers* are usually the same in printing as in developing, although a special dilution may be necessary. Also, as with film, a *clearing agent* such as Perma Wash improves upon plain water washes.

Safelights. Since most papers are not panchromatic, and as a result do not respond to all colors of light, low-intensity red or amber colors often will not affect paper at all. Therefore, you can use safelights of these colors to allow you to see in the darkroom while the normal room lights are off. Because papers vary in sensitivity to safelight illumination, be sure to follow the manufacturer's instructions for the type of paper you are using. As a rule, you will be safe as long as your light source is of the proper color, is produced by a bulb no stronger than 15 watts, and is located no closer than 4' (1.2 m) from the paper.

Cleanliness and care. Any speck of dust on the negative will block light and produce a white spot on the final print. Although you can "spot" or retouch prints, you will save yourself later effort by making certain your negative is scrupulously clean when you use it to ex-

pose the print. An anti-static brush and a can of compressed air will remove dust easily and effectively. If your negative has become scratched or nicked, Edwal No Scratch applied according to the manufacturer's instructions will help. A magnifying glass such as the Agfa 8x lupe will assist you in inspecting negatives for dust and scratches.

Tongs. Although some photographers use their hands to transfer prints from tray to tray, that technique invites contamination of the print caused by chemicals clinging to the fingertips. The safe way to transfer paper from tray to tray is to use tongs—a separate pair for each tray.

Temperature. More important than keeping a specific temperature for each chemical is keeping all chemicals at the *same* temperature during processing. Room temperature of around 68F (20C) is adequate, but make certain that any water you draw from the tap is adjusted to the same temperature as your other chemicals.

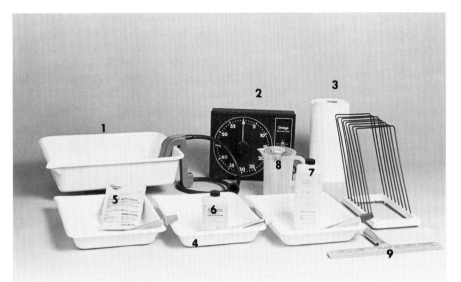

WET-SIDE SUPPLIES

1. **Wash tray and siphon**
2. **Timer**
3. **Paper towels**
4. **Processing trays and tongs**
5. **Developer**
6. **Stop bath**
7. **Fixer**
8. **16 oz or 32 oz (500 or 1000 ml) graduated beaker and thermometer**
9. **Print-drying squeegee**
10. **Print dryer**

PRINTING PAPER

TYPES OF PAPER

If you have never made your own prints, you might initially feel overwhelmed by the wide assortment of black-and-white papers on the market. However, you can quickly become quite knowledgable by asking your photo supply dealer to show you a sample book of papers by Agfa, Ilford, or Kodak. If you have never seen any paper other than that used by commercial processing labs, you may be surprised at the variety of surface textures, colors, and weights available. Study and compare the samples carefully to gain a feel for the way papers differ.

Described below are some terms you will find printed on the labels of the boxes in which papers are sold. By being familiar with their definitions before you enter the store, you will be able to decide quickly upon the type of paper you want to buy.

Base. Historically, photographic emulsions were mounted on fiber-base papers. Recently, however, resin-coated papers such as Kodak RC and Ilford Ilfospeed have been introduced which are water resistant. This type of paper requires a much shorter processing time and dries more quickly than its untreated counterparts. Because water-resistant paper is a new development, no one knows for certain how quickly it will deteriorate over years or decades. Nonetheless, there is no question that water-resistant papers are a vast convenience.

Weight. Papers are sold in various thicknesses from light (or single) weight to medium weight to heavy (or double) weight. Lightweight papers are satisfactory for prints up to 8"x10" (20x25 cm), but are too fragile for larger size prints.

Surface. Paper surfaces differ in terms of texture and luminosity.

Texture refers to the degree of smoothness shown by a paper's surface. Common textures include glossy, lustre, semi-matt, matt, and pebbly. However, imitation silk, linen, tapestry, and other textures are also available. *Luminosity* is closely related to texture and refers to the brilliance shown by the paper's surface. Glossy and lustre surfaces show high luminosity, whereas matt and imitation surfaces are noticeably duller.

If you would like to, you can further enhance the shine of glossy paper by means of *ferrotyping*, a process in which you dry the paper face down on a highly polished sheet of ferrotype tin. However, you may well find that the high glare produced by ferrotyping is a distraction.

As a rule, you want a glossy surface if your print will be reproduced (for example, in a newspaper or magazine). If you plan to display the print itself, selecting a more textured surface will help minimize surface glare. Keep in mind, however, that image sharpness decreases as surface texture increases.

CONTRAST GRADES

Contrast. Every negative contains a certain number of tones (shades of gray) between total black and total white. Likewise, each photographic paper *produces* a certain number of tones between black and white. When the tonal sensitivity of the paper corresponds to the number of distinct tones present in the negative, you obtain a print as "true" to the negative as you can achieve.

The number and range of distinct tones that a paper can produce is indicated by its *contrast grade number*. The tonal range of #2 papers roughly corresponds to the full range of tones that black-and-white

film can record. Printing a negative containing this range of tones on a higher grade of paper would reduce the number of tones contained in the final print. Because this would result in fewer gradations between the remaining tones, the print would display increased contrast. On the other hand, printing the negative on a *lower* grade of paper would preserve all the tones in the negative but would reduce the separation between the individual tones. As a result, the contrast would be decreased.

In short, different paper grades provide you with a means for controlling or correcting the contrast of your final prints. For example, suppose you have photographed a scene under harsh sunlight such that your negative displays a high degree of contrast. If you print on #1 paper, the printed image will show a more normal range of tones than is on the negative. Likewise, if you have shot a scene on a hazy day, and have produced a low-contrast negative, you can print on high-contrast paper to generate a more normal range of tones.

Variable-grade papers. The wider the variation in amount of contrast from one negative to the next, the greater the number of paper grades you will need—unless you use a variable-grade paper such as Kodak Polycontrast, Polycontrast Rapid, or Ilford Multigrade. With these papers, you can change contrast grade by placing special filters in front of your enlarger lens. (Actually, the filters can be assembled from color-printing filters, so if you have a dichroic head, you can control the paper's contrast by "dialing in" the correct filtration. Consult your owner's manual for details.)

Traditional papers are sold in contrast grades of 1, 2, 3, 4, and 5 whereas variable-grade papers

can produce contrast grades of 1, 1½, 2, 2½, 3, 3½, and 4. As you can see, variable-grade papers can produce intermediate-value contrasts for "fine tuning," but cannot reach the extreme contrast grades possible with single-grade papers. Also, bear in mind that the grade designations are not always interchangeable; that is, for any individual paper grade, the variable-grade equivalent may produce slightly higher or lower contrast.

Paper tone. The term *black* actually encompasses several different color tones. *True black* refers to a neutral black tone, while black with a cream tone is said to be *warm*, and black with a blue tone is said to be *cold*.

In the early years of photographic printing, the choice of paper tone was considered an important aesthetic judgment, and photographers sometimes rendered their blacks in shades of green, blue, orange, and other colors. Today, the range of paper tones available is very limited, and most photographers do not even consider any tone other than neutral black—even though a change of paper tone can aesthetically improve the final print.

You can influence the tone characteristic of an image through your choice of paper or by employing one of the color toners available from camera stores.

Not all negatives are best printed on normal #2 paper. In the top photo, harsh midday sunlight produced such deep shadows and bright highlights that the range of light intensities in the scene exceeded the film's ability to record them. Moreover, what little detail *was* present in the shadows and highlights of the negative did not show up on #2 paper. Printing the same negative on #1 paper would have caused more shadow and highlight detail to appear.

In the lower photo, the range of contrasts on the negative was so uniform that the image appeared dull when printed on #2 paper. Had this negative been printed on #3 paper, contrast would have been improved and the print made more interesting.

PROCESSING THE PRINT
Step-by-step

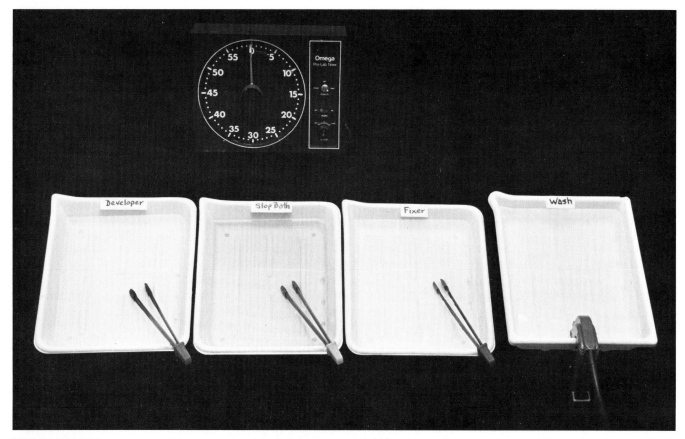

WET-SIDE SETUP

Even before you expose a sheet of printing paper, you should prepare the supplies and equipment you will need in order to process it. Mix the necessary chemicals, pour them into trays, arrange the trays in the order that you will use them, and provide for a water wash.

A print is processed for any of three purposes: to produce a contact print, to make an exposure test, or to produce a final print. In each case, you should process the paper as soon as it is exposed. Since the general procedure for processing prints is the same for contact printing, determining exposure, and final printing, we will discuss it first, before discussing the specific procedures for each case.

PRELIMINARIES

Print processing is very closely related to film processing, but it has the advantage of allowing you to see what you are doing under a safelight of the correct color. Before you begin to process a print, be certain you have prepared the chemicals shown in the photo above and have assembled all the equipment you will need. The time shown in the instructions at right

for developing the print is 1½ minutes. This is the recommended time for fiberbase papers, but if you are developing a resin-coated paper, the recommended time is only 1 minute. Underdeveloping a print causes its blacks to appear gray; overdeveloping has little effect up to 3 minutes of total processing time and no effect at all after that. As a rule, you should process fiberbase papers for no less than 1 minute and no more than 3 minutes, whereas you should process resin-coated papers for no less than 45 seconds and no more than 2 minutes.

1. Immerse exposed paper in developer. Start timer. Immerse the print by sliding it in as shown to ensure that liquid covers the entire surface all at once. The timer should be set to 1½ minutes for fiber-base papers, 1 minute for resin-coated papers.

2. Agitate. As the image starts to appear, gently rock the tray back and forth to establish a wave motion in the liquid.

3. Remove paper. Drain.

. . . and allow the liquid on the surface of the paper to drain into the tray for a few seconds before continuing to the next step.

4. Immerse print in stop bath. Start timer.

5. Agitate in stop bath for 10 seconds.

PROCESSING THE PRINT (Continued)
Step-by-step

6. *Remove print. Drain.*

7. *Immerse print in fixer.* **The print should be left in the fixer between 2 minutes and 10 minutes, depending on the paper and the type of fixer. The heavier the paper and the more exhausted the fixer, the longer the time should be. Consult the instructions packaged with the fixer.**

8. *Agitate.* **Continue to agitate the tray as long as the print is in the fixer.**

9. *Remove print. Immerse print in water wash.* **Wash fiber-base papers for 60 minutes, resin-coated papers for 4 minutes.**

10. *Squeegee print.* **First run the squeegee across the back of the print, then across the front.**

11. *Dry print.* **Either use a drying rack or place the print on absorbent paper.**

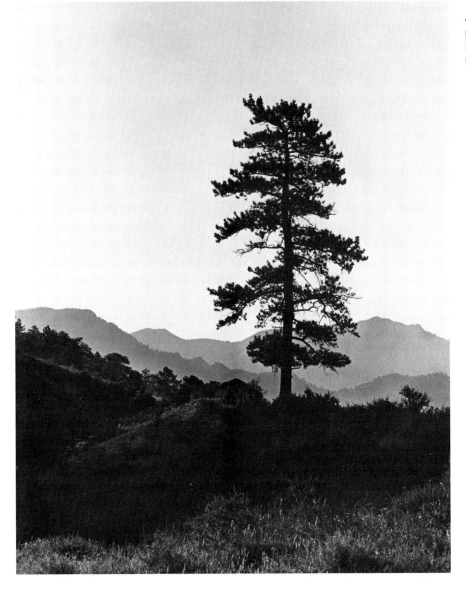

The sudden materialization of the image on your very first print, which you have exposed and processed entirely on your own, is one of the most exciting experiences in photography.

CONTACT PRINTING

THE ROLL AT A GLANCE

Once you have developed a roll of film, you must decide which frames you want to print. Although with practice you can learn to "read" negatives fairly well, usually you will want to make printing decisions based upon a *contact print* of the entire roll of film.

To make a contact print, you place the entire roll of film in direct contact with a single sheet of printing paper, turn on your enlarger long enough to properly expose the paper, and then process the paper in the normal manner. The resulting print will contain a positive image of each frame on the roll.

Actually, contact printing and determining exposure are interrelated: you cannot make a contact print without some idea of the best exposure time, but you usually do not want to make a test exposure before you have made a contact print. Therefore, familiarize yourself with both these topics before attempting either.

Contact printing frames. In order to hold the film flat against the paper, you will need to use a contact printing frame. You can either purchase a frame or make one of your own. All you need is a wooden frame that will hold a sheet of printing paper, and a sheet of glass to lay over the film to hold it flat. Hinge one edge of the glass to the frame with tape.

Paper. In most circumstances, normal #2 paper will produce satisfactory contact prints. However, you may find that the increased contrast of #3 paper will make your contacts easier to read.

A 36-frame roll of film cut into six strips of six frames each will just fit onto a standard 8"x10" sheet of printing paper.

Making a contact. To make a contact print, first cut your roll of 35mm film into strips of six frames each, then follow the instructions at right.

MAKING A CONTACT

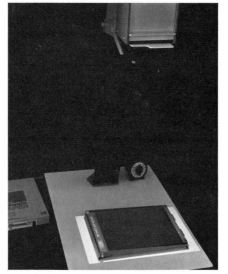

1. *Adjust enlarger head* so that the lamp produces a patch of light on the easel slightly larger than the paper you are using.
2. *Turn off all lights except safelight.*

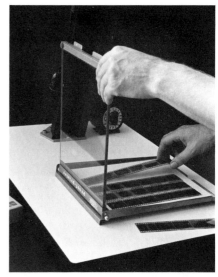

3. *Insert sheet of printing paper*, emulsion side *up*, into your contact printing frame.
4. *Arrange strips of negatives* along the length of the paper, emulsion side *down*. (Six strips will just squeeze onto an 8"x10" (20x25 cm) sheet of paper.)

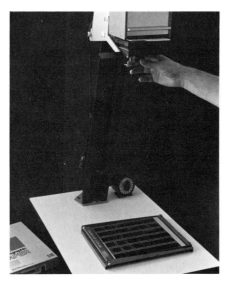

5. *Lay glass cover on top of negatives.*
6. *Set enlarger lens to f/8*, or thereabout.

7. *Turn on enlarger lamp* for 3–8 seconds. (See the section on determining exposure, page 72).
8. *Develop print* normally.

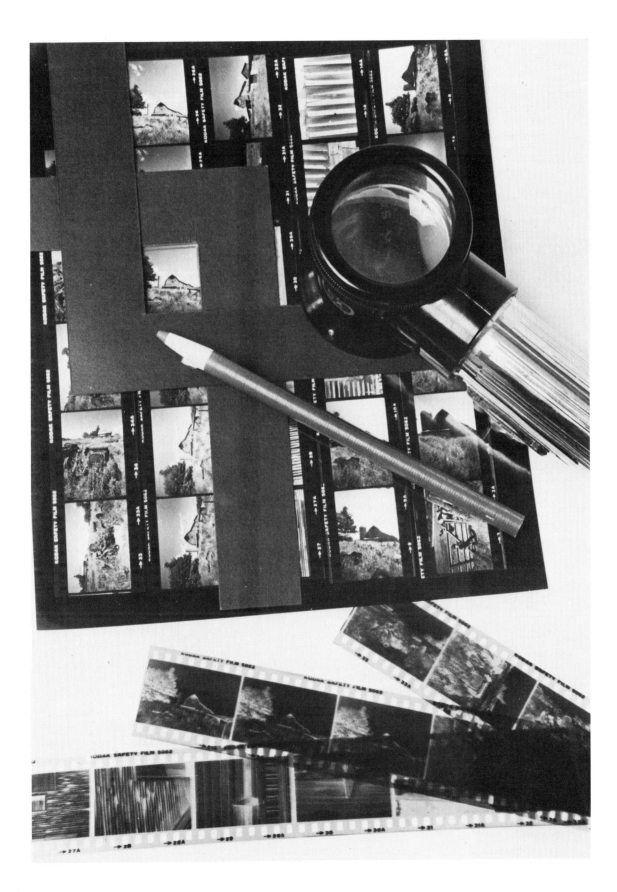

DETERMINING EXPOSURE

EVALUATING A TEST PRINT

Each strip in your test print corresponds to a different exposure time. The lightest strip represents the shortest exposure, the darkest strip the longest. The strip that shows the best exposure indicates the amount of time to expose the final print. For example, in the above photo, the third strip from the right was given the best exposure time. Since each strip in this example represents an additional five seconds of exposure, the correct exposure for the final print) is fifteen seconds.

If all the strips are too dark, you need to repeat the test using a smaller lens aperture and/or a shorter exposure interval. If all strips are too light, repeat the test using a larger lens aperture and/or a longer exposure interval.

If your test print indicates that an inconveniently long exposure time is needed, you can cut the time by one-half by opening the lens one *f*-stop, or by one-quarter by opening the lens two *f*/stops, and so on. Likewise, you can increase a very short exposure time by closing down the lens and increasing the time correspondingly.

APERTURE AND EXPOSURE TIME

If all negatives were of equal density, and if you always enlarged prints to the same degree, you would always use the same exposure time and lens opening. However, since conditions do vary, you need to make a test print that includes different exposures from which you can select the best. An excellent technique is to expose different sections of a single print for different lengths of time. After the paper is processed, the section that looks best indicates the setting at which you should make the final exposure.

Exposure. The relationship between lens aperture, exposure time, and printing paper is analogous to the relationship between lens aperture, shutter speed, and film in a camera. In the darkroom, a proper exposure depends on your using the correct combination of aperture and exposure time for the amount of light being generated and the sensitivity of the paper. Closing or opening the enlarger lens one *f*-stop has the same effect on degree of exposure as halving or doubling the exposure time; that is, *f*-stop and exposure time are reciprocal. For example, *f*/8 at 3 seconds is equivalent to *f*/11 at 6 seconds, *f*/16 at 12 seconds, and so on.

Making a test print. The procedure for making a test print is similar to that for making a final print, which is illustrated on pp. 74–75. Before making a test print for the first time, read those pages so that you understand how making the text exposure fits into the overall process. Then make the test print by following the step-by-step description at right. Evaluate your results as described in the photo at left, above.

A printing aid, such as Kodak's Projection Print Scale, makes it easy to establish exposure time. Place your negative in the enlarger, focus, and set the lens to *f*/8. Then put the scale on top of your test paper in the easel and make a 60-second exposure. After the print is developed, you can select the best exposure time by examining the print and identifying the band that looks best.

DETERMINING EXPOSURE

1. *Adjust enlarger height. Focus image.* The test image must be enlarged to the same size as you want the final print to be.

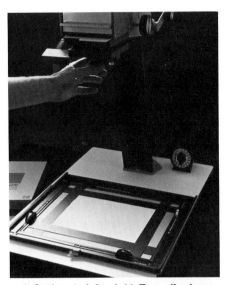

2. *Set lens to f/8 or f/11. Turn off enlarger lamp.* The specific setting is arbitrary, but f/8 and f/11 are intermediate apertures that provide good depth of field yet allow flexibility should your test reveal that a major exposure adjustment is necessary.

3. *Set timer. Mount paper on easel.* The greater the degree of enlargement, the longer the time duration should be. For small prints (smaller than 8" x 10") (20 x 25 cm) try 3, 4, or 5 seconds. For larger prints (11" x 14" or larger) (28 x 36 cm) try 10, 12, or 14 seconds.

4. *Cover all except last sixth of paper. Expose print.* Cover the print with a sheet of dark cardboard. Hold the cardboard motionless while the enlarger lamp is on.

5. *Uncover one additional sixth of paper. Expose again.* Continue repeating this step until the entire sheet of paper has been exposed, one additional strip at a time. (Note: You can expose the test print in quarters, fifths, sevenths, or other fractions, if you prefer.)

6. *Process print normally. Evaluate results.* Processing is described beginning on p. 67. How to evaluate the test print is explained on the page opposite this one.

EXPOSING THE PRINT
Step-by-step

EXPOSING THE PRINT

Once you have developed a roll of film, made a contact print, decided on an individual frame to enlarge, selected a paper to print on, and made a test exposure, you are ready to expose the final print following the procedures below.

1. *Identify emulsion side of negative.* Dry film is bowed so that the emulsion lies on the *inside* of the bow.

2. *Clean negative.* Usually a blast from an air gun is sufficient to remove all dust, but sometimes you may also need to use an anti-static brush or even a liquid film cleaner.

3. *Insert negative into enlarger,* emulsion side down. Be certain the negative is properly aligned in the negative carrier and is held firmly.

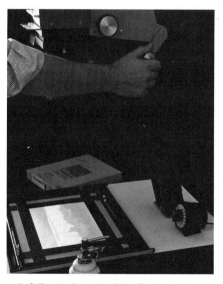

4. *Adjust enlarger height. Focus image.* You can focus most easily and accurately if you open your lens to its widest aperture.

5. *Select* f-*stop setting.* Use the same aperture you used to make your test print.

6. *Set timer.* Use the time that your test print indicated would give the best exposure.

7. *Turn off enlarger lamp. Remove sheet of printing paper from storage.* Be sure that the only illumination is from a safelight of the correct color for the paper you are using.

8. *Identify emulsion side of paper.* The emulsion side is usually the shinier side.

9. *Place paper in easel*, emulsion side up.

10. *Expose print.* The procedures for processing the print after exposure are explained on p. 66.

DODGING AND BURNING-IN

TOTAL EXPOSURE CONTROL

The primary difference between film and printing paper is the base on which the light-sensitive emulsions are applied: film has a transparent base, printing paper has an opaque base. Not surprisingly, the same variations that occur in the developing rate of shadows and highlights on film occur on paper as well. With film, you can affect the appearance of shadows and highlights only by altering the development time, and you cannot selectively affect one area more than another. With paper, because of the comparatively long exposure times and the fact that you can see the image during exposure, you can locally manipulate the appearance of shadows and highlights.

Suppose you make a print in which shadow detail has been lost. If you shorten the printing time to bring out the shadow detail, you will lose highlight detail and the print will appear too light overall. However, if you could selectively reduce the shadow exposure time, while exposing the rest of the print normally, your print would have both shadow detail and a correct overall exposure. The technique for holding back shadow exposure is called *dodging*.

Similarly, if your properly exposed print has insufficient highlight detail, your goal is to expose the overall print normally but to allow extra exposure time in the highlight areas. The technique to use in this case is called *burning-in*.

Dodging. Dodging involves blocking a portion of an image for part of the exposure time in order to make that portion lighter. For example, if a print's overall exposure requirement is 20 seconds, but you have found from your exposure test that 15 seconds is better for the shadow area, then for 5 seconds

TOOLS FOR DODGING AND BURNING-IN

Tools for dodging and burning-in are quite simple to make. Pieces of dark paper or cardboard with holes of various sizes and shapes will help burn-in small areas.

You can make a wide variety of dodging tools by cutting circles, squares, and other shapes from cardboard and gluing them to a coat-hanger wire. The piece of cellophane attached to one end of the wire in the above photo softens the image (makes it somewhat less distinct) while allowing light to pass through to darken the dodged area.

DODGING

Selectivity holding back some of the light from one part of the print (in this case the woman's face) is easy if you use one of the tools shown in the photo at the top of this page. Keep the wand in constant motion and don't let the handle remain over any one area during the exposure; otherwise, a distinct circular edge will form around the dodged area, and a line will appear where the shadow of the handle falls on the paper.

BURNING-IN

By placing a piece of paper with a hole in its center in the path of the light projected by your enlarger, you can selectively allow more light to reach one area of a print than another. In the photo above the entire print was exposed for 20 seconds, then the face was given an additional 5-second exposure. Keep your burning-in tool in constant motion to prevent a distinct outline of the hole from appearing around the burned-in area.

during the exposure you should block light by placing an opaque object in the light path between the enlarger lens and that area of the print. The devices you use for dodging can be a piece of cardboard or your hand for large areas, and specially constructed wands, such as the ones illustrated here, for small areas.

The technique of dodging is not difficult to learn. The only general rule is that you should constantly move the dodging instrument with a circular motion to prevent a sharp edge from occurring around the dodged area.

Burning-in. Burning-in involves blocking light for part of the exposure time from all areas except the area you want to darken in the print. For example, if the overall exposure requirement is 20 seconds, but you have found from your exposure test that 30 seconds is better for the highlights, then set your timer for a 30-second exposure. After 20 seconds, place something in the light path to block all light except that hitting the highlight area.

Instruments for burning-in can be a piece of cardboard with a hole in it or your hands held in such a way that most light is blocked. As with dodging, you should take care to keep your tool moving in small circles to prevent a sharp outline from forming.

With experience you will learn to combine both dodging and burning-in on the same print, thereby greatly extending your printing capabilities.

Straight Print

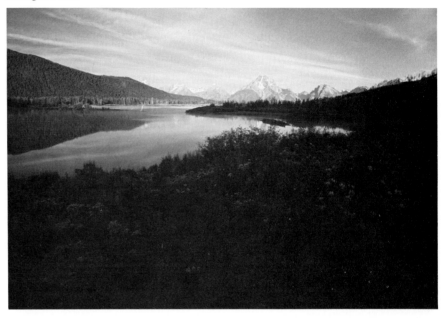

Manipulated Print

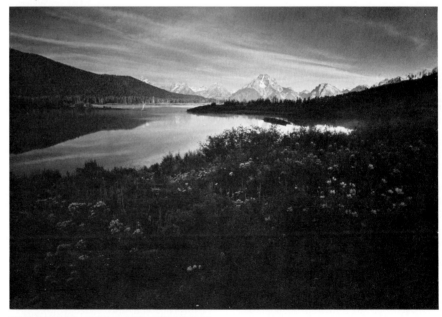

COMBINING DODGING AND BURNING-IN

Confronted by the scene above and relying only on your eye, you might think that the hills and flowers were recorded on film with equal density. However, the top photo, which is a straight print from the negative, shows that the early morning sun spilling across the distant mountains had not been high enough to light up the foreground. When printing the bottom photo, some light was blocked from the flower section by dodging during the exposure. The sky was then given extra exposure by burning-in. In both cases, the tool used was the photographer's hand.

Note also how burning-in the mountain on the left made it darker and thereby improved the composition by leading the viewer's eye toward the main subject, the distant mountains.

PRINTING FOR PERMANENCE

AN ARCHIVAL PROCESSING KIT

Ilford manufactures the Ilfobrom Archival Processing Kit which contains chemistry specifically designed for archival printing. Although archival printing is not difficult to perform for anyone familiar with black-and-white processing, the kit does offer the convenience of having all the necessary chemicals packaged together along with detailed instructions for their use. (Note that Ilford's archival-processing procedure differs from the general procedure described here.)

ARCHIVAL PROCESSING

Unless a conventionally processed black-and-white print is exposed to extreme conditions, it can survive for decades without special attention. Many photographs have lasted fifty years or more without becoming faded or discolored. Nonetheless, if you wish to guarantee that a photo retain its appearance as long as possible, or if you expect a photo to encounter harsh conditions, *archival processing* will enhance its likelihood of enjoying a long life. Since a print's destruction can be caused by the very chemicals used to create the image in the first place, archival processing removes the last traces of these chemicals and then adds a protective coating of selenium or gold to further preserve the image.

Paper. Because fiber-base papers are absorbent, they retain some of the chemicals used to process the image. Even an overnight wash will not remove all vestiges of the chemicals. (Since resincoated papers absorb very little moisture, they do not benefit from the traditional techniques of archival processing.)

Double fixing. As already discussed, the fixing step in film developing and developing a print removes unexposed silver halide compounds from the film or paper's emulsion layer. Therefore, the first stage in archival processing is to immerse the print in the fixer a second time to be absolutely certain that the fixing process has reached completion. The procedure is to prepare two trays of fixer and immerse the print into each tray for five minutes. Most of the fixing activity occurs in the first tray, and the second tray finishes the process. Discard the fixer in the first tray when it becomes exhausted, and replace it with the second tray, which is still at nearly full strength. Then prepare fresh fixer and pour it into what becomes the new second tray.

Removing residual fixer. When you remove the print from the second fixer, residues of fixer as well as compounds of fixer and silver still cling to the paper. To remove residues, treat the print with a solution of Kodak Hypo Clearing Agent followed by a water wash. Finally, remove the last traces of fixer by immersing the print in a hypo eliminator.

Coating the image. By depositing a thin layer of selenium or gold over the image, you protect it from pollutants in the air. You can add selenium toner directly to the hypo clearing agent (2 oz (59 ml) of toner per gallon of hypo clearing agent), but you can add gold toner only after the hypo eliminator has been removed by a water wash.

ARCHIVAL PROCESSING

Procedure	Time	Comment
Develop normally		
Acid stop bath	30 sec.	
First fixing bath	3–5 min.	
Second fixing bath	3–5 min.	
Water rinse	30–60 sec.	
Hypo clearing agent	2–3 min.	Agitate constantly
Hypo eliminator	6 min.	
Water wash	10 min.	
Gold toner*	10 min.	Use immediately after mixing
Water wash	10 min.	
Dry normally		Use acid-free blotter

*Selenium or other less expensive toners can be substituted.

ARCHIVAL PRINTING, STEP BY STEP

1. *Prepare two trays of fixer, one tray of hypo clearing agent, and one tray of hypo eliminator.*
2. *Develop print* as usual.
3. *Immerse print in stop bath* as usual.
4. *Immerse print in first tray of fixer* for 3–5 minutes (depending on paper weight).
5. *Transfer print to second tray of fixer* for an additional 3–5 minutes.
6. *Wash in water* for 30–60 seconds.
7. *Immerse print in hypo clearing agent* for 2–3 minutes.
8. *Wash in water* for 10–20 minutes.
9. *Immerse print in hypo eliminator* for 6 minutes (with selenium toner added, if applicable).
10. *Wash in water* for 10 minutes.
11. *Immerse in gold toner*, if applicable.
12. *Wash in water* for 10 minutes.

Hypo Eliminator

1. **Add ½ oz (15 ml) of concentrated (28%) ammonia to 5 oz (148 ml) of water.**
2. **Mix together 3½ oz (104 ml) of the ammonia solution, 4½ oz (133 ml) of 3% hydrogen peroxide solution, and 17 oz (503 ml) of water.**
3. **Add additional water to bring total volume to 34 oz (1l)**

Caution: Store the hypo clearing solution in an *open* bottle to prevent the gasses formed from breaking the bottle.

CREATIVE TONING

CREATIVE TONING

Beyond the capacity to protect a print from the ravages of time, toning can be used creatively to alter the color in a black-and-white photograph. Toners work by replacing the blacks (oxidized silver) in a print. Although some toning processes are complex and difficult to perform, most toners are easy to mix, easy to store and easy to use. In addition, toning takes place at room temperature and under normal room lighting.

The toners most commonly used are shades of the color brown. Sepia toners especially are very popular, but products which generate almost any color are readily available from photo supply stores.

The toning instructions provided by manufacturers are clear and easy to follow, but read all warnings carefully to avoid accidentally producing dangerous fumes. Below are summaries of the important steps involved in two of the many toning procedures available.

KODAK SEPIA TONER

Kodak sepia toning involves two basic stages, plus an optional step.

In the first stage you immerse the print in a bleach solution which you have previously prepared. Within one minute (slightly longer for very dark prints) the image will have disappeared or turned a very pale yellow, at which time you remove the print and wash it in water for two minutes.

In the second stage you immerse the print in a toning solution, also previously prepared, for thirty seconds or as long as necessary for the toning process to run to completion.

Finally, because the toning process softens the print's emulsion layer, you have the option of immersing the print in a hardening bath (available from photo supply

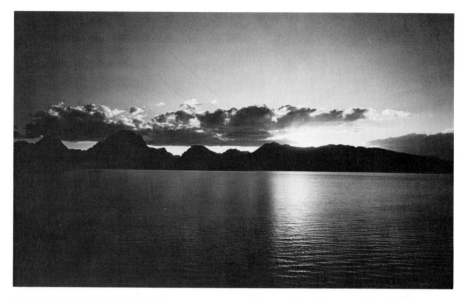

stores) to protect the print from damage.

EDWAL COLOR TONERS

In addition to the color brown, the Edwal color toners offer you the opportunity to add the colors blue, red, green and yellow to a print. Because Edwal toners do not involve a bleaching step, they are even easier to use than Kodak's Sepia Toner.

To use an Edwal toner, you mix and dilute the toner crystals in accordance with the manufacturer's instructions. Next, you immerse a thoroughly washed, still wet print in the toning solution. By monitoring the progress of the toning reaction, you can decide when to remove the print. The longer you allow the print to remain in the toner, the more brilliant the final color will be. Since you can add additional toner but

You can introduce a variety of different colors into a print by using one or more of the many toners available from photo supply stores.

The bottles shown in the photograph at left contain color toners made by Edwal. Inside each bottle cap is a small container in which crystals are stored until it is time to use the toner. Once the crystals and the liquid have been mixed, the toning solution has a shelf life of three to four weeks. The number of 8″×10″ prints a bottle can tone depends upon the length of time the prints are allowed to remain in the toner.

The packets shown in the photograph at left contain the powders which, when mixed with water, become the bleach and toning solutions used to sepia tone a print. Once mixed, the solutions have an indefinite shelf life. One set of packets is sufficient for toning forty 8″×10″ prints.

The photographs shown on the next page illustrate the results of applying Kodak sepia toner and Edwal color toners to the black-and-white print reproduced above.

you cannot remove toner once it has replaced the silver in a print, you should remove and wash the print for one minute while you are still certain that you have not toned the print more than you want, then immerse it again in toner, if necessary. A final wash of five minutes halts the toning process completely.

Usually, the print will look better with the white border trimmed off.

In a sepia-toned print the rich brown color illustrated here replaces the black tones originally present. Unlike the Edwal colors shown below, sepia toning is an all or nothing process in that all of the black present in the original print is completely replaced by the color brown.

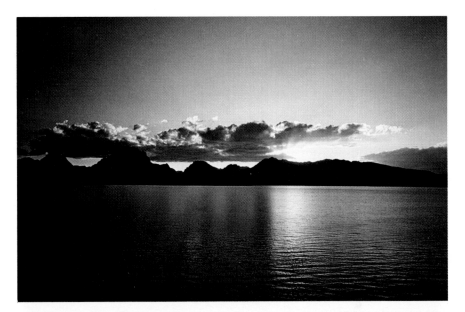

All three of these photographs were toned with Edwal color toners. Red toner was used in the photograph at bottom left and blue toner at bottom right.

The multi-color effect present in the upper photograph is possible because the Edwal toning process need not run to completion. In this instance, the print was immersed for only two minutes in blue toner, washed, and then immersed in red toner for another three minutes. The second immersion caused the remaining silver oxide granules to be replaced by the red tone.

You can limit toning to selected portions of a print either by applying the toner carefully with a small paint brush or by masking areas with rubber cement before immersing the print in the toner. After the print is toned, the cement can be easily removed by rubbing. Interesting effects are possible by toning one section of a print one color and another section a different color.

5. PROCESSING COLOR FILM

You do not need to fully understand the underlying principles of color photography in order to perform the mechanical operations involved in developing and printing color film. However, if you know the whys of color processing as well as the hows, you will be able to master the procedures much more efficiently.

Modern color photography exploits the phenomenon that any color in the visible spectrum can be produced by some combination of the *primary* colors, blue, green, and red. Color film and color processing use those three colors to reproduce the entire range of colors encountered in nature.

The specific method usually used is called the *subtractive method* and involves passing white light (which contains all colors) through filters which block selected colors but allow other colors to pass. The effect of the filters is to subtract from the white light all colors except one. That one color then continues through the filters unhindered.

Three filters are involved in the subtractive method: a *cyan* filter (which blocks green light but passes blue and red light), and a yellow filter (which blocks blue light but passes green and red light).

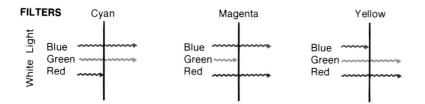

Combining any *two* of the filters and passing white light through them generates one of the three primary colors: cyan and magenta filters reduce white light to blue light; cyan and yellow filters reduce white light to green light; magenta and yellow filters reduce white light to red light.

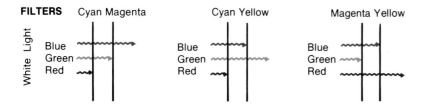

Thus, with the proper combination of cyan, magenta, and yellow filters, each of the three primary colors (blue, green, red) can be produced subtractively from white light.

HOW THE COLOR PROCESS WORKS

HOW A COLOR SLIDE WORKS

1. The image in this example, a red cloth, forms a black-and-white image on the red-sensitive layer of a frame of color film, but leaves the blue- and green-sensitive layers unaffected.

2. During processing the images are reversed: the image on the red layer is transferred to both the blue and green layers. The blue layer is dyed yellow, and the green layer is dyed magenta, but the red layer is *not* dyed cyan.

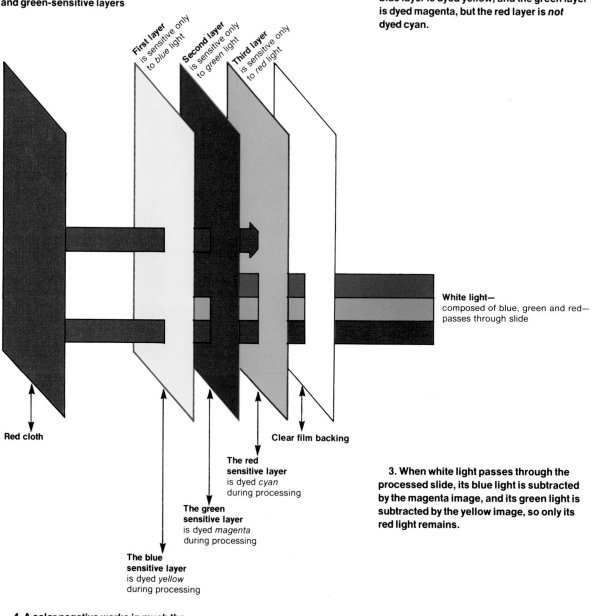

First layer is sensitive only to *blue* light

Second layer is sensitive only to *green* light

Third layer is sensitive only to *red* light

White light— composed of blue, green and red— passes through slide

Red cloth

Clear film backing

The red sensitive layer is dyed *cyan* during processing

The green sensitive layer is dyed *magenta* during processing

The blue sensitive layer is dyed *yellow* during processing

3. When white light passes through the processed slide, its blue light is subtracted by the magenta image, and its green light is subtracted by the yellow image, so only its red light remains.

4. A color negative works in much the same way, except the reversal process takes place not on the surface of the film but on the surface of the paper.

COLOR TEST CHART

Any time that you want to make the process of adjusting color in your photographs as easy and accurate as possible, photograph this chart on the first frame of the roll of film you are using. Later, when making prints, you can use the chart as the basis for determining filtration changes.

Color film consists of a strip of celluloid coated with three separate layers of *emulsion*, one layer responsive to blue light, one layer responsive to green light, and one layer responsive to red light. Light striking a segment of color film causes changes in whichever emulsion layers are sensitive to the colors contained in the light, and in a sense, the emulsion layers capture the light. Later, processing of the film creates subtractive filter layers capable of reproducing the original color.

For the sake of learning, let us assume that a photograph is being taken of a piece of red cloth and that its image fills the entire frame of film. The red-sensitive emulsion layer on the film would respond, but the other two layers would not respond,

Since red is generated by passing white light through the combi-nation of a magenta filter and a yellow filter, processing the frame of film in this example will ultimately produce one magenta filter layer and one yellow filter layer. Once these filter layers are produced, white light projected through them (either from a projector bulb or from the light reflected off the white backing of printing paper) will be reduced to red light, thereby reproducing the original color. Let us see how processing accomplishes this task.

When a light-sensitive emulsion layer responds to a color, a *black-and-white* latent, or undeveloped, image—not a color image—is formed in that layer. Color in the form of dyes is coupled to the black-and-white image later, during the course of processing. Therefore, when red light strikes the film in our example, a black-and-white latent image is formed in the film's red-sensitive layer. Dye *couplers* must then be added before a color image is formed.

The specific steps involved in converting the black-and-white image into a color image differ depending on whether the final product is to be a slide or a print. In the case of slides, the processed film itself is viewed. Therefore, the color of the original scene must be generated in the film. In the case of prints, the film is not viewed; instead, it is used to reproduce the colors of the original scene *on a sheet of printing paper*. Therefore, the colors present on print film after processing are not the final colors on the print, or the colors that were present in the original scene.

The illustration on this page summarizes how color is produced on slides and negatives.

HOW THE COLOR PROCESS WORKS
(Continued)

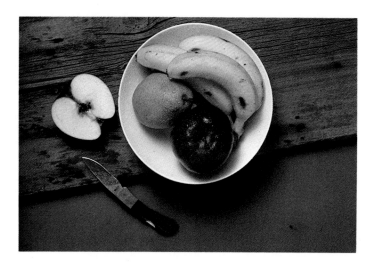

EMULSION LAYER RESPONSES

Each point on the three emulsion layers of color film responds proportionately to the amount of blue, green, and red present in a scene. If the light striking a point is of a primary color (that is, if its color is pure blue, pure green, or pure red), only one emulsion layer will respond. If the light striking a point is not of a primary color, then its color is a *mixture* of primary colors, and more than one emulsion layer will respond. Furthermore, the relative densities of the images formed on the layers will be proportional to the relative contribution of each primary color to the mixed color. For example, the color purple will form an image on both the blue and red emulsion layers, but the image on the blue layer will be denser than the image on the red layer.

On this page the photograph is shown as it would be recorded on each of the emulsion layers of a frame of color film.

A Slide

A Negative

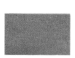

orange filter

Yellow image Magenta image Cyan image

Yellow image Magenta image Cyan image

When color film, whether for slides or prints, is exposed to a scene containing a range of different colors, black-and-white negative images are formed in each of the film's three light-sensitive emulsion layers. In the case of slide film, the images in the three layers are reversed during processing to form positive images which are then coupled with colored dyes. In the case of print

film, the reversal process is not necessary, and the dyes are coupled to the original negative images.

In addition to the color provided by the three dyed layers, color negatives for prints also possess an orange cast necessary to reduce contrast and properly balance the color dyes.

SLIDE FILM

To understand how slide processing works, assume that the photo of the red cloth in our example was taken on slide film. Since slides are viewed directly, a magenta filter and a yellow filter must be formed *right on the film's surface* if a red image is to be ultimately created from white light. This process, known as *color reversal*, occurs on the surface of the film in what can be thought of as four stages. *Stage 1*: The latent image in the red layer of the film is developed using standard black-and-white processing techniques. Since no latent image exists in the blue-sensitive and green-sensitive emulsion layers at this point, they are left unchanged by the developer and remain sensitive to light. *Stage 2*: By intentionally exposing the film to white light (or to chemicals which have that effect), two black-and-white latent images which are identical to the *developed* image are produced, one image in the blue-sensitive layer and one in the green-sensitive layer of the film. This leaves a developed black-and-white image in the red layer and identical but as yet *undeveloped* black-and-white images in the blue and green layers. *Stage 3:* The black-and-white latent images in the blue and green layers are developed and are simultaneously *coupled* chemically with color dyes. The developed image in the blue layer is coupled with yellow dye, and the developed image in the green layer is coupled with magenta dye. (Coupling takes place during development; therefore, the already developed image in the red layer remains uncoupled.) *Stage 4:* The black-and-white images in all three layers are completely "bleached" away through the action of bleaching chemicals, leaving only the colored dyes behind.

The final result is a slide consisting of a yellow filter layer and a magenta filter layer. White light projected through the slide will now be changed to red light by the subtractive action of the filters, thereby reproducing the original color of the scene.

Print film. Assume now that the red cloth in our example was photographed not on slide film but on print film. With prints, the film itself is not viewed directly but instead is used to form a color image on a separate sheet of printing paper, which itself is coated with three light-sensitive emulsion layers. As a result, the black-and-white processing step used in the first stage of developing slides is unnecessary because no additional latent images need to be produced on other layers of the film. Instead, the film needs to be prepared during processing so that it can later be used to produce magenta and yellow filter layers in the emulsions on the printing paper. Therefore, during initial development of the film, the latent image present in the red-sensitive layer in our example is coupled immediately with *cyan* dye. Thereafter, the developed black-and-white image on the film is bleached away, and the other two emulsion layers are chemically eliminated, so all that remains on the final film is a single cyan image.

Since cyan filters pass blue and green light but block red light, the cyan-dyed film when placed in an enlarger serves as a means of producing latent images in both the blue-sensitive and green-sensitive emulsions layered onto a color printing paper's surface. Once these latent images are formed on the printing paper, the procedures for processing the print are very similar to those used for processing slides: during development of the latent images, yellow dye is chemically coupled with the black-and-white image in the blue layer, and magenta dye is coupled with the black-and-white image in the green layer. (Because cyan light does not effect the red-sensitive emulsion layer on the paper, the red-sensitive emulsion is removed during the course of processing). Again through the mechanism of color subtraction, light (from a lamp, for example) shining through the magenta and yellow filter layers on the paper reflects off the white paper backing and ends up as red light.

The basic principles of slide and print processing remain the same regardless of the color that hits the film—all that changes are the specific filter layers ultimately produced and their relative intensities. Colors other than pure blue, pure green, and pure red generate latent images on more than one emulsion layer, but the net effect after all processing is completed remains the same: filter layers are created to reproduce from white light the colors originally present in a scene.

PROCESSING COLOR FILM

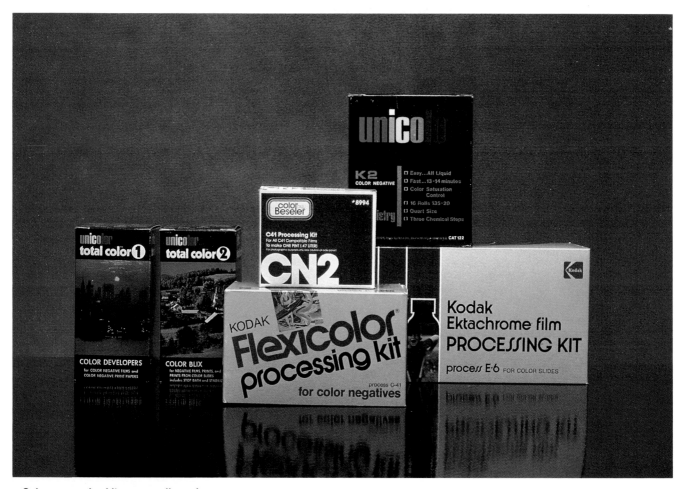

Color processing kits are usually packaged with all the chemistry you need for processing between 6 and 16 rolls of film, depending on the product. Some kits feature fewer steps, easier temperature control, or longer shelf life than others, but most products will produce good results if you are willing to follow the manufacturer's instructions scrupulously.

WHAT YOU NEED

Processing color film requires only a few more items of equipment than are necessary for processing black-and-white film. The chief difference is that the color process is less likely to forgive any errors you make.

Before you begin processing the film, make certain you have the following items on hand.

Photo thermometer. Temperature is critical and in some cases must be maintained within a range of $\pm\frac{1}{4}$F ($\pm\frac{1}{8}$C).

Water bath. An easy way to stabilize color chemistry at the proper temperature is to immerse all chemicals in a temperature-adjusted water bath. Any watertight household tray will work as long as it is large enough to accommodate all the containers (including the developing tank) for the process you are using and is deep enough to provide a water level close to the level of liquids within the containers.

Bottles and measuring containers. You will need a separate bottle for each chemical used in a process and measuring containers suitable for the volumes of liquid you will be dispensing. Plastic bottles work best because they can be squeezed to eliminate air. Color chemicals have a very short shelf life when stored in partially filled containers.

Stir rods and funnels. You will need stir rods and funnels for mixing and pouring.

Timing device. A stopwatch or regular darkroom timer will work well. To eliminate fumbling around during processing, ''programmable'' timers which can be preset to time an entire sequence of steps are also available.

Developing tank and reels. The same tanks and reels used for black-and-white processing are suitable for color processing. Remember that when only one roll of film is being processed in a tank designed to hold two rolls, you need to include an empty reel *on top* of the loaded reel. (This prevents overagitation by keeping the film reel stationary.) If you plan to submerge the tank in a water bath, choose a tank that is waterproof.

Changing bag. If you do not have a darkroom, a changing bag (available from camera stores) will provide sufficient darkness to enable you to transfer the film safely into the developing tank.

Color chemistry. Chemistries are usually sold as complete kits. You will obtain the highest quality results if you use the chemistry recommended on the instruction sheet packaged with the film you want to process. With color negative films, however, alternative chemistries are available which you may elect to use for reasons discussed on pp. 94–95. The most popular chemistries are discussed in detail on the following pages.

> **WARNING**
>
> Remember that color chemicals can irritate or burn your skin. To be safe, handle chemicals only with rubber gloves. Read the manufacturer's warnings carefully for specific instructions.

THE COLOR PROCESSING SETUP

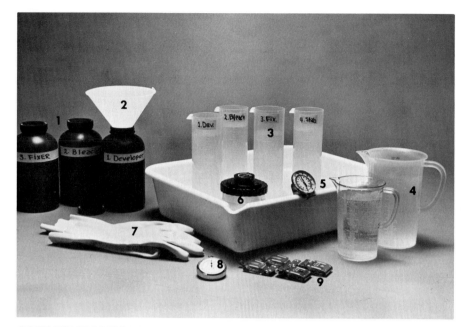

SETUP FOR PROCESSING COLOR FILM

1. Bottles of chemicals mixed according to the manufacturer's instructions
2. Funnel
3. Measured amounts of chemistry in a temperature controlled water bath
4. Beakers of hot and cold water for maintaining correct bath temperature
5. Thermometer
6. Processing tank in temperature-control bath
7. Protective rubber gloves
8. Stopwatch or timer
9. Clips with which to hang processed film

CONTROLLING WATER-BATH TEMPERATURE

In many color processes it is extremely important to maintain chemicals within a narrow temperature range by keeping them in a water bath that has been warmed to the specified temperature. Since water cools during the processing procedure, you should keep on hand a container of very hot water to add to the bath as necessary to bring the temperature back up when it falls. A container of ice water kept nearby will be useful in case you accidentally raise the temperature too high.

Be sure to return the processing tank to the water bath as often as possible in order to maintain the proper temperature of the chemicals inside.

Discipline yourself to perform the following steps each and every time you begin a color process.

1. *Lay out materials carefully.* Make certain every item you will need is located within easy reach. Develop a consistent placement pattern to eliminate fumbling during a procedure.
2. *Premeasure needed chemicals.* (Be certain your chemicals have not exceeded their shelf lives.) Avoid later mistakes by pouring the correct volume of each chemical into a *labeled* pouring container that you have numbered in the sequence in which you will need it. Measure out enough of each chemical to *fill the tank*, not simply to cover the reel.
3. *Prepare temperature-control water bath.* Fill the water bath tray with water that is at the correct temperature. If the chemicals need to be warmed to a temperature well above that of the room, the water you use should initially be a few degrees warmer than the temperature required. Adjust the bath tempera-

ture as necessary by adding hot water or ice water. (A plastic bag filled with ice can be placed in the bath and then removed when the temperature drops sufficiently.)
4. *Place chemical containers in water bath.*
5. *Check temperature of each chemical.* Swirl each chemical around with the thermometer as you take your readings. (*Caution:* Thoroughly clean the thermometer between chemicals to prevent contamination of one chemical by another.) Continue to monitor the chemicals and water bath until all have stabilized at the correct temperature.
6. *Prepare container of very hot water.* As the temperature of the water drops during processing, you can add hot water as needed. (This is not necessary when the recommended processing temperature is near room temperature.)
7. *Study instructions.* Be certain you understand the procedures you will have to perform. Especially important are the points below.
 a. *Determine proper agitation method.* Proper agitation is as critical as proper temperature. Use the agitation technique illustrated here unless the instructions packaged with the chemicals specify otherwise. Be absolutely certain before you begin that you know how often to agitate and for how long.
 b. *Calculate proper development time.* Depending on the process you are using, development time may need to be increased based upon the number of rolls already processed in the chemistry. The manufacturer's instructions will tell you exactly how to

calculate the correct development time. A "dry run" performed without film and using water instead of actual chemicals will reveal any steps that may be unclear to you.

c. *Place step-by-step outline of process close at hand.* Should the process you are using not be covered in detail here, prepare your own outline from the manufacturer's instruction sheet.

Once you have the chemicals at the correct temperature, the film loaded in the tank, the equipment laid out, the timer set, and your gloves on, you are ready to begin. Specific instructions for individual chemistries are given in the following pages, but first, here are some general rules that apply to all processes.

1. *Timing.* Begin timing the process when you start to pour chemicals into the processing tank. Begin pouring chemicals out of the tank 10–15 seconds *before* the step should be over, the exact time depending on how long it takes your tank to drain.

2. *Washing.* If you cannot use running water in the steps calling for a water wash, then fill the tank with water of the correct temperature and agitate continuously, changing the water at least once every 30 seconds until the end of the designated washing time.

3. *Drying.* When drying color film, do *not* wipe the emulsion side of the film. Using stabilizer in the final wash will generally produce sufficiently clean film. If you must wipe the film, gently apply soft sponges only to the non-emulsion side. To prevent water spots use stabilizers, even with kits that indicate it as optional.

By keeping containers of hot and cold water close at hand, you can adjust the temperature of your water bath as necessary during the course of processing.

AGITATION

Before you begin any process, be certain that you know how often to agitate and for how long. The basic technique discussed on p. 51 is also applicable to most color processes.

REUSING CHEMISTRY

In processing color film you can usually reuse chemistry at least once, so normal procedure is to pour the used developer back into its bottle. Check the instructions prepared by the manufacturer to find out if a particular developer can be reused as is, or if replenishment is required. (When a developer is reused without replenishment, the developing time after the first roll or two should usually be increased.) Some kits contain two solutions of developer which require that halfway through the life of the kit you discard the first developer solution and prepare the second. The developer is the only chemical that becomes exhausted in this manner.

PROCESSING COLOR NEGATIVES
Kodak C-41

KODAK PROCESS C-41

Step	Time* min.	Temperature F	Temperature C	Type of Agitation
1. Developer	3¼**	100 ± ¼	37.8 ± .15	initial 30 sec. then 2 sec. every 15 sec. period.
2. Bleach	6½	75–105	24–40.5	initial 30 sec., then 5 sec. in every 30-sec. period
Remaining steps can be done under normal room light				
3. Wash	3¼	75–105	24–40.5	running water
4. Fixer	6½	75–105	24–10.5	initial 30 sec. 5 secs. in every 30 sec. period
5. Wash	3¼	75–105	24–40.5	running water
6. stabilizer	1½	75–105	24–40.5	initial 30 sec. only
7. Dry	usually 10–20 min.	75–110	24–43.5	

*Start timing as soon as the chemistry is poured. Allow 10 seconds to pour out chemicals.

**This time increases as the developer is exhausted. See the section "Development time compensation" in the instructions packaged with your kit for the type of film you are processing.

Note: If you have never before processed color film, study the step-by-step photographs for E-6 processing commencing on p. 100. Although the C-41 and E-6 processes differ with respect to specific details, their underlying techniques are the same.

KODAK FLEXICOLOR PROCESSING KIT PROCESS C-41

Use. This kit is suitable for any negative film calling for C-41 processing, including Kodacolor II, Kodacolor 400, Kodak Vericolor II, Fujicolor F-II and F-II 400, Sakuracolor II and 400, Agfacolor CNS 400, and Kodak type 5247.

Depletion compensation. Increase developing time after each roll (consult the manufacturer's instruction sheet that is included). Do not open the second bottle of developer until the first is entirely depleted or empty.

Temperature. 100F ± ¼ (37.8C ± ⅛)

Agitation. Agitation is especially critical due the relatively short development time (3¼ minutes).

Total processing time. 24¼ minutes.

Special instructions. Prepare and maintain the water bath temperature at 100.5F (38C) if there is a large difference between room temperature and the chemical temperature. Read the warnings in the manufacturer's instruction sheet. Save all chemicals.

STEP-BY-STEP

Developing
1. *Perform setup procedures* described on pp. 92–93.
2. *Load film in tank* (do this in complete darkness).
3. *Set timer* for 3¼ minutes plus depletion compensation time. (Be sure to compensate for partially depleted developer, if necessary.)
4. *Check temperatures:* 100F ± ¼ (37.8C ± ⅛)
5. *Pour developer into tank. Start timer.*
6. *Tap tank* to dislodge any air bubbles.
7. *Agitate continuously* for 30

seconds (over and back, once
per second).

8. *Agitate intermittently* thereafter
for the last 2 seconds of every
15-second interval until time is
up, replacing the tank in the
water bath between agitations.

9. *Drain tank,* pouring the devel-
oper back into its container,
starting 10 seconds before the
developing time is up.

Bleaching
10. *Set timer* for 6½ minutes.
11. *Pour bleach into tank. Start
timer.*
12. *Agitate continuously* for 30
seconds (over and back, once
per second).
13. *Agitate intermittently* thereafter
for the last 5 seconds of every
30-second interval.
14. *Drain tank,* pouring the bleach
back into its container, starting
10 seconds before the bleach-
ing time is up.

Washing (from this phase on, light
will not affect the film)
15. *Set timer* for 3¼ minutes.
16. *Start timer.*
17. *Wash film* in running water at
100F.
18. *Empty water from tank* after 3¼
minutes.

Fixing
19. *Set timer* for 6½ minutes.
20. *Pour fixer into tank. Start timer.*
21. *Agitate continuously* for 30
seconds (over and back, once
per second).
22. *Agitate intermittently* for the
last 5 seconds of every 30-sec-
ond interval, replacing the tank
in the water bath between agi-
tations.
23. *Drain tank,* pouring the fixer
back into its container starting
10 seconds before fixing time
is up.

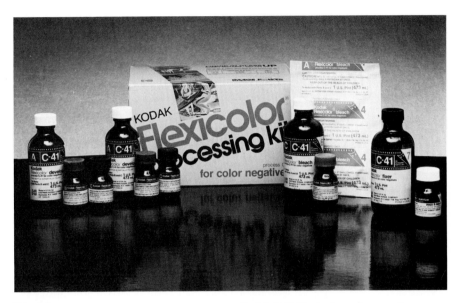

**Kodak C-41 Flexicolor color negative proc-
essing kit**

Washing
24. *Set timer* for 3¼ minutes.
25. *Start timer.*
26. *Wash film* in running water at
100F.
27. *Empty water from tank* after 3¼
minutes.

Stabilizing
28. *Set timer* for 1½ minutes.
29. *Pour stabilizer into tank. Start
timer.*
30. *Agitate continuously* but gently
for 30 seconds.
31. *Place tank in water bath* and
leave it there.
32. *Drain tank,* pouring the stabili-
zer back into its container
starting 10 seconds before
stabilizing time is up.

Drying
33. *Hang film to dry* in a dust-free
area no warmer than 110F
(43C) (10–20 minutes is usually
sufficient). Do not squeegee
the film.
34. *Remove water spots* by care-
fully wiping the film with a
sponge moistened with stabili-
zer. Wipe *only* the non-emul-
sion side of the film. (Spotting
can be minimized if the stabili-
zer solution used is mixed in
distilled water.)

PROCESSING COLOR NEGATIVES
Unicolor K-2/Total Color

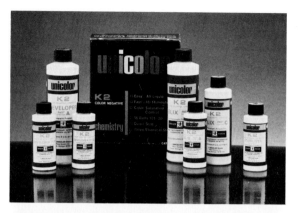

Unicolor K2 color negative processing kit

Unicolor Totalcolor for processing negatives as well as prints with the same chemistry. Both boxes are necessary for processing.

As a general rule, you will obtain the highest quality results if you develop your film in the chemistry produced or recommended by the film's manufacturer. However, alternative chemistries are available with such advantages as lower processing temperatures, fewer chemicals to mix, shorter processing times, longer shelf lives, and greater economy—advantages that may sufficiently appeal to you to compensate for somewhat diminished quality.

Processing alternative chemistries. The individual steps and chemicals may vary from process to process, but the fundamentals will remain essentially the same. For example, the techniques of tank agitation and film drying are consistent in all processes. If you study the step-by-step instructions for the Kodak C-41 process, you will be well prepared to tackle any of the alternative chemistries described here.

UNICOLOR K2 UNICOLOR TOTAL COLOR

Use. These products are used for processing color negative film. (The Total Color unit can also process color prints.)

Depletion compensation. Add 15 seconds to the developing time for a second roll and 30 seconds for a third roll, in each 8 oz working solution.

Temperature. 100F (38C) for the developer step, 95–105F (35–41C) for the remaining steps.

Total processing time. 12¾ minutes.

Comments. K2 and Total Color differ only in that K2 comes as a kit and is used exclusively for developing film. Total Color comes as a premixed concentrate and can be used for both developing film and processing prints. Both K2 and Total Color have especially short

processing times, and both can be prepared in small quantities, if desired. Total Color's ability to be reused to process prints makes it economical for processing limited quantities of film and prints. (Note: Chemistry that is used to process prints *cannot* then be used to develop film.)

K2 AND TOTALCOLOR

Step	Time* Min.	Temp. F	C	Agitation
1. Developer**	3¼	100	38	Continuously for first 30 sec. for Total Color (15 sec. for K2), then 2-3 sec. each 15 sec. thereafter
2. Blix	6	95–105	35–41	
Remaining steps can be done with normal room lights				
3. Wash	3	95–105	35–41	Running water
4. Stabilizer	½	Room temperature		

*Developing times should be increased after the first roll in the same developer. See instructions packaged with chemistry.

**For all films but Fujicolor II which start with a developing time of 3 minutes.

Note: If you have never before processed color film, study the step-by-step photographs for E-6 processing which commence on p. 100. Although the processes differ with respect to specific details, the underlying techniques involved are the same.

PROCESSING COLOR NEGATIVES
Beseler CN2

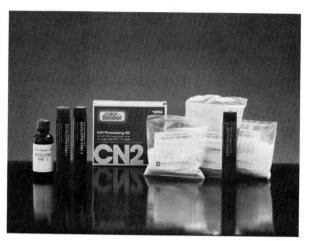

Beseler CN2 color negative processing kit.

BESELER CN2

Use. This kit is used for processing color negative film. (Kodacolor II, Kodacolor 400, Vericolor II, Eastman 5247, Fujicolor II, Fujicolor 400, Sakuracolor II, Sakuracolor 400)

Depletion compensation. After each roll of 36-exposure Ektachrome, increase the preceding development time by 5%, up to a six-roll total capacity. Compensations for other films are listed in the kit instructions.

Temperature. 75 or 85F (24 or 30C).

Total processing time. 29½ minutes at 75F; 20¼ minutes at 85F.

Comments. The chief attraction of the Beseler CN2 process is the choice it offers of two relatively low processing temperatures. The 75F temperature is often close enough to room temperatures to be used without a water bath, while the 85F temperature is much easier to maintain than 100F and cuts the processing time to 20½ minutes. The kit consists of seven elements which will process six 36-exposure rolls in four steps using three chemicals.

Note: If you have never before processed color film, study the step-by-step photographs for E-6 processing which commence on p. 100. Although the processes differ with respect to specific details, the underlying techniques involved are the same.

Beseler CN2 Processing Steps at 75°F (24°C)

Step	Time* min. Rolls 1+2	3+4	5+6	Temperature °F	°C	Type of Agitation
1. Developer	16	18	20	75 ± 1	24 ± .6 24 ± .6	Tape for bubbles, one gentle inversion every 15 sec.
2. Bleach/Fix	9	9	9	75 ± 6	24 ± 3	Coninuous for the first 15 sec., then one inversion every 15 sec. thereafter
Remaining steps can be done in normal room light						
3. Wash	4	4	4	75–100	24–38	Running water or (8) water changes with continuous agitation
4. Wetting agent	½	½	½	68–100	20–38	None
5. Dry						You may squeegee the film back but *not* the
	Total 29½					film emulsion side

*Time is for a 36-exposure 35mm roll. After each roll is processed, the preceding developing time should be increased by 5%, up to a six-roll capacity. Capacity and time increases on other films are given in the instructions.

Beseler CN2 Processing Steps at 85°F (30°C)

Step	Time min. Rolls 1&2	3&4	5&6	Temperature °F	'C	Type of Agitation
1. Developer	8	9	10	85 ± ½	30 ± .3	See above chart
2. Bleach/fix	8	8	8	85 ± 10	30 ± 6	See above chart
Remaining steps can be done in normal room light						
3. Wash	4	4	4	75–100	24–38	See above chart
4. Wetting agent	½	½	½	68–100	20–38	None
5. Dry	Total 20½					See above chart

PROCESSING COLOR SLIDES
Kodak E-6

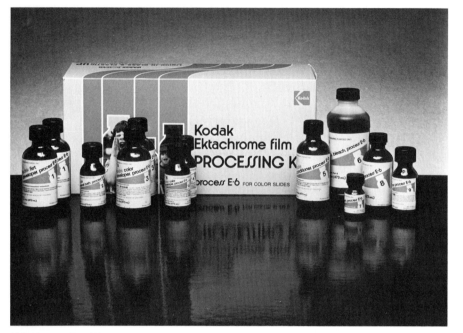

E-6 Processing Kit

Once a roll of slide film has been developed and dried, it can be viewed and evaluated immediately. Negative film, however, requires that the image on a frame be transferred onto printing paper before the image can be accurately evaluated. Since exposing and processing prints entails complex skills, most people prefer to learn first how to develop slide film and then apply that knowledge to negative film. Also, most people seem to find it easier to learn how to make prints from slides than from negatives, even though the fundamental principles for both are the same. Therefore, E-6 film processing is presented below in great detail.

THE E-6 PROCESS

Kodak's E-6 processing kit is sold in two sizes: 1 pint and 1 gallon. The pint size (shown here) will process eight 36-exposure rolls of Ektachrome, or twelve 20-exposure rolls. The entire chemistry is liquid, which makes it easy to mix; the reversal process is accomplished by chemicals rather than light. Total processing time (not including drying) is 37 minutes.

The kit consists of seven chemicals with shelf lifes varying from one week to twenty-four weeks, once mixed. The first developer and the color developer are supplied in two sets to extend the life of the kit. Do not mix the second set until you have exhausted the first.

If E-6 chemistry becomes contaminated even slightly, uneven color will result. Therefore, take care to keep all mixing and storage containers clean. Be especially careful not to contaminate the first developer, reversal bath, or color developer with the fixer, or to contaminate the first developer with the reversal bath. Also, keep the first and color developers separated.

KODAK PROCESS E-6

Step	Time min.	Temp F	Type of Agitation	
1. First developer	7*	100 ± ½	Initial 15 sec. + every 30 sec.	Total darkness
2. Wash	2	92–102		Total darkness
3. Reversal Bath	2	92–102	Initial sec. only	Total darkness
Remaining steps can be done in normal room light				
4. Color developer	6	100 ± 2	Initial 15 sec. + every 30 sec.	
5. Conditioner	2	92–102	Initial only	
6. Bleach	7	92–102	Initial 15 sec. + every 30 sec.	
7. Fixer	4	92–102	Initial 15 sec. + every 30 sec.	
8. Wash	6	92–102		
9. Stabilizer	1	92–102	Initial 15 secs. only	
10. Dry		not over 104 F		

*Each pint of first developer can process 4 rolls of 36 exposure film. 7 minutes is used for the first 2 rolls but the time should be increased to 7½ minutes for the second 2 rolls.

Proper agitation and temperature control are especially important. Read the instructions carefully because the agitation method required varies with the chemical used. Although the chemicals in some steps only need to be maintained within a 10F temperature range, try to keep the temperatures of all the chemicals as close to each other as possible.

KODAK E-6 PROCESS
Step-by-step

THE KODAK E-6 PROCESSING KIT

Use. This kit is suitable for all Kodak Ektachrome slide films.

Depletion compensation. Add 2 minutes to development time after two rolls have been processed.

Temperature. First developer: 100F ±½F (37.8 ±¼C): color developer: 100 ±2F (38 ±17C); other liquids: 92–102F (33–39C) (but try to keep all temperatures as near to each other as possible).

Total processing time. 37 minutes.

Comments. Adjust the temperature of the running water to 92–102F (33–39C). Be careful to keep all mixing and storage containers clean, as E-6 chemicals contaminate easily. Be especially careful to keep the fixer out of the developers and reversal bath, and the reversal bath out of the first developer. Also, keep the two developers completely separated.

FIRST DEVELOPER

1. *Set timer* to 7 minutes.
2. *Verify temperature* (100.4F ± ½F) (38 ± 18C). Adjust if necessary.
3. *Pour developer into tank. Start timer.*
4. *Tap tank.*
5. *Agitate.*
6. *Drain tank* starting 10 seconds before time is up.

WATER WASH

7. *Set timer* to 2 minutes.
8. *Verify temperature* of water (92–102F) (33–39C). Adjust if necessary.
9. *Fill tank with clean water (92–102F). Start timer.*
10. *Discard water then replace with clean water* continually until the timer rings.

REVERSAL BATH

11. *Set timer* to 2 minutes.
12. *Verify water temperature (92–102F).* Adjust if necessary.
13. *Pour reversal bath into tank. Start timer.*
14. *Tap tank.*
15. *Agitate continuously* for 1 minute.

16. *Do not agitate* for the second minute. (Remainder of the process can be completed with tank cover removed, see photo.)
17. *Drain tank* starting 10 seconds before time is up.

COLOR DEVELOPER

18. *Set timer* to 6 minutes.
19. *Verify temperature* of color developer (100.4 ± 1.1F) (32 ± 17C)
20. *Adjust temperature* if necessary.
21. *Tap tank.*
22. *Agitate.*
23. *Drain tank* starting 10 seconds before time is up.

CONDITIONER

24. *Set timer* to 2 minutes.
25. *Verify temperature* (92–102F). Adjust, if necessary.
26. *Pour conditioner in tank. Start timer.*
27. *Tap tank.*
28. *Agitate once* (over and back).
29. *Return tank to water bath.*
30. *Drain tank* starting 10 seconds before time is up.

BLEACH

31. *Set timer* to 7 minutes.
32. *Verify temperature* (92 \pm 102F). Adjust, if necessary.
33. *Pour bleach into tank. Start timer.*
34. *Tap tank.*
35. *Agitate.*
36. *Drain tank*, starting 10 seconds before time is up.

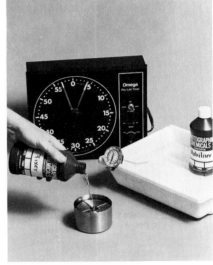

FIXER

37. *Set timer* to 4 minutes.
38. *Verify temperature* (92–102F). Adjust, if necessary.
39. *Pour fixer in tank. Start timer.*
40. *Agitate.*
41. *Drain tank* starting 10 seconds before time is up.

WATER WASH

42. *Set timer* to 6 minutes.
43. *Verify temperature of water* (92–102F).
44. *Wash film* in continuously running water.
45. *Drain tank* when time is up.

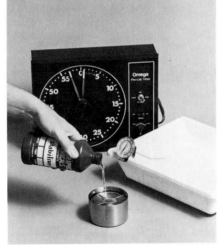

STABILIZER

46. *Set timer* to 1 minute.
47. *Pour stabilizer into tank* (its temperature is not critical)
48. *Start timer.*
49. *Agitate once,* (over and back.)
50. *Replace tank in water bath.*
51. *Drain tank* starting 10 seconds before time is up.

DRYING

52. *Hang film to dry.*
53. *Wipe non-emulsion side* (optional) with sponge moistened with *stabilizer.* Do not squeegee or apply sponge to emulsion side.
54. *Remove film* when dry. Wet film has a milky blue cast which disappears when the film is completely dry.

PUSHING COLOR FILM

"PUSHING" OR "PULLING" FILM

Film is "pushed" or pulled" by setting the camera's exposure meter to an ASA higher (for pushing) or lower (for pulling) than the film's designed speed.

	Kodacolor 400 Fujicolor F-II 400 Sakuracolor 400	Vericolor II Kodacolor II Fujicolor F-II Sakuracolor II
	Set Meter to	Set Meter to
To push 2 stops	1600	400
To push 1 stop	800	200
To expose normally	400	100
To pull 1 stop	200	50
To pull 2 stops	100	25

Guide for Altering the Speed Through Processing E-6

Camera Exposure	Film Type and ASA Equivalent				Change First Developer time by:*	
	Ekt.50	Ekt.160	Ekt.200	Ekt.400		
2 stops underexposed	200	640	800	1600	+80%	5½ min.
1 stop underexposed	100	320	400	800	+30%	2 min.
Normal	50	160	200	400	Normal time	
1 stop overexposed	25	80	100	200	−30%	2 min.
2 stop overexposed	12	40	50	100	−50%	3½ min.

*Note that first development times can vary according to the number of rolls of film already processed, in which case you should use the percentage figures to calculate the amount to increase or decrease development time.

PUSH PROCESSING

Like black-and-white films, color films can be "pushed" to a higher ASA rating and then left longer in the developer to compensate. The result is a final product that shows color shifts, changes in contrast, and increased grain. There is a tendency to think that the only advantage to push processing is the opportunity it gives to "rescue" film shot in low-light conditions. In fact, an equal advantage to push processing is the creative effect it can produce (see photo at right).

Choosing a scene. Many scenes do not lend themselves well to push processing. If detail in the subject of a photograph does not show good contrast, that detail will be lost after push processing. Thus, the very scenes most likely to require pushing (i.e., scenes shot in low light) are also the scenes in which detail is mostly likely to suffer. On the other hand you can expect push processing to exaggerate gross differences in contrast. For example, a backlit portrait would show great contrast between the subject and the background, but little or no detail in the face.

Pushing negative film. Negative films are especially susceptible to increase in grain, fog, and contrast when pushed. Unless you find those increases desirable for creative reasons, you will probably obtain better results from pushing slides. Since negative films have more exposure latitude than slides, you may be better off underexposing the film by one stop, processing normally, and compensating for the underexposure by altering exposure time when printing the negative.

In low-light situations the speed of the film in your camera may not allow you to use a shutter speed fast enough to avoid blurring if the subject or the camera moves. With slide film, if you underexpose (push) the film in order to use a faster shutter speed, you *must* compensate by changing the development time. With negative film, however, you can compensate for underexposure by changing the printing time; therefore, you can develop the pushed film as if it had been properly exposed.

PULL-PROCESSING

Very rarely, you may find yourself shooting film too fast for the brightness of the scene you are photographing. One solution is to "pull" the film to a lower ASA and then "pull-process" it in the darkroom. In essence you are overexposing the film in the camera, then underprocessing it. Pull-processing diminishes contrast to some extent but does not substantially affect color or grain.

6. THE COLOR PRINT

Walk into a photo supply store and you will be confronted with shelf after shelf of competing products, each recommended for a special set of conditions, each with its own advantages and disadvantages. No matter which chemistries you select, if you understand the fundamentals of filtration and color printing and follow the manufacturers' processing instructions carefully, you will be assured of good results—even if you have never entered a darkroom before. Moreover, once you have complete command of one of the processes, the others lining the store shelves will be so similar that you will easily be able to transfer the skills you have learned. Times and temperatures may change, but sequences and methods will remain essentially the same.

Think of color printing as consisting of two stages. The first stage, *exposing the print*, involves selecting the proper filtration and determining the correct exposure. The second stage, *processing the print*, involves the mechanical procedures of mixing chemicals and using them correctly in drums or trays to produce a final, properly developed image.

If you have never attempted color processing before, here is a simple, nearly foolproof strategy for quickly learning to produce high-quality color prints.

1. Study the concepts and procedures for determining correct filtration and exposure until you understand them thoroughly (pp. 106–109).
2. Decide whether you want to print from slides or negatives. (Unless you expect to be printing exclusively from negatives in the future, start with slides because it is far easier to visualize the effect of filtration on slides than on negatives. Switch to negatives later, if you wish.)
3. Select and purchase one of the chemistries described in this chapter. It is not too important which you select as long as your selection is consistent with the type of film you want to print from (slides or negatives).
4. Purchase or borrow the equipment you will need.
5. Select a "practice" slide or negative that is properly exposed, preferably contains flesh tones, and displays a variety of colors.
6. Follow the instructions on pp. 72–73 for making test prints and a final print. If the processing chemistry you have chosen is not covered in detail on the following pages, refer to the section in its manufacturer's instruction sheet that relates to your needs.
7. Continue to use the same chemistry over and over with different slides or negatives (as appropriate) until you have completely mastered exposure, filtration, and the manufacturer's process.
8. Eventually, try alternative chemistries that sound interesting or that allow you to switch from slides to negatives or vice versa.

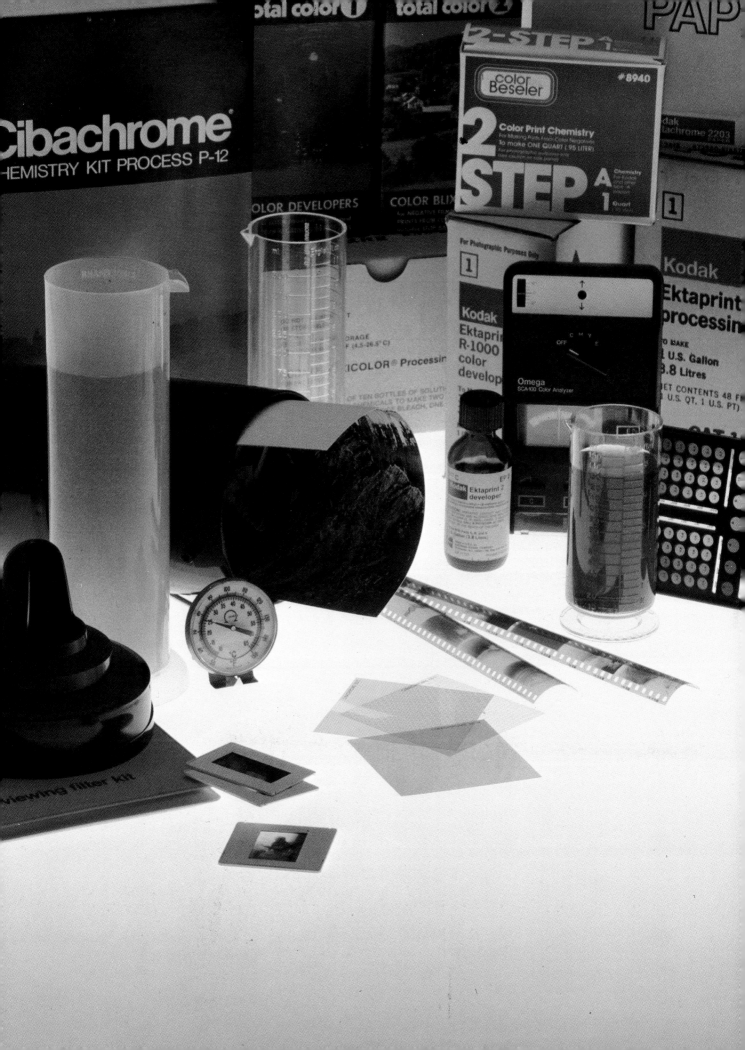

DETERMINING FILTRATION

The first step in adjusting filtration is identifying the color that is out of balance in your print. In most circumstances, you will find that color imbalances are easiest to read where they affect flesh tones.

In the photo above, the three color-compensating filters (yellow, magenta, and cyan) have been laid over a color transparency to illustrate how color imbalances affect flesh tones. Study the photo carefully until you are certain you can recognize the effect of each imbalance by sight and can correctly name the out-of-balance color.

Note that where two filters overlap, a primary color is formed, and where all three overlap, the area of neutral density appears darker but the actual color of the skin remains unchanged.

Filter exposure compensations

Whenever you change the amount of filtration you use with a condenser-head enlarger, exposure also changes. If you *add* filters, to find the new exposure time *multiply* your standard exposure (see p. 108) time by the appropriate factor given in the chart below. If you *subtract* filters, *divide* your exposure time by the appropriate factor. For changes involving two filters, first multiply the respective filter factors together, then proceed as described above. Each time you add or subtract filters, you must make an additional exposure compensation.

	C	M	Y
5	1.1	1.2	1.1
10	1.2	1.3	1.1
20	1.3	1.5	1.1
30	1.4	1.7	1.1
40	1.5	1.9	1.1
50	1.6	2.1	1.1

UNDERSTANDING FILTRATION

In color printing, inaccurate duplication of the original colors of a scene may occur for three reasons: inconsistencies in the light produced by different enlarger bulbs; variations in the colors present in the slides or negatives being used to make a print; and differences in the responsiveness of paper batches to the colors contained in light. Each time you expose a print, these three sources of color inaccuracy combine, requiring that you use compensating filters in order to produce a print with natural color balance.

The heart of successful color printing is the analyzing of a print to determine which colors are out of balance. Therefore, it is crucial that you spend time studying the color chart on the next page until you can identify and name each of the six colors by sight.

Color filters. If you recall from p. 82, there are three filters used in subtractive color photography: yellow, magenta, and cyan. Furthermore, by stacking the filters in various combinations of two, you can generate the primary colors, blue, green, and red. Finally, stacking all three filters produces what is called a *gray* or *neutral density (ND) filter;* that is, a filter that has no color but which causes light passing through it to lose intensity.

Filter density. The intensity of the color in a filter is measured in terms of color *density*. Dichroic heads allow you to adjust filtration in single units of density, whereas color-printing (CP) and color-compensating (CC) filters commonly are available in increments no smaller than 5 units. (A supply of CP or CC filters with the densities 5, 10, 20, 40, and 50 in each of the colors yellow, magenta, and cyan should satisfy your needs.) In general, 5 units repre-

sents a minor correction, 10–15 units a moderate correction, and 20 or more units a large correction; however, some papers, such as Cibachrome, require larger changes.

The filter pack. The filtration in your enlarger is referred to as a *filter pack*, whether you are using actual filters or dialing in filtration on a dichroic head. Even a brand new enlarger will have some filtration in its filter pack because of the colors generated by the enlarger's own internal components. Also, every paper batch responds differently to the colors in light. Each time you switch to a different paper batch, you must make a test print based on the manufacturer's recommended filtration and then adjust the color as necessary by adding or removing filters from the filter pack.

Eliminating neutral density. Since equal densities of all three filters produce neutral density, removing equal amounts from all three filters of a filter pack will not affect the color of the print. In other words, normally you should not expose a print if your filter pack contains all three filter colors. Instead, first eliminate the filter of lowest density and then subtract that density from the two remaining colors. For example, from a filter pack containing 5Y, 20M, and 30C, you should remove 5Y, 5M, and 5C, leaving 15M and 25C.

ADJUSTING FILTRATION

Once you have decided which color is out of balance in a print, you must decide how to make the necessary filtration adjustment. Charts that present two alternative methods for correcting each of the six possible color imbalances are shown on p. 111 (for printing from slides) and p. 113 (for printing from negatives). In each case, one method involves adding filters and the other subtracting them. Either

method will work, but one is usually easier to use than the other depending on which filters are already in the filter pack. Here is a useful procedure for making the adjustment.

1. Remove any neutral density from the filter pack.
2. Consult the appropriate chart (pp. 111 or 112) to determine the two filtration options you have.
3 If possible, select the option that permits you to work with the colors already in your filter pack.

If step 3 requires you to subtract more of a color than is already present in the filter pack, then do the following:

4. Use the additive option instead.
5. Remove any neutral density that is formed.

For example, suppose that when printing from a slide, you determine that the test print contains far too much magenta. From the chart on p. 111, you see that you can solve the problem either by subtracting magenta or by adding yellow and cyan. If you estimate a correction of 20 units, and your filter pack already contains 10Y and 25C, you would add 20Y and 20C, ending up with a filter pack containing 30Y and 45C.

Suppose, in the above example, that you are printing from a negative instead of a slide. In that case, from the chart on p. 112 you see that you can remove magenta from the print by *adding* magenta to the filter pack or by *subtracting* cyan and yellow. However, because you cannot subtract 20Y from a filter pack containing only 10Y, you must elect to add 20M, producing a filter pack which contains 10Y, 20M, and 25C. Removing 10 units of neutral density, your final filter pack ends up with 10M and 15C.

THE COLOR WHEEL IN TERMS OF NEUTRAL DENSITY

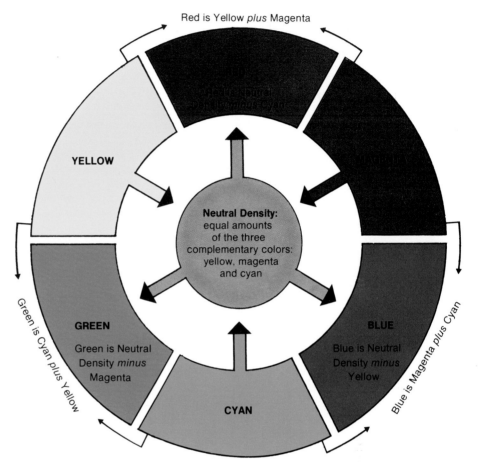

Red is Yellow *plus* Magenta

YELLOW

Neutral Density: equal amounts of the three complementary colors: yellow, magenta and cyan

Green is Cyan plus Yellow

Blue is Magenta plus Cyan

GREEN

Green is Neutral Density *minus* Magenta

BLUE

Blue is Neutral Density *minus* Yellow

CYAN

The relationship between the primary colors (blue, green, and red) and the complementary colors (yellow, magenta, and cyan) is the foundation of color filtration. For color printing, you will find it most useful to commit the following to memory:

1. **Magenta plus yellow produces red (M+Y=R), cyan plus magenta produces blue (C+M=B), and yellow plus cyan produces green (Y+C=G).**
2. **When all three colors are combined, neutral density (which has no color) results.**
3. **Each primary color can be formed *by removing the appropriate complementary (or secondary) color from neutral density.***

DETERMINING EXPOSURE

EXPOSING PRINTS

In color printing, improperly exposed prints suffer from unpredictable color shifts. Therefore, your final filtration must be based on a test print that is correctly exposed.

Controlling exposure. The particular combinations of enlarger-lens f-stop and exposure duration required for a properly exposed print are dictated by four factors: the power of your enlarger lamp, the density of your slide or negative, the size of your enlargement, and the light-sensitivity of your paper.

You can adjust exposure by changing either f-stop or exposure time. In practice, however, you will find it far easier to choose a standard exposure time and use it whenever possible, making all your exposure adjustments by changing f-stop alone. This method is favored because some color printing papers do not respond predictably to changes in exposure time. Changes in f-stop, on the other hand, produce completely predictable exposure changes that are consistent irrespective of the paper used.

Selecting a standard exposure time. You will greatly simplify your darkroom efforts if you establish a standard exposure time that will allow you quickly and consistently to select a correct f-stop without having to make more than one test print. Set your enlarger at f-8 and, using the paper you expect to em-

ploy most frequently, experiment to determine the exposure time that will produce a properly exposed 8"x10" (20x25 cm) enlargement (see p. 72). The f-8 setting gives you an intermediate lens opening which will permit you to make f-stop changes in either direction while still using your standard exposure time. This strategy facilitates finding the correct exposure for various enlargements because changing to 5"x7" (13x18 cm) or 11"x14" (28x36 cm) from 8"x10" requires a change in exposure of exactly one f-stop, and changing to 4"x5" (10x13 cm) or 16"x20" (41x51 cm) requires a change of exactly two f-stops.

Selecting a test paper size. You can make a test print on paper of any size. The 4"x5" size is economical to use, but 4"x5" processing drums are not readily available.

Some 8"x10" drums will accommodate the smaller paper size, but you will still need to use as much chemistry as an 8"x10" sheet requires.

Regardless of the size of your test paper, you must adjust the enlarger for your test print so that the image striking the paper is exactly the size it will be in the final print.

Making a test for exposure. Perform a test for exposure as follows:

1. *Prepare testing "L" for test paper size you have selected.* (See middle photo at top.)
2. *Place slide or negative in enlarger,* emulsion side down.
3. *Insert (or dial in) estimated filter pack* recommended by the paper manufacturer (or one you have derived by experience).
4. *Turn off all lights* except the enlarger lamp.

CUTTING A TESTING "L"

In an exposure test, you expose each of four quadrants of a sheet of paper at a different f-stop, then use the exposure that looks best to make the final print. A testing "L" simplifies the process of exposing one quadrant at a time.

To make a testing "L," cut a piece of cardboard to the same size as your paper, then cut out one quadrant as shown.

PERFORMING THE EXPOSURE TEST

When performing the exposure test, place the "L" so that one quadrant of the paper is uncovered, set your lens to the smallest f-stop you will be using, then make your exposure, Next, rotate and/or turn the cardboard so that a different quadrant is uncovered, open the lens one f-stop, and make your second exposure. Repeat this process until all four quadrants have been exposed, each at a different f-stop. Finally, process the print and select the best exposure to use for your final print.

5. *Adjust enlarger head* to produce the correct enlargement size.
6. *Focus* at the widest *f*-stop.
7. *Turn off enlarger lamp.*
8. *Place test paper on easel* (in total darkness).
9. *Place cardboard "L" on paper* so cutout is in upper left-hand corner. (See right photo at top.)
10. *Set lens at f/16* (or the smallest *f*-stop your lens has).
11. *Expose paper for your standard time.*
12. *Repeat steps 8, 9, and 10 three times,* but simultaneously turn and rotate the cutout clockwise to a different corner and open the lens by one *f*-stop each time.
13. *Load test print in a processing drum,* emulsion side *in.*
14. *Process print normally.* (See later sections of this chapter.)

Evaluating an exposure test. Evaluate the results of an exposure test as follows:

1. *Dry print thoroughly.* Never try to judge a wet print, because color and brightness change as a print dries.
2. *Decide which of the four exposures is best.* Often the best exposure will fall between two *f*-stops.
3. *Repeat the test* (as described below) if all four exposures are either underexposed or overexposed, or if the filtration is grossly in error.

Repeating an exposure test. Occasionally all four exposures on your test print will be over-or underexposed, in which case you must test again using a different exposure time. The procedure is as follows:

1. *Determine whether you need to increase or decrease the exposure.* For prints from slides, increasing the amount of light

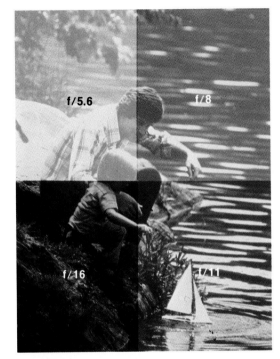

EXPOSURE TEST
After you have performed an exposure test, your processed test print should appear similar to the one above. In this example, the best exposure is at f/11. If all quadrants in your test print appear over- or underexposed, you must repeat the test using a different sequence of f-stops.

falling on the paper *lightens* the print, and vice versa. For prints from negatives, increasing the amount of light falling on the paper *darkens* the prints, and vice versa.
2. *Select a different exposure time.* If you must increase the exposure time, do so by more than double. If you must decrease the exposure time, do so by more than half.
3. Repeat the entire test procedure at the new exposure time.

Making a filtration test. If the properly exposed quadrant on your exposure test reveals that your filtration is off, you may want to estimate the filtration correction and then perform a separate filtration test, unless you are confident that your estimated correction will be

accurate. The advantage of a test is that you can do it on a small piece of printing paper. You do not need to use the testing "L" because you only need to make a single exposure at the correct *f*-stop .

Maintaining a darkroom log. To aid you in your darkroom endeavors, you should maintain a darkroom log. Notes to yourself, problems and their solutions, ideas, comments, and the like, will prove invaluable for later reference. Because the same exposure and filter pack will almost always produce a high-quality print from any properly exposed slide or negative enlarged to the *same size* on the *same paper batch,* you will find it especially useful to include in your log a record of the exposure and filtration data for each batch of paper you use.

COLOR PRINTING FROM SLIDES

Paper types. The two papers most widely available for making color prints directly from slides are Kodak Ektachrome RC Type 2203 paper and Cibachrome paper. Type 2203 paper can be processed in Kodak Ektaprint R-1000 chemistry or in alternative chemistries produced by other manufacturers. However, no manufacturer other than Cibachrome makes chemistry designed specifically for use with Cibachrome paper. Generally, you will achieve the highest quality results if you use the paper manufacturer's own chemistry.

Exposures. Cibachrome recommends that you make exposure adjustments by changing lens openings while keeping exposure time constant, whereas Kodak recommends altering exposure time instead. However, if you follow the procedures for determining a standard exposure time suggested on p. 108 you can adjust exposure by changing lens opening with either paper.

Exposure and filtration corrections. Exposure and filtration corrections are easier with slides than with negatives because corrections seem intuitively logical. For example, if a print is too dark, you lighten it by using a larger *f*-stop, thereby increasing the amount of light striking the paper, and if the print displays too much of a color, you subtract that color from the enlarger's filter pack.

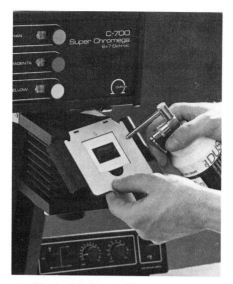

1. *Clean slide* thoroughly.
2. *Place slide in enlarger*, emulsion side down (i.e., facing the easel).

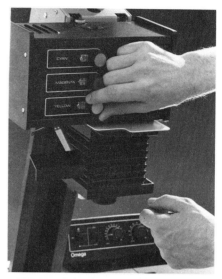

3. *Insert (or dial in) filter pack* as determined from your test prints.
4. *Turn off all lights* except the enlarger lamp.
5. *Adjust focus* with the lens set at its widest *f*-stop.

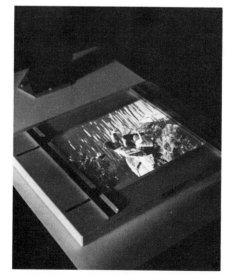

6. *Position easel* to crop the print where you wish.
7. *Close down aperture* to the exposure setting as determined by your test exposures.
8. *Turn off enlarger lamp.*
9. •*Place paper on easel* without changing the easel's position.
10. •*Expose paper* for the standard time interval (or a special interval as determined by your test exposures).

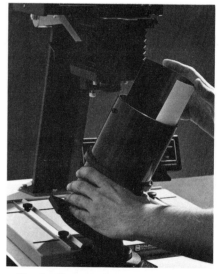

11. •*Load paper in processing drum*, emulsion side *in*.
12. •*Cap ends of drum.*
13. *Turn lights on.*
14. *Process print.*

Execute steps preceded by a "•" in complete darkness.

The two illustrations and their accompanying captions on this page will serve as a guide to making exposure and filtration decisions. (Remember not to judge a print until it is dry.)

Printing from a slide. In order to make a final print from a slide, you need to have (1.) decided on the enlargement size you want to make, (2.) made an exposure test, (3.) determined the best exposure setting, and (4.) calculated the adjustments to make in your enlarger's filter pack to correct any color imbalances. Once these preliminaries have been completed, follow the steps outlined in the captions at right to produce your final print.

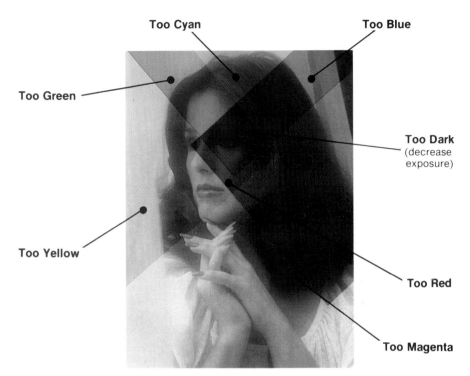

Too Cyan　Too Blue　Too Green　Too Dark (decrease exposure)　Too Yellow　Too Red　Too Magenta

ADJUSTING COLOR FILTRATION WITH SLIDES

The above photo shows various color errors and the filters that produce them. Errors show up most clearly in flesh tones. You correct color errors in prints made from slides by *subtracting* from the filter pack the color that contributes to the error, or by *adding* its complementary color (see chart below). Be sure to remove any neutral density that your corrections produce in the filter pack (see p. 107).

If you do not know how large a correction to make, start with a filter density correction of 20 units. (Viewing aids, which are discussed on p. 116, will help you estimate corrections.

Adjusting Color Filtration with Slides

If your print is too	Then subtract	Or add
Blue	Magenta + Cyan	Yellow
Green	Yellow + Cyan	Magenta
Red	Yellow + Magenta	Cyan
Yellow	Yellow	Magenta + Cyan
Magenta	Magenta	Yellow + Cyan
Cyan	Cyan	Yellow + Magenta

SELECTING A LENS OPENING

In the sample test print shown at left, the exposure at f/16 seems too dark and the one at f/8 seems too light, so for the final print you would set the enlarger aperture to f/11.

If all four quadrants of your test print appear too light, you must repeat the test using an exposure time *less* than half as long (4 seconds instead of 10 seconds, for example). If all four quadrants of your test print appear too dark, repeat the test using an exposure time *more* than twice as long (25 seconds instead of 10 seconds, for example).

f/5.6　f/8

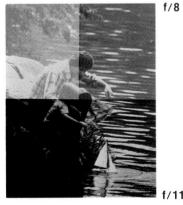

f/16　f/11

COLOR PRINTING FROM NEGATIVES

Color negatives, unlike slides, bear no apparent color resemblance to the prints they produce. Moreover, the negatives contain an orange cast designed to reduce contrast in the final print. The orange cast in no way interferes with color renditions but since the film contains a negative rather than a positive image, the cast makes it difficult to evaluate the quality of a negative without actually making a print.

Printing from color negatives requires that you produce a contact print of each roll of film so that you can evaluate the individual frames on the roll and decide which frames you want to enlarge. The dilemma is that in order to produce a contact, you must first know how to make a print; but in order to select a good negative, you first need to make a contact. Therefore, you need to be familiar with the information on this page as well as on the following two pages before you begin printing.

Paper types. The most readily available and widely used papers for printing from color negatives are Kodak Ektacolor 74RC and 78RC papers. These papers are sold in three surface textures, E ("Luster-Lux"), F (glossy) and N (smooth). Any photo supply dealer can show you samples. The type you use is a matter of personal preference. You will achieve the highest quality results with these papers if you process them in Kodak Ektaprint 2 chemistry. However, alternative chemistries are also available.

Exposure and filtration correction. The effects of changes in exposure and filtration when printing from color negatives are exactly the opposite of what you would logically expect. If a test print is too dark, you must *decrease* the exposure to lighten the print, and vice versa. If a test print displays too

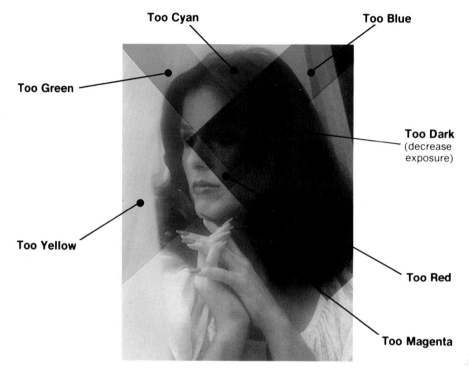

Too Cyan **Too Blue**

Too Green

Too Dark
(decrease exposure)

Too Yellow

Too Red

Too Magenta

ADJUSTING COLOR FILTRATION WITH NEGATIVES

The above photo shows various color errors and the filters that produce them. Errors show up most clearly in flesh tones. You correct color errors in prints made from negatives by *adding* to the filter pack the color that contributes to the error or by *removing* its complementary color (see chart below). Be sure to remove any neutral density that your corrections produce in the filter pack (see p. 107).

If you do not know how large a correction to make, start with a filter density correction of 20 units. (Viewing aids, which are discussed on p. 116 will help you estimate corrections.)

Adjusting Color Filtration With Negatives

If your print is too:	Then add	Or subtract
Blue	Magenta + Cyan	Yellow
Green	Yellow + Cyan	Magenta
Red	Yellow + Magenta	Cyan
Yellow	Yellow	Magenta + Cyan
Magenta	Magenta	Yellow + Cyan
Cyan	Cyan	Yellow + Magenta

SELECTING A LENS OPENING

In the sample test print shown at left, the exposure at f/8 seems too dark while the one at f/11 seems too light. For the final print, you would set the enlarger between f/8 and f/11.

If all four quadrants of your test print appear too light, you must repeat the test using an exposure time *more* than twice as long (20 seconds instead of 8 seconds, for example). If all four quadrants of your test print appear too dark, repeat the test using an exposure *less* than half as long (3 seconds instead of 8 seconds, for example).

much of a color, you *add* that color to the enlarger's filter pack; if you need to add a color to the print, you subtract that color from the filter pack.

The two illustrations on this page will serve as a guide for making exposure and filtration decisions. As always, remember not to judge a print's color until it is dry.

Printing from a negative. In order to make a final print from a negative, you need to have (1.) made a contact print (p. 114) and selected a frame to enlarge, (2.) decided on the enlargement size you want, (3.) made a test exposure, p. 108 (4.) determined the best exposure setting, and (5.) calculated the adjustments to make in your enlarger's filter pack to correct any color imbalance (this page).

Once you have completed these preliminaries, follow the steps outlined in the captions on the previous page to produce your final print.

INTERNEGATIVES

Background. In the early days of color printing, reversal printing papers produced a substantial increase in contrast, so slides were copied onto negative film (thereby producing an internegative) which was then used to make a print on standard negative-to-positive paper. Today, reversal papers are so vastly improved that the slightly better contrast possible with negative paper does not compensate for the loss in image quality produced by generating an internegative.

Printing from internegatives. To produce an internegative, load your camera with negative film and then follow the procedures described on p. 138 for slide copying. Then make your print by following the normal procedures for printing from a negative.

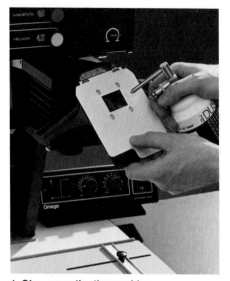

1. *Clean negative* thoroughly.
2. *Place negative in enlarger*, emulsion side down (i.e., facing the easel).

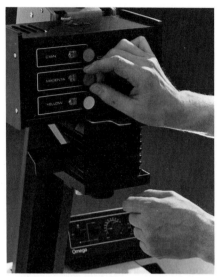

3. *Insert (or dial in) filter pack* as determined from your test prints.
4. *Turn off all lights* except the enlarger lamp.
5. *Adjust focus* with the lens set at its widest *f*-stop.

6. *Position easel* so as to crop the print where you wish.
7. *Close down aperture* to the exposure setting determined by your test exposures.
8. *Turn off enlarger lamp.*
9. *•Place paper on easel* without changing the easel's position.
10. *•Expose paper* for the standard time interval (or a special interval as determined by your test exposures).

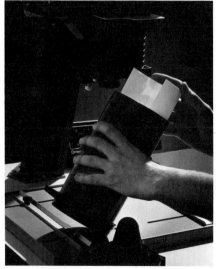

11. *•Load paper in processing drum*, emulsion side *in*.
12. *•Cap ends of drum.*
13. *Turn on lights.*
14. *Process print.*

Execute steps preceded by a "•" in complete darkness.

113

COLOR CONTACTS

PRINTING CONTACTS

Before you can make a satisfactory contact print of a roll of negative film, you must determine the correct filtration for the paper you are using and the correct exposure for an 8"x10" enlargement. Once you know these figures, they will be applicable any time you make a contact using the same paper batch. Be sure to make a note in your darkroom log of the height of the enlarger head above the easel, as well as the exposure and filter-pack values.

Test frames. You can use any properly exposed negative as a test frame, but you will obtain the best results if your test frame contains flesh tones and a broad range of colors. An excellent technique is to prepare your own special test frame consisting of a portrait of a person holding up a standard color chart (color charts are available from photo supply stores). Save the test frame and use it whenever you use a new paper batch.

Contact printer. The same contact printers used for black-and-white photography are suitable for color.

Making the contact. Once you have established the correct exposure for an 8"x10" enlargement and the correct filter pack for the paper you are using, follow the steps outlined in the captions on this page to produce your final print.

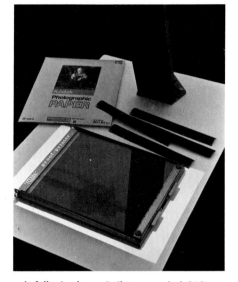

1. *Adjust enlarger* to the proper height for the light to cover an 8"x10" (20x25cm) sheet of paper.
2. *Set correct lens opening* as determined from your test prints.

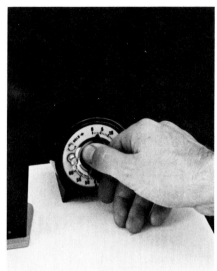

3. *Set timer.*
4. *Insert (or dial in) correct filter pack* for the paper batch being used.
5. *Turn off all lights.*

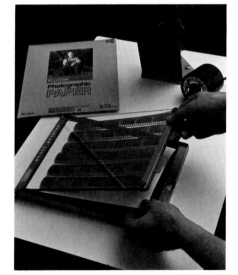

6. *•Insert 8"x10" paper in contact printer,* emulsion side up.
7. *•Place negatives on top of paper,* emulsion side down.
8. *•Close contact printer.*
9. *•Position contact printer* directly below the enlarger lens.

10. *•Expose paper* for the standard time interval.
11. *•Load paper in processing drum,* emulsion side *in.*
12. *•Cap ends of drum.*
13. *Turn lights on.*
14. *Process print.*

Execute steps preceded by a "•" in complete darkness.

BLACK-AND-WHITE PRINTS FROM COLOR ORIGINALS

On occasion you may find you have a color negative that you would like to print in black and white. Special papers enable you to do so.

Paper. Since normal black-and-white printing paper does not respond to all colors, you cannot use it to print from a color negative because some colors present in the original will not show up in the print. Kodak Panalure paper, however, which comes in F (glossy) and E (lustre) surfaces, is sensitive to all colors and is suitable for producing a black-and-white image from a color original.

Safelights. Panalure's sensitivity to all colors makes the use of a safelight risky. Kodak says you can use a #10 amber filter with a 15-watt bulb at no closer than 4′ for brief periods, but you are safest exposing the paper to no extraneous light at all until processing is completed.

Filtration. Filters have the same effect on Panalure paper as on black-and-white film. For example, if you want to darken the sky in a print, you can hold a medium yellow or red filter below the enlarger lens as you make the exposure.

Processing. You process Panalure paper using standard black-and-white processing procedures, except that without having the visibility provided by a safelight, you will have to use an audible timer to determine when developing is completed.

Image quality suffers when normal black-and-white paper is used to make a print from a color negative. Notice how the above photo has become "contrasty," in that detail has been lost in the shadows (especially in the man's face) and in the highlights (the large rock). Also, the print shows increased grain.

Black-and-white papers specifically intended for use with color negatives preserve image quality. Because these papers are designed to respond to all colors in the spectrum, contrast remains substantially the same; on the other hand, no safelight can be used. Grain, like contrast, remains within acceptable levels.

COLOR PRINTING AIDS

COLOR CALCULATOR

Color calculators work by blending together all the colors in a slide or negative, then projecting the mixture through a wide range of different filter combinations and densities onto a sheet of printing paper. The filter combination that produces a neutral gray color on the test print will produce a proper color balance on the final print.

With experience, you will probably be able to judge filtration by eye as accurately without the calculator as with it.

VIEWING FILTERS

The Kodak Color Print Viewing Filter Kit can be extremely useful in helping you learn to analyze prints and make filter corrections. To use the kit, you simply find the card and "window" (see photo below) through which the colors in a test print appear in correct balance. A notation below the window then tells you the correction to make in your enlarger's filter pack. Read one side of the card if you are printing from slides and the other side if you are printing from negatives.

VIEWING AIDS

Because correct filtration is so essential to color printing, various aids are available which make it easier for you to learn filtration and in general speed the process of making adjustments when needed.

The aids presented below can be useful, but be careful not to rely on them so much that they become crutches instead of aids. There is no substitute for your own knowledge and understanding.

CC and CP filters. The most basic aids are the same color-compensating or color-printing filters you use in your enlarger. (Of course, you may not own these filters if your enlarger has a dichroic head.) First, analyze the print by eye to decide which color is out of balance. Next, regardless of whether you are printing from a slide or a negative, consult the chart on p. 111 and view the print through the recommended filter or filters. Make any further adjustments until the colors in the print look correct to your eye. (Be sure to view both the original and the print in the same light.) Finally, if you are printing from a slide, simply add the correcting filters to the enlarger's filter pack, remove any neutral den-

sity, and expose your print. If you are printing from a negative, you must *subtract* the correction from the enlarger's filter pack (or consult the chart on p. 112 to find the proper filters to *add* to the filter pack, if subtraction is not possible).

Using CC and CP filters in this way works, but is inconvenient and can be confusing, especially when printing from negatives. Viewing filters (described at left) are a more convenient alternative.

Color calculators. Color calculators function on the principle that if a photograph that contains all colors is properly filtered and exposed, scrambling the colors should produce a neutral gray tone. Color calculators contain a diffusion filter that you place over your enlarger lens to blend together the colors in a slide or negative, and a perforated card that you lay upon your printing paper before you make the exposure. The scrambled light passes through holes in the card which contain a wide range of filter combinations and densities. Once you have processed and dried the print, you compare the colored disks formed on the print by the filters to a standard gray which has been printed on the type of paper you are using. The disk that matches the standard gray signals the adjustments required in your filter pack to achieve proper color balance. In addition, a separate series of disks indicates exposure corrections.

Test prints made using a color calculator can be hard to "read" if the print requires only minor filtration corrections, but for correcting gross filtration errors, such as those which occur when changing to a new paper batch, a color calculator can be useful.

Color analyzers. Once you have determined the correct filtration to use with a particular paper batch, a

color analyzer enables you to make subsequent prints from different slides or negatives without needing to make additional test prints. If you regularly print from properly exposed slides onto one basic paper type, you probably will not need to make enough test prints to justify the relatively high initial cost of a color analyzer.

A color analyzer works by electronically comparing the colors in a negative to a "standard" negative for which you have already determined the correct filtration. As long as you do not change to a different paper batch or switch to a different processing chemistry, the analyzer will tell you very precisely how to change the enlarger's filter pack so that a new slide or negative will produce a print with colors in the same balance as the standard you used to program the analyzer.

You will obtain the best results if your standard negative contains tones you can readily identify from photograph to photograph—flesh tones and neutral grays work especially well—and if it is shot under the same conditions (e.g., outdoors, indoors, etc.) as the photos to which it will be compared.

When you change to a different paper, you must program the analyzer again to your standard negative. However, if you maintain a record of the enlarger filter packs and analyzer settings that correspond to each paper and emulsion batch you use, you will be able to switch from one paper to another with ease.

Although the primary function of color analyzers is to provide filtration information, they have other uses as well.

Exposure control. With either color or black-and-white film, you can use the analyzer to measure exposure settings.

OMEGA SCA-100 COLOR ANALYZER

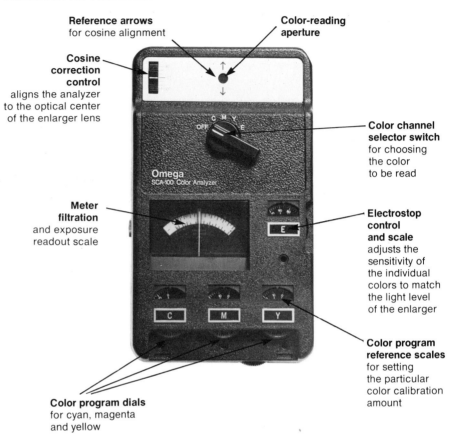

Reference arrows for cosine alignment

Color-reading aperture

Cosine correction control aligns the analyzer to the optical center of the enlarger lens

Color channel selector switch for choosing the color to be read

Meter filtration and exposure readout scale

Electrostop control and scale adjusts the sensitivity of the individual colors to match the light level of the enlarger

Color program reference scales for setting the particular color calibration amount

Color program dials for cyan, magenta and yellow

Contrast grades of paper. You can use the analyzer to determine the exposure range in a black-and-white negative and select a contrast grade of paper that will accommodate that range.

Unusual lighting situations. An analyzer can correct for color imbalances induced by a non-standard light source. (For example, if you shoot tungsten film outdoors, or outdoor film under fluorescent lights, the analyzer can automatically make corrections when you prepare a print).

Color analyzers may be luxury, but a luxury worth considering if you need highly accurate filter corrections or if for any reason you find yourself wasting substantial quantities of paper making routine test prints.

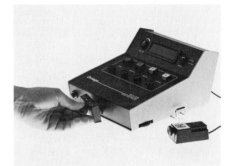

DIGITAL READOUT, PROGRAMMABLE ANALYZER

The most sophisticated analyzers not only provide color filtration readouts in precise didital display but also possess memory modules that "remember" the correct filtration for a particular paper batch. When you switch papers, you need only plug in the appropriate module and the machine will immediately be ready to analyze color for the new paper batch.

THE PROCESSING DRUM

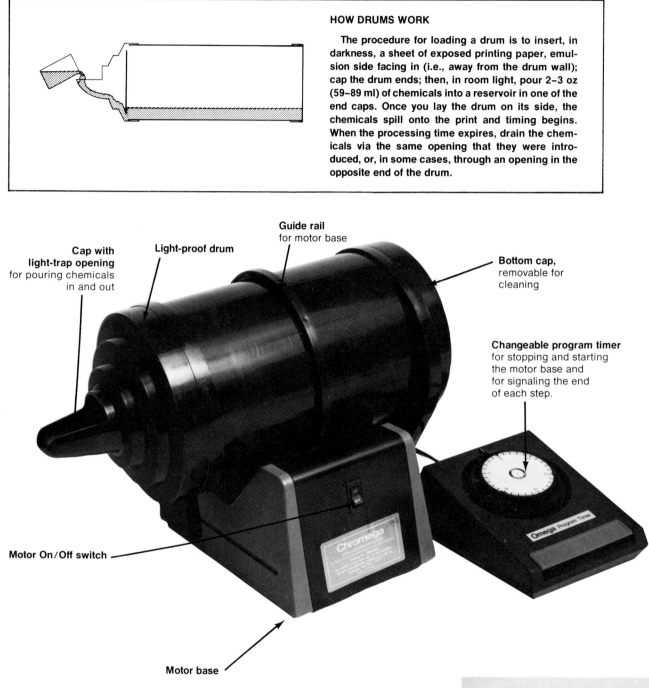

HOW DRUMS WORK

The procedure for loading a drum is to insert, in darkness, a sheet of exposed printing paper, emulsion side facing in (i.e., away from the drum wall); cap the drum ends; then, in room light, pour 2–3 oz (59–89 ml) of chemicals into a reservoir in one of the end caps. Once you lay the drum on its side, the chemicals spill onto the print and timing begins. When the processing time expires, drain the chemicals via the same opening that they were introduced, or, in some cases, through an opening in the opposite end of the drum.

Cap with light-trap opening for pouring chemicals in and out

Light-proof drum

Guide rail for motor base

Bottom cap, removable for cleaning

Changeable program timer for stopping and starting the motor base and for signaling the end of each step.

Motor On/Off switch

Motor base

DIFFERENT SIZES OF DRUMS

Processing drums come in a variety of sizes which correspond to standard paper sizes. By choosing the correct size for the paper you are using, you will use smaller quantities of chemicals. The large drum at right can hold one 20"x24" (51x61cm) print, two 16"x20" (41x51cm) prints, or six 8"x10" prints, using in each instance the same 8 oz. (237ml) of chemistry.

Processing drums are hollow, light-tight plastic cylinders in which you process exposed printing paper. A special opening in one end of the cylinder permits you to pour in and drain out chemicals without admitting light. Internally, some drums are smooth-walled to facilitate cleaning, while others contain grooves to promote circulation of chemicals over the surfaces of the printing paper. Different sizes of drums accommodate a variety of paper sizes, with 8"x10", 11"x14", 16"x20", and 20"x24" (51x61 cm) most readily available. Some drums are sold with inserts to make it possible to fit small paper sizes into larger drums.

Advantages. Drum processing requires less counter space than tray processing; it can be performed with the room lights on; and it uses chemicals far more economically than trays do.

Disadvantages. A single 8"x10" drum is somewhat more expensive than the trays you would need to perform the same process. Also, many types of drums can accommodate only a single sheet of printing paper at a time.

What to buy. You will need at least one drum to handle the size paper you expect to use most frequently. If you also want the ability to print on smaller paper, choose a model with special inserts for the purpose. If you plan to make many 8"x10" prints, you may want to consider a 20"x24" drum which can accommodate six 8"x10" prints at once. Even if you make prints predominantly of one size, you may still want to purchase an assortment of drums in order to process more than one size at a time and in order to avoid wasting chemistry (as happens when a small print is processed in a large drum). If the processes you expect to use most frequently require high temperatures, you may want to select a model with watertight ends so the drum can be immersed in a temperature-controlled water bath.

Agitation. In order to agitate by hand, you repeatedly roll the drum one complete revolution back and forth across a flat surface. *Motorized agitator bases* produce a much smoother agitation than is possible by hand. Some bases rotate the drum in only one direction, but the better bases turn first in one direction, then the other. The very best bases also produce a rocking motion which prevents streaks by insuring uniform chemical distribution across the entire surface of the paper. Some processes require manual agitation at high speed for a few seconds before the drum can be placed on the slower, motorized base.

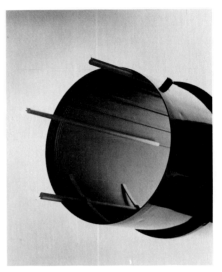

RIBS INSIDE DRUM

This drum has adjustable ribs so that it can be made to accommodate various paper sizes. The clips on the rib at the top of the drum are used to keep odd-size prints in place.

Replenishment. Since only 2–3 oz. (59.2–88.8 ml) of chemistry are used in a drum with most processes, the chemicals are completely depleted after one use and can be discarded.

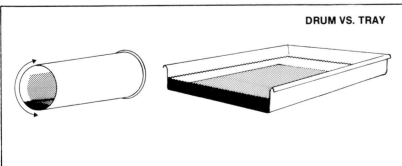

DRUM VS. TRAY Color prints can be processed either in drums or in trays, but drums have some distinct advantages. Because the drum rolls the print through a small pool of chemistry, the drum requires a much smaller volume of chemistry than the tray. For example, a drum requires only 2½–3 oz. (60–89 ml) of chemistry to process an 8"x10" (20x25 cm) print whereas a tray requires 32 oz. (.9 l). In addition, you can keep the lights on while using the drum, except when loading it. With trays, you must work in total darkness until the entire process is nearly complete.

HOW TO USE THE DRUM

Load the drum so that the emulsion side of the paper faces the drum's center. If the drum you are using contains adjustable ribs to accommodate different paper sizes, be sure the paper fits between the ribs securely.

Premeasure the correct amount of chemistry for the paper size you are using, then pour the liquid rapidly into the drum's opening. Begin agitating immediately so that the chemistry does not "pool" on one section of the print. (The particular drum shown above is designed so that "pooling" cannot occur.)

Drain the contents of the drum quickly, making certain no residual liquid remains to dilute the next chemical.

When using a drum you can obtain excellent results with minimum difficulty, as long as you observe some basic rules carefully. A complete trial run-through using water instead of chemicals will familiarize you with procedures in a non-critical atmosphere. Once you begin processing a real print, you cannot stop to read directions without ruining your print.

CLEANLINESS

Chemicals are easily contaminated. To keep pure the chemicals that come in contact with your prints, wash your processing drum thoroughly with warm or hot water after each use, and then dry the drum completely. Careful drying will prevent droplets of water from streaking a print between the time the paper is loaded and the time agitation begins.

LOADING

The emulsion side of the printing paper must always face the center of the drum, *not* the drum wall. If you are loading more than one print in a drum, be especially careful not to let the prints overlap, or else areas of incomplete development will result. After loading the drum, be certain that its end caps are on tightly enough to prevent light leakage. On drums that use pins and grooves to guide alignment of the end caps, make sure the pins are properly engaged in the grooves.

AGITATION

If you are agitating manually, roll the drum back and forth with a constant, steady motion as in the photo sequence at right. Do not let the drum stop rolling for longer than an instant when changing direction, or your print will show the effects of uneven development. Start timing as soon as the drum begins its first roll, and continue steady agitation until it is time to start pouring out the drum's contents.

Agitate the contents of a processing drum by rolling it back and forth with a slow, rhythmic motion. Each backward or forward motion constitutes one complete revolution of the print.

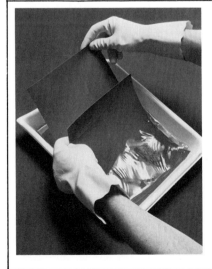

Processing Color Prints in Trays

You can process more than one print at a time in a tray of color chemistry; however, during each processing step you will have to move the bottom print to the top every few seconds to ensure that each print continually receives fresh chemistry and proper agitation. Since you must perform this exchange procedure in total darkness, you will have to set up each tray beforehand or the process will not flow smoothly. Be sure to wear rubber gloves to protect your hands, and be careful when handling prints not to damage the emulsions, which are soft when wet and easily scratched or torn.

COLOR PRINTS FROM NEGATIVES
Kodak Ektaprint 2

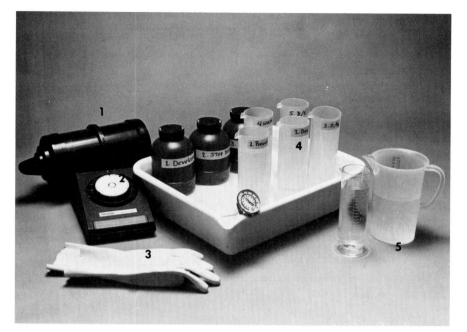

SETUP FOR KODAK EKTAPRINT 2

1. **Processing drum**
2. **Timer**
3. **Rubber gloves**
4. **Chemistry in a temperature-controlled water bath**
5. **Containers of hot and cold water for controlling the water-bath temperature**

Kodak Ektaprint 2 processing kit

Use. Kodak Ektaprint 2 chemistry is used for processing Kodak Ektacolor 74 RC and 78 RC papers.

Capacities. 1 gallon size. 1 quart (.94 l) develops twelve 8"x10" prints.

Shelf life. Once mixed, 6-8 weeks in full, stoppered bottles.

Processing temperatures. You will obtain the highest quality prints possible if you process at 91 ± ½ F (32.8 ± 0.33C), but by increasing developing and bleach-fixing times, you can process at temperatures as low as 68F (20C).

Processing times. Total processing time requires 7½ minutes at 91 F and 27 minutes at 68 F. (See chart on next page.)

Depletion compensation. Ektaprint 2 chemicals should be discarded after one use.

Prewetting. For drum processing there is an additional prewet step to prevent the developer from causing streaks on the paper.

Mixing chemicals. Because of the prewet step, chemical concentrations for drum processing must be stronger than for tray processing. Be sure to follow the mixing instructions for "tube processing" packed with the chemicals. You can make your own stop bath solution by adding 48 ml of 28% acetic acid to 1 liter of water. (To make 28% acetic acid, add three parts of glacial acetic acid to eight parts water.) *Caution:* Always add acid to water, not water to acid.

Advantages. Ektaprint 2 chemicals are specifically designed for use with Kodak papers and will yield higher quality results than products developed by other manufacturers.

PROCESSING SUMMARY FOR EKTAPRINT 2

Step	Temp F	Temp C	Time (min.)	Amt. of Soln. for 8x10 print ml.	Amt. of Soln. for 8x10 print ozs.
1. Prewet	91	33	½	500*	17.5
2. Develop	"	"	3½*	70	2.4
3. Stop Bath	"	"	½	50	1.75
4. Bleach-Fix	"	"	1*	50	1.75
5. Wash	"	"	2**	500	17.5
6. Dry	not over 225°	107°			
Total Time			8 min.		

*If the drum does not hold 500ml, then fill to capacity.

**Transfer print to a tray, then drain and fill four times, agitating 30 seconds each time for 2 minutes.

COLOR PRINTS FROM NEGATIVES
Unicolor: Total Color

Unicolor Total (Printing)

Step	Temperature*		Time*
	F	C	
1. Water prewet	100	38	1 min.
2. Developer	80	27	4 min.
3. Stop bath	80	27	15-30 sec.
4. Blix	80	27	2 min.
5. Water rinse	80	27	2 min.
6. Stabilizer**	80	27	½-1 min.

*Time and temperature are determined from a nomograph supplied in the instructions.

**Stabilizer should be used in a tray after the print has been removed from the drum.

Unicolor Totalcolor 1 and 2 for processing color negatives and prints using the same chemistry for each

ALTERNATIVE COLOR-PRINT PROCESSES UNICOLOR TOTAL COLOR

Use. This product is for processing color negatives and, after remixing, to process color prints on any resin-coated paper (Kodak 74RC and 78RC, Beseler RC, Unicolor RB, etc.).

Capacities. 48 oz. (1.4 l) of print chemistry will drum process twenty-four 8" x 10" prints.

Shelf life. 24 months for unused concentrates in tightly capped air-free containers.

Processing temperatures. 120–70F (49–21C).

Processing times. 6½ minutes at 120F, to 15½ minutes at 70F.

Depletion compensation. Chemistry used for processing prints cannot be replenished, nor can it be used to process film.

Prewetting. A 1-minute prewetting step is mandatory. The temperature of the prewet water affects development time (see chart).

Mixing chemicals. Unicolor chemicals require only dilution, not mixing (which is why their shelf lifes are so long).

Advantages. Unicolor Total Color is especially well suited for the occasional processing of small batches of prints. It is economical because the same chemistry can be used to process the film and then to make the prints, and it can be used in small quanities due to a long shelf life.

ALTERNATIVE COLOR PRINT PROCESSES BESELER 2-STEP

Use. Beseler 2-Step chemistry is used for processing Kodak 74RC, Kodak 78RC, Beseler, and other type "A" papers.

Capacities. one quart size: 10 8" x 10" prints; one gallon size: 42 8" x 10" prints; 3½ gallon size: 149 8" x 10" prints. Above capacities can be increased by making multiple prints within a short period of time.

Shelf-life. Once mixed, 8-10 weeks in tightly-capped bottles.

Processing Temperatures. 107F (42C) to 66F (19C)

Processing Times. Total processing time requires 2 minutes at 107F (42C) and 13 minutes at 66F (19C).

Depletion compensation. Chemistry can be used as many as four times within a few hours. After each 8" x 10" print add ½ oz of fresh chemistry for replenishment and increase development time by 10%.

Prewetting. A prewetting step is optional, but recommended.

Advantages. Beseler Type A chemistry requires only two steps and is the easiest process available with a wide time and temperature latitude.

Beseler 2-Step Processing

Temperature F	C	Step 1 Developer	Step 2 Bleach-Fix	Wash*
107	42	1	1	
101	38	1½	1	
96	36	2	1	
92	33	2½	1	
89	32	3	1½	
86	30	3½	1½	2½
83	28	4	1½	
81	27	4½	2	
79	26	5	2	
77	25	5½	2	
72	24	6	2½	5
70	22	7	2½	

*Washing is done in a tray with running water.

Beseler two-step chemistry for processing color prints from negatives.

COLOR PRINTS FROM SLIDES
Kodak Ektaprint R-1000

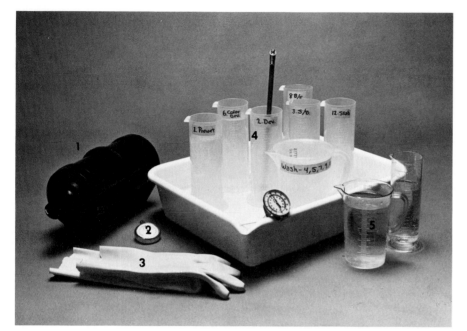

**SETUP FOR KODAK
EKTAPRINT R-1000**

1. **Processing drum**
2. **Timer**
3. **Rubber gloves**
4. **Chemistry in a temperature-controlled
 water bath**
5. **Containers of hot and cold water for con-
 trolling the water-bath temperature.**

Kodak Ektaprint R-1000 processing kit

KODAK R-1000

Use. Kodak R-1000 chemistry is used for processing Kodak 2203 paper for prints made directly from color transparencies (slides).

Capacity. 1 quart develops 13 8"x10" prints.

Shelf life. After mixing, 4–8 weeks in full, stoppered bottles, 2–4 weeks in partially filled bottles.

Processing temperature. 100F (38C). The starting temperature of chemicals can be raised to produce an average processing temperature of 100F, but a constant-temperature water bath gives the best results.

Processing time. 13¼ minutes.

Depletion compensation. R-1000 chemicals should be discarded after one use.

Prewetting. For drum processing there is an additional prewet step to prevent the developer from causing streaks on the paper.

Kodak 2203 paper. The paper used with R-1000 processing requires careful handling. Exposure must take place in total darkness because the paper is sensitive to all wavelengths of light. If you have no basis for selecting a beginning filtration, try 20 Cyan and 20 Magenta if your slide was taken on Kodachrome, 30 Cyan and 20 Magenta for Ektachrome. Due to the potential effects of reciprocity failure, if at all possible keep exposure time to 10 seconds or less. Processing should take place no more than 8 hours after exposure.

Alternative processing temperatures and times. Instructions packaged with R-1000 chemicals provide information on processing at temperatures as low as 70F (21C). At the lower temperatures, processing time must be increased; at 70F (21C), the total processing time becomes 31¼ minutes instead of 13¼ minutes.

Kodak Ektaprint R-1000

**Steps for tube processing of Kodak Ektachrome 2203 paper
using Kodak Ektaprint R-1000 chemicals.**

| Step | Temperature | | Time* min. | Amount of solution per 8x10 print |
	F	C		
1. Prewet	100	38	1	150 ml. (5 oz)
2. First Developer	"	"	2	70 ml (2.4 oz)
3. Stop Bath	"	"	½	70 ml (2.4 oz)
4. Wash	"	"	1	150 ml (5 oz)
5. Wash	"	"	1	150 ml (5 oz)
6. Color Developer	"	"	2	70 ml (2.4 oz)
7. Wash	"	"	½	150 ml (5 oz)
8. Bleach / Fix	"	"	3	70 ml (2.4 oz)
9. Wash	"	"	½	150 ml (5 oz)
10. Wash	"	"	½	150 ml (5 oz)
11. Wash	"	"	½	150 ml (5 oz)
12. Stabilizer	"	"	½	70 ml (2.4 oz)
13. Rinse (Water)	"	"	¼	150 ml (5 oz)

*These times include a 10 second drain time or the drain time you have determined for your tube processor.

R-1000 processing steps. If you have processed color prints previously, the information summarized in the chart on the next page will be sufficient for you to successfully process a color print using R-1000 chemicals. If you have never before processed a color print, study the step-by-step instructions for the Cibachrome process in the next section. R-1000 and Cibachrome differ in specifics, but not in skills required. Once you think you understand how each step in color processing is performed, verify your understanding by making a trial run following R-1000 instructions but without using paper, and using plain water instead of chemicals.

COLOR PRINTS FROM SLIDES
Cibachrome

Processing a color print requires that you combine elements of preparation, organization, precision, and attention to detail if you are to achieve quality results with consistency. Different processes call for different procedures, but there are enough similarities among the processes that if you can perform one process with proficiency, you will easily be able to transfer the skills from that process to another.

In this section, the Cibachrome process for making prints from slides is described in detail, step by step. The Cibachrome process has been chosen as an example for a variety of reasons: it is representative of other processes, produces very high quality prints, involves only three chemicals, has a wide tolerance for temperature deviations, and is simple to execute properly. In short, it is an excellent process to learn if you have never before printed in color.

Moreover, Cibachrome manufactures a Discovery Kit that includes processing chemistry, 4" x 5" paper, and a 4" x 5" processing drum. If you decide after purchasing a Discovery Kit that you do not want to continue processing in color, you will not have invested an unreasonable amount of money in chemicals and equipment, and if you find that you want to pursue color processing beyond your first experience, the 4" x 5" drum will always be useful for making test prints.

Two additional washing steps are included in the step-by-step instructions presented below. The steps take little extra time but are well worth the effort. Once you can consistently obtain good results, you may try eliminating the extra washes to see if your results are affected.

Use. Cibachrome chemistry is used for processing prints made from slides, on Cibachrome liter symbol paper.

Capacity. 1 quart (.94 l) develops ten 8" x 10" prints.

Shelf life. After mixing: developer, 3 weeks; bleach, 5 weeks; fixer, 1 year.

Processing temperatures. 82–68F (28–20C). Recommended: 75F ± 3F (24C ± 1½C).

Processing times. 10 minutes at 82F (28C); 12 minutes at 75F (24C); 14 minutes at 68F (20C).

Depletion compensation. Cibachrome chemicals should be discarded after one use; however, used bleach must first be neutralized by means of a powder provided in the kit.

Prewetting. None required.

Mixing chemicals. You can mix Cibachrome chemistry in quantities sufficient for a single 8" x 10" print, for ten 8" x 10" prints, or for twenty 8" x 10" prints. Bleach and fixer can be mixed in 1-quart (.94 l) and ½-gallon (1.9 l) quantities.

Advantages. Cibachrome prints produce sharp images with deep color saturation. Processing time is moderate, and tolerance of temperature variations during processing (± 3F) is excellent.

Disadvantages. Cibachrome prints cost more to produce than Kodak prints. Also, some people criticize Cibachrome prints for having too much contrast, but in most prints the increased contrast is not noticeable. In the cases where contrast is a problem, it can be reduced by either shortening development time by 30 seconds or switching to a "softer" developer such as Kodak Selectol and then experimenting to find the best development time and filtration.

Cibachrome paper. Unlike Kodak papers, Cibachrome paper contains color dyes, which is why black-and-white developers such as Kodak Selectol will work on it. Ci-

Cibachrome

Step	Temperature	Time
1. Developer		2 min.
2. Rinse		10 sec.
3. Bleach*	75F ± 3 (24C ± 16)	4 min.
4. Rinse		10 sec.
5. Fixer		3 min.
6. Wash**		3 min.

*Neutralize used bleach in a bucket, as per the manufacturer's instructions

**The print is carefully removed from the drum and washed under running water in a tray. Do not wash the print in the drum.

bachrome paper is subject to reciprocity failure in exposures longer than 10 seconds, so it is especially important to maintain a standard exposure time and adjust exposure by means of lens opening. If necessary, exposed paper can be held for a few days before processing. Because the paper's emulsion layers are extremely soft and easily damaged when wet, handle wet prints with extreme care. Also, keep in mind that wet prints have a reddish cast until completely dry. Note that Cibachrome paper must be exposed in total darkness.

Draining. As with most processes, the final drain time in the Cibachrome procedure is included in the agitation time. Determine the particular drain time for your drum, then start pouring out its contents that many seconds before the designated agitation time expires. (10–15 seconds drain time is typical, 10 seconds is used here for illustration purposes). To avoid contamination or dilution of subsequent chemicals, be certain to allow sufficient time to drain the drum thoroughly.

Temperature. If the temperature at which you are processing exceeds room temperature, you will need to place all chemicals and wash waters in a temperature-adjusted water bath. In addition, you must control the temperature of chemicals within the processing drum. If your drum is watertight, you can maintain temperature by performing the agitation steps in a water bath. Otherwise, you will have to make certain the *average* temperature of the chemicals in the drum equals the recommended temperature. You can do this by starting with chemicals a few degrees too *warm* so that when the agitation time is over, their temperature will have become a few degrees too *cool*. You can experiment with 2–3 oz of water in an empty drum to find the best starting temperature, or consult the chart on this page.

Organization. Regardless of the process you choose, the care with which you organize your materials can affect the quality of your results. Before you begin, make certain all equipment is at hand and all chemicals are at the proper temperature. Place your chemical bottles in the order you will need them, and have sufficient water ready for the washes required by the process. Have a bag of ice or a supply of hot water nearby if you will need to precisely control processing temperatures. And do not forget to wear rubber gloves to prevent chemical burns.

CIBACHROME
Step-by-step

CIBACHROME, STEP BY STEP

Detailed instructions for processing Cibachrome color printing paper are illustrated on this and the following three pages. Be sure to read pp. 128–129 before starting. Many of the procedures shown here (for example, agitation) are applicable to drum processing in general, regardless of the specific chemistry being used.

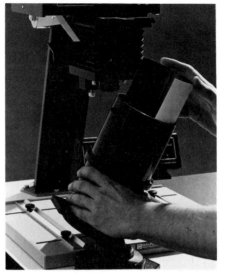

1. *Load paper in drum*, emulsion side *in*.
2. *Cap drum ends.*
3. *Turn on lights.*

4. *Pour neutralizer powder into waste bucket.*

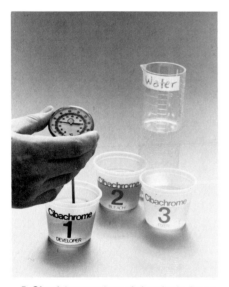

5. *Check temperature of chemicals.* Place in a water bath, if necessary.

6. *Set timer* for 2 minutes.

7. *Pour developer into drum.*
8. *Start agitation. Start timer.*

9. **Agitate** one complete back-and-forth revolution per second for 15 seconds (must be done manually even if a motorized base is available).

10. **Agitate continuously thereafter** on a motorized base, or manually at the rate of 40 complete back-and-forth revolutions per minute.

11. **Drain drum**, pouring out the developer *starting 10 seconds* before the developing time expires.

12. **Pour wash water into drum.**
13. **Agitate** for 10 seconds.

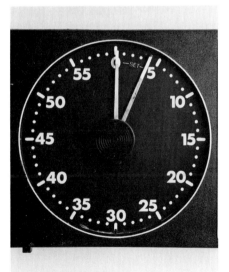

14. **Drain drum thoroughly.**

15. **Set timer** for 4 minutes.

16. **Pour bleach into drum.**

CIBACHROME (Continued)
Step-by-step

17. *Start agitation. Start timer.*

18. *Agitate* one complete back-and-forth revolution per second for 15 seconds (must be done manually even if a motorized base is available).

19. *Agitate continuously thereafter* on a motorized base, or manually at the rate of 40 back-and-forth revolutions per minute.

20. *Drain drum* into a bucket containing the neutralizer, starting 10 seconds before the bleaching time expires.

21. *Pour wash water into drum.*

22. *Agitate* for 10 seconds.

23. *Drain drum thoroughly.*

24. *Set timer* for 3 minutes.

25. *Pour fixer into drum.*

26. *Start agitation. Start timer.*

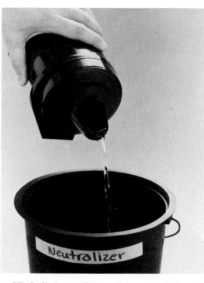

27. *Agitate continuously* on a motorized base or manually at the rate of 40 back-and-forth revolutions per minute.

28. *Drain drum,* pouring out the fixer starting 10 seconds before the developing time expires.

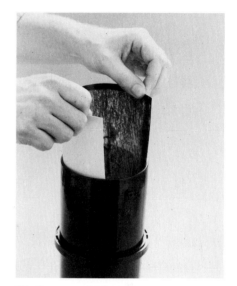

29. *Remove print from drum.*

30. *Wash print in tray* for at least 3 minutes in running water.

31. *Remove print from tray.*

32. *Place print on towel* or another soft, absorbent surface.

33. *Squeegee front and back surfaces* (optional).

34. *Dry prints* by either using a drying rack, hanging them, or blowing them with a hair dryer.

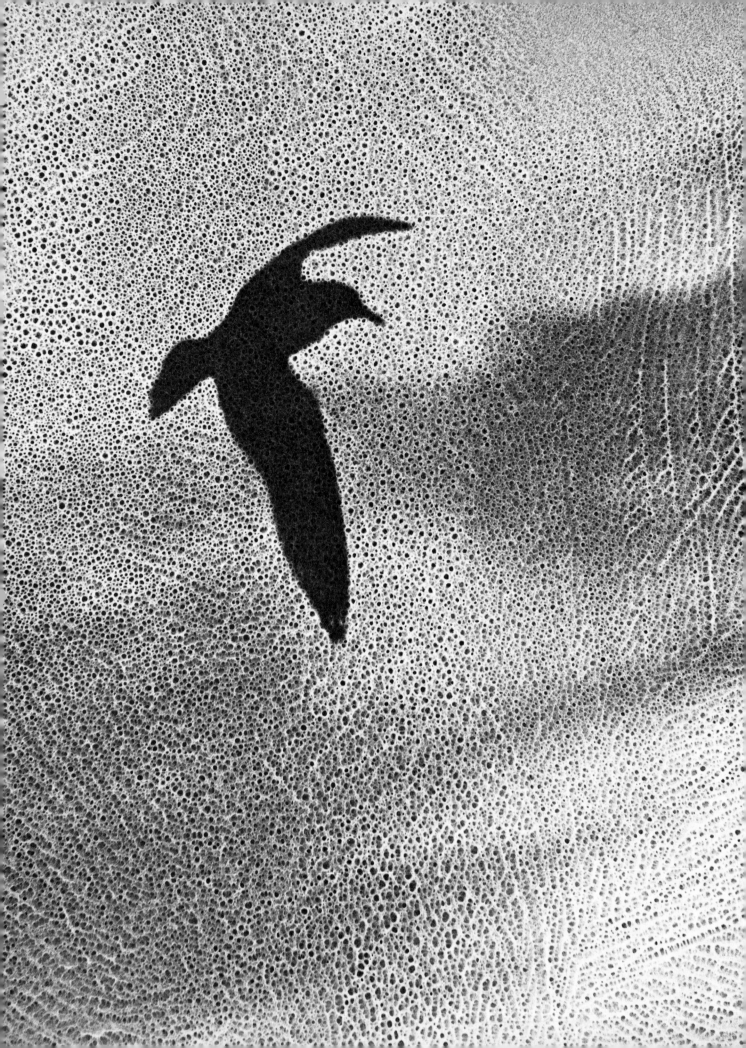

7. SPECIAL TECHNIQUES

This photograph was made from a 35mm negative that was reticulated during processing and then, after processing, was frozen while still wet. Manipulative procedures such as this should be tried only on copy negatives, since the results are both unpredictable and permanent.

As we have already stressed, your first priority should be to master the fundamentals of darkroom processing until they become second nature to you. However, after you have confidence in your mastery of the basics, you may want to try your hand at some of the advanced techniques of printing, and thereby experience what many photographers consider to be the chief attractions and benefits of do-it-yourself processing.

Many of the techniques described in this chapter involve substantial alteration to create the way an image ultimately appears. Although it is true that what looks horrible to one person may seem perfectly acceptable to another, it is also true that few things are more jarring than a photo on which an inappropriate manipulative technique has been used. Therefore, to avoid wasting your time and money on results that might appear gimmicky, you should usually employ a specific technique only when you have a clear aesthetic reason for using it, and you know what the effect will be ahead of time. By having a clearly defined *aesthetic intent* when you use a special technique, its effects are more likely to appear in harmony with the original image.

Some of the techniques described here involve altering the original negative or slide. In order to prevent alterations from becoming permanent, you may want to perform them on *duplicate* negatives and slides, as explained on the following pages. By making duplicates you will always have an intact original image to which you can return if, despite your careful planning, something goes awry, or if you find that the effect you have produced is not as pleasing as you had anticipated. If you exercise care in making the duplicates, their quality will be only slightly diminished from that of the their originals. In addition, the very process of duplication introduces opportunities for manipulation which can be effective in their own right.

COPYING EQUIPMENT

To make high-quality copies you need three elements: a source of even illumination, a method of producing an image on film at least as large as the slides or negatives being duplicated, and a lens which will not produce distortion at magnifications of 1:1 or greater.

The *light source* can be daylight, a tungsten lamp, or an electronic flash unit. The light can be made smooth by reflecting it off a white surface or by passing it through frosted acetate or glass.

Sufficient *magnification* can be produced by using lens-extension tubes, a bellows extender, or a macro lens. (Supplementary close-up lenses, which attach like a filter, introduce too much distortion to be useful.)

A *high-quality image* can be produced by using an enlarger lens, since the way enlarger lenses are designed minimizes image distortion when used for close-up photography. "Normal" lenses, that is, lenses with a focal length approximately equal to the diagonal of the film size (50mm with 35mm film) can also be used. If you use a normal lens, it should be reversed by means of a reversing ring when the distance between the item being copied and the front of the lens is less than the distance between the rear of the lens and the film.

Homemade systems. As long as you use a camera and lens of good quality and take care to align all elements precisely, you will be able to make excellent copies with an improvised homemade system. The most basic setup consists of a tripod-mounted camera fitted with a bellows extender or macro lens that is capable of delivering a subject-image enlargement ratio of at least 1:1. In such a system, you place the slide or negative to be copied on a sheet of white cardboard which is placed below the setup. If you ex-

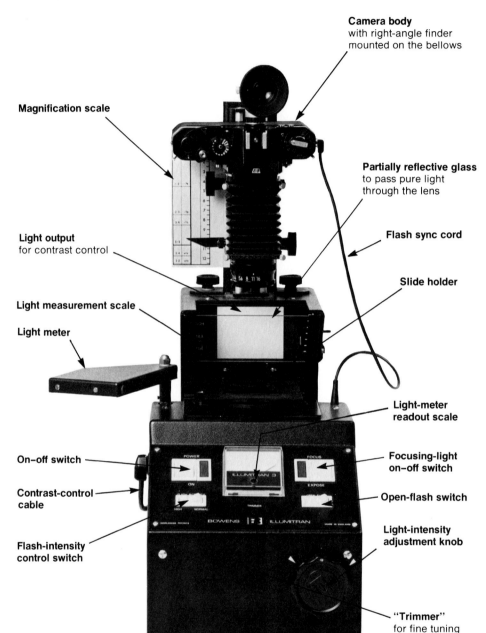

Camera body
with right-angle finder mounted on the bellows

Magnification scale

Partially reflective glass
to pass pure light through the lens

Flash sync cord

Light output
for contrast control

Slide holder

Light measurement scale

Light meter

Light-meter readout scale

On–off switch

Focusing-light on–off switch

Contrast-control cable

Open-flash switch

Flash-intensity control switch

Light-intensity adjustment knob

"Trimmer"
for fine tuning meter scale

THE BOWENS ILLUMITRAN

The Bowens Illumitran is one of the most sophisticated devices available for copying slides by flash illumination. The Illumitran incorporates an ingenious device that helps to lower contrast by diverting light around the slide and up into the camera lens.

pect to make many copies, you can build a more permanent device by constructing a small wooden box with a frosted acetate top, such as the one shown at right. In one side of the box, cut an opening in which a flash unit will fit; then mount a piece of white cardboard inside the box at a 45° angle so that the cardboard reflects the light coming through the opening up toward the top of the box. Finally, install a small tungsten lamp inside the box to provide enough light for focusing. You will need to ascertain the best exposure by experimentation, but once determined, the exposure usually remains relatively constant. If you want to, you can place filters under the slide or negative being copied to adjust color or produce special effects.

Spiratone dupliscope. The Spiratone company sells a self-contained unit consisting of a tube with its own optical elements, which you mount on your camera in place of a standard lens. You place your slide or negative in one end of the tube and any desired color-correction or special effects filters in the other. (Some models permit cropping.) If your camera has through-the-lens metering, and you use daylight or tungsten illumination, exposure determinations are simple. Otherwise, you must experiment or bracket your shots to be certain to achieve a correct exposure.

Bowens Illumitran. One of the most advanced devices available for duplicating slides and negatives is the Illumitran made by Bowens. This expensive piece of equipment contains its own built-in flash system and employs a very sophisticated method for controlling copy contrast (see p. 136). The illumitran is fitted with a bellows extender to allow great cropping versatility, and a filter drawer to make color correction and special effects possible.

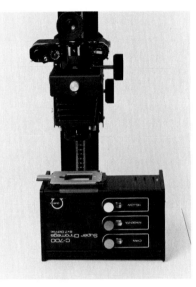

However, you must add your own camera body and lens to the basic unit.

Omega copy attachment. For use with its dichroic enlarger head, Omega makes an attachment that allows you to mount a camera body where the enlarger head usually sits and thereby convert the head into a copying light source (see photo). Because the head contains built-in dichroic filters, color correction is simple. Moreover, cropping is easy. If you already own an Omega enlarger, this attachment provides you with an inexpensive means for producing excellent duplicates.

AUXILIARY COPYING DEVICE

Although copying devices like the one at right are inexpensive to buy and easy to use with either daylight or tungsten illumination, the optics these devices contain are usually inferior to a regular camera or enlarger lens used on a bellows.

OMEGA SLIDE-COPY ENLARGER ATTACHMENT

A simple accessory manufactured by Omega converts their C-700 dichroic enlarger head into a convenient, color-correcting slide copier.

To use the attachment, you remove the enlarger head, lay it upside down on the enlarger baseboard, and install the accessory where the head usually sits. The accessory then permits you to mount your camera body, as shown above, and photograph a negative or slide placed on the enlarger head. This setup produces excellent results when used with Kodak 35mm Ektachrome Duplicating Film 5071.

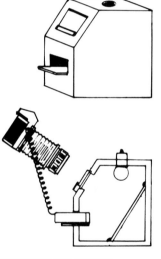

HOMEMADE SLIDE COPIER
You can construct your own slide copier by mounting a flash, a viewing bulb, and a white reflective surface inside a box. The opening for the slide should be covered with a small square of frosted acrylic plastic.

137

MAKING COPIES

Each time you make a copy you will find that the dark tones become darker and the light tones become lighter. For the most part, the usefulness of a film or item of equipment for copying relates directly to its ability to minimize the increase in contrast, or to compensate for it. Another potential problem is an unwanted increase in film grain size. Recently, color duplicating films have been improved to the point where they produce only extremely small increases in contrast and no noticeable increase in grain size. Duplicating films are sold in 35mm rolls (designated Ektachrome 5071 for tungsten light and SO-366 for flash) and in sheets (designated Ektachrome 6121).

If your light source is sunlight or a strobe, you have little choice other than to use Kodachrome 25 if you want to obtain as exact a duplicate as possible. The grain of Kodachrome 25 has such excellent resolution that using it for making copies introduces no grain-related problems, but contrast does become significantly greater. To camouflage the increase in contrast, Kodachrome 25 can be "flashed" with a burst of white light. The flash, which must be carefully controlled to prevent the entire frame from becoming overexposed, compensates for the additional contrast by lightening the dark tones on the film. Flashing does nothing to replace lost detail in the shadow and highlight areas of the image, but it does make dark areas appear lighter. An important attribute of the Bowens Illumitran is that it contains a device that controls flashing quite accurately.

Another way to control contrast with Kodachrome 25 is to have a special "contrast-control mask" prepared by a commercial lab; however, such masks are very expensive.

With black-and-white film, you can minimize contrast increase by underdeveloping. The amount to underdevelop varies according to the copy technique, but try reducing development time by 20% at first. If contrast remains high, underdevelop your next roll of film even more. If your negatives begin to appear too weak, however, you must slightly increase development time again.

COLOR FILTRATION

Any time you copy a color slide or negative onto color film, you will be faced with color-filtration considerations similar to those you must face when making color prints. Specifically, you must use filters to balance the color of your light source with the characteristics of your batch of film. Since each time you change to a new emulsion batch you must determine another filtration, you should set aside as many rolls of film from a single emulsion batch as you think you will use before the film's expiration date. Then perform a filtration test as follows:

1. Select a slide or negative showing a range of colors and some flesh tones.
2. Determine the filtration to use by consulting the instructions packaged with the film.
3. Place the suggested filters between your light source and the slide or negative to be copied.
4. Copy the original onto the test film.
5. Process the test film normally.
6. Use the techniques described in Chapter Six to determine which filters you will need to add or subtract to achieve a correct color balance. (If you are copying a negative onto duplicating film, or a slide onto negative film, you will need to make a print be-

fore you can evaluate the filtration.)

4" x 5" FILM

You can avoid the problem of needing special duplicating equipment by enlarging your slide or negative onto 4" x 5" duplicating film. The technique involves placing the original in your enlarger and projecting it onto the easel. After adjusting image size and focusing, you turn off the enlarger lamp, take out a sheet of 4" x 5" duplicating film, place it in the easel just as you would a sheet of printing paper, expose the film, and then process it. This technique will provide you with excellent duplicates, but, of course, your enlarger head must be able to accommodate 4" x 5" film if you are to print from the duplicate, and you must have a 4" x 5" sheet-film developing tank if you want to process the film yourself.

EXPOSURE

The same exposure principles that apply to macrophotography apply to slide and negative copying. Through-the-lens metered cameras make exposure determinations with daylight or tungsten bulbs easy, whereas other types of cameras and light sources require either exposure calculations or a series of test exposures. Once you have determined the best exposure for your particular setup, however, you will find that the exposure remains fairly constant unless you change the enlargement size substantially.

FILM

Because Kodak Ektachrome duplicating film produces an exact positive copy of the original, rather than a negative copy, duplicating in color requires only a single copy generation. To reproduce black-

and-white negatives, however, you must produce *two* generations: a copy and then a copy of the copy in order to obtain another negative, or you can special order Kodak Professional Direct Duplicating Film SO-015 (sheet film) for one-step duplicating. Sometimes you may prefer to make a black-and-white print from the negative, then photograph the print as a means of producing a copy.

SLIDE SANDWICH

Often a dull slide can be "sandwiched" with another slide and a duplicate can be made of the combination. The duplicate then becomes the "original" for the purpose of making prints. Because the degree of enlargement required for slide copying results in very shallow depths-of-field, you must remove the mounts from the slides in-

volved in the sandwich and place the slides in contact with each other. Otherwise, the distance between the film surfaces caused by the thickness of the slide mounts may cause one image or the other to be out of focus in the copy.

SLIDE SANDWICH

The photo above of a plane flying across the sun is actually a black-and-white copy of a "sandwich" made from the two slides shown below. The two slides were removed from their mounts, cleaned thoroughly, mounted together, and copied onto Kodachrome film using the Bowens Illumitran. The image of the plane was so dark when placed over the sun photo that a compensation of three f-stops was needed to achieve an acceptable exposure.

HIGH CONTRAST PRINTING

PRODUCING HIGH CONTRAST

If an image you have on film has distinct lines that you would like to emphasize, you can eliminate all gray tones from your final print by either transferring the image to special high-contrast films or making a series of contact prints on very thin paper.

High-contrast film. Kodalith Ortho #2556, type 3 film, intended for use by graphic artists and printers, is the film most commonly used for producing extremely high contrast. Kodalith film is sold in 100-foot 35mm rolls or in sheet-film sizes. (4″ x 5″ film is easier to work with and retouch than 35mm film, so if your enlarger can accommodate the larger size, by all means use it.)

Kodalith film produces a negative image; therefore, if you are starting from a negative, you will need a second copy generation to obtain an image from which you can make a positive print. If you are starting from a slide, you can use the first-generation copy to make a print on negative paper. Also, if the first-generation copy does not eliminate all grays, you will need to make additional generations.

Kodalith film is orthochromatic—not sensitive to red light—so you can work with it under a #1A safelight. Be careful when copying color transparencies onto Kodalith, however, because red areas on the original will appear black on the copy.

Retouching. You can eliminate blemishes and unwanted detail by drawing directly on the duplicating film in one of the copy generations. You can use waterproof ink or a felt-tip pen. Any marks you make will appear white in the next generation.

Choosing an image. Since you will be reducing the original image to pure black and white, try starting with an image that already shows good contrast. Areas of white or light gray will totally disappear, and areas of medium or dark gray will become completely black. Some manipulation in the form of retouching may be necessary to restore lost details.

Developing. You must decide on the development process you are going to use *before* you expose Kodalith film, since your decision determines the film's ASA. You might try using ASA 8 with processing in Kodalith Developer (2¾ minutes at 68F (20C) or ASA 25 with processing in Kodak D-11 (2½ minutes at 68F). See the processing instructions packaged with the film for more specific details.

Paper contact method. If you place a developed print on top of an unexposed sheet of printing paper and expose the combination to light, you will produce a high-contrast contact print of the original image on the second sheet after it is processed. Since the new image will be a negative of the original image, you must repeat the process to obtain a positive image. Because the light must pass through the paper on which the original is printed, exposure will be relatively long and must be determined by experimentation. You can draw directly on any of the print generations and can add or subtract detail by over- or underexposing the print.

CONVERTING TO HIGH CONTRAST

Three generations of Kodalith copies were needed to transform the barn photo above into the high-contrast image at left. First, the negative was enlarged onto 4″x5″ (10x13 cm) Kodalith film. Next, after processing and spotting with a felt-tip pen, the positive Kodalith image was contact printed with another sheet of Kodalith film which yielded a new, high-contrast negative. Finally, the second negative was enlarged onto paper to produce the photo above.

Note how the very contrasty light in the original scene produced sharp shadows which converted effectively into a line image. The same scene photographed on an overcast day might not produce enough detail in the barn wood or the tall grass to form the basis for a high-contrast print.

DEVELOPING TIMES FOR KODALITH

Developer	ASA (Tungsten)	Developing time at 68F (20C)	Agitation
Kodalith A + B	8	2¼–3¼ min.	Constant
D-11	25	2–3 min.	Constant

MULTIPLE PRINTING

MULTIPLE PRINTING

Occasionally you may find yourself confronted by a negative or slide that alone is dull, but which, if printed together with another negative or slide, would be much more interesting. Although the technique for printing two or more negatives or slides onto one sheet of paper is an exacting task, the results are often well worth the effort.

Sandwiching negatives or slides. The easiest way to make a multiple print is to sandwich two negatives or two slides, one on top of the other, before placing them in the enlarger's negative carrier. Sandwiching will not be successful with any two images chosen at random, however. For example, detail in the light area of one scene will not show up if that area is sandwiched against a black or very dark area in the other scene. The technique works best where one of the components of the sandwich is primarily translucent except for the areas that correspond to the lighter areas of the other component.

Note that often the sandwich requires a longer exposure time than either of the images it contains.

Successive exposures. A more versatile and more difficult method for printing from multiple negatives or slides involves printing first from one image and then from another. By carefully blocking light from some sections of the paper while each exposure is being made, many of the limitations inherent in sandwiching can be overcome. Moreover, you can enlarge two or more images to different sizes in successive exposures.

To produce a multiple print by making successive exposures:

1. Place a piece of white drawing paper cut to the same size as your printing paper in your enlarger's easel.

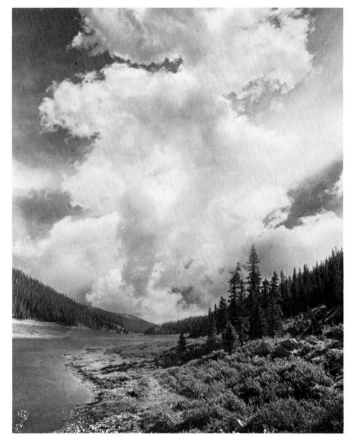

ADDING A DRAMATIC SKY

The inspiring photo above was made by combining the cloud photo below with the scenic Rocky Mountain photo next to it. Since exciting cloud formations are not always available on the spot to perk up an otherwise dull scene, you should collect good sky shots whenever you find them. By doing so you can later add dramatic skys to shots which alone would be lifeless and uninteresting.

2. Compose one of the images on the drawing paper exactly as you want it on the final print.
3. Sketch an outline of the major components of the image on the drawing paper.
4. Mark the position of the enlarger head on the enlarger column so you can return it to the same height later.
5. Replace the first negative or slide with the second.
6. Compose the second image so that it complements the composition of the first image.
7. Sketch an outline of the major components of the second image.
8. Using the sketch as a guide, prepare a mask out of black paper so that while the second image is being exposed, the area where the first image is to be printed will be covered. Then prepare another mask so that while the first image is being exposed, the area containing the second image will be covered.
9. In darkness or under a suitable safelight, insert a sheet of printing paper in the easel.
10. Expose the second image while holding the appropriate mask slightly above the paper and jiggling it constantly during the exposure (to prevent the edge of the mask from producing a hard line.)
11. Transfer the printing paper to a light-tight container. (Make a mental note of how the paper was oriented on the easel.)
12. Replace the second negative or slide with the first, adjust the height of the enlarger head, and compose as before.
13. Return the printing paper to the easel.
14. Expose the first image while holding the remaining mask slightly above the paper and jiggling it constantly during the exposure.
15. Process normally.
(In some instances you will be able to use your hands to cover the necessary areas instead of making paper masks.)

In all likelihood one of your primary goals when processing color or black-and-white film will be to

DOUBLE EXPOSURE

With careful preparation and planning, you can use double-exposure techniques to produce unusual—even surrealistic—effects. In the photo below, at left, a woman's torso has been superimposed across the sky to echo the outline of the mountains below her. Double exposures are difficult to execute effectively but, when successful, can be quite striking.

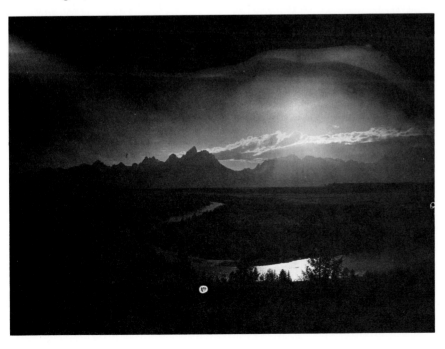

RETICULATION AND TEXTURE SCREENS

RETICULATED IMAGE

The interesting grain pattern in the above photo of a woman was achieved by reticulating a copy negative on Panatomic-X, a film not usually recommended for reticulation. The grain pattern is a little finer and more regulated than the pattern that would occur with faster films, but its overall effect enhances the softness suggested by the woman's expression.

produce as sharp an image as possible. Occasionally, however, you may wish to introduce some texture, either by inducing *reticulation* or by using a *texture screen*.

RETICULATION

If, instead of maintaining a constant temperature level during the development process, you alternately heat and cool the roll of film, a rhythmic pattern of grainy clumps will form across the surface of the film. These clumps lend the final print a "soft" look that can be quite pleasing. To be safe, you should attempt reticulation only on a duplicate negative, both because the results are somewhat unpredictable and because reticulated emulsions

are very soft and therefore easily damaged.

Black-and-white reticulation. To reticulate black-and-white film:
1. *Determine development time* for developing at 105F (41C) by consulting the film manufacturer's instructions.
2. *Develop film* at 105F for the appropriate time.
3. *Wash in ice water* for 30–60 seconds.
4. *Fix* film as usual at normal temperature in an *acid-hardening* fixer.
5. *Wash film* for 30 minutes in water at normal wash temperature, but do not use a wetting agent.
6. *Hang film* without removing excess water (to avoid damaging the emulsion).
7. *Blow dry* with a hair dryer (optional).

Black-and-white reticulation, alternative method. The primary drawback to the above technique is the very short development time required by the high development temperature. The following alternative method eliminates that problem.

1. *Develop film* normally, at normal temperature.
2. *Treat with an acetic-acid stop bath* for 60 seconds at 140°–150°F (60–66C).
3. *Wash film* immediately in ice water for 60 seconds.
4. *Fix film* as usual at normal temperature in an *acid-hardening* fixer.
5. *Wash film* for 30 minutes in water at normal wash temperature, but do *not* use a wetting agent.
6. *Hang film* without removing excess water, to avoid damaging emulsion.
7. *Blow dry* with a hair dryer (optional).

For a more dramatic and frostlike reticulation pattern, after processing and while the film is still wet,

place it in a freezer for approximately 15 minutes. Also, note that the faster the film you use (the higher its ASA), the greater the amount of reticulation that will occur because of thicker emulsions and larger grain structures.

Color reticulation. Reticulating color film requires only that you perform a few special steps before following normal processing procedures.

1. *Wash film* for 60 seconds in ice water. *Do not agitate.*
2. *Wash film* in water at the correct processing temperature to raise the film's temperature.
3. *Process film* normally.
4. *Hang film* to dry without removing excess water, to avoid damaging emulsion.

Color film can be frozen in the same manner as black-and-white film, but the results vary considerably according to the freezing time (which can be as short as 5 minutes).

TEXTURE SCREENS

While reticulation produces its effect by inducing unpredictable structural changes in a film emulsion, a similar effect can be produced photographically by sandwiching your slide or negative with a texture screen and copying or printing the two together. One advantage of screens over reticulation is that you can anticipate your results simply by placing the screen over the negative. Texture screens lend themselves equally well to color and black-and-white uses.

Commercial screens. You can purchase texture screens in a variety of patterns. Some patterns closely resemble reticulations, some produce an effect reminiscent of film grain, and some imitate fabric textures such as silk, tweed, canvas, or linen.

Improvised screens. You can make your own texture screens without too much difficulty. Start by photographing patterns you like: frost on a window, perhaps, or chipped paint or rippled water. After processing the film, you can either use the frame as is, or enhance its pattern by copying the image onto high-contrast film to eliminate any distracting gray tones. Sometimes the texture effect will be better if the pattern is sandwiched as a positive instead of as a negative. You will have to experiment.

To make a reticulated texture screen, photograph a neutral gray card and then reticulate the film. Because the reticulated emulsion will be fragile, copy the reticulated negative onto Kodak High Contrast Copy Film. This will also enhance the reticulation effect as well as increase the amount of contrast.

TEXTURE SCREENS

The fabric texture in the above photo was created by using a texture screen obtained from the kit shown below. Because a 35mm frame is so small, when it is used with a texture screen the texture may appear too prominent. You can minimize the texture effect by copying the 35mm frame onto a larger film size before adding the texture screen and making the final print.

8. DISPLAYING YOUR PHOTOS

Displaying photos involves much more than simply making them available for viewing. A wide variety of seemingly unimportant factors—the way a photo is mounted or framed, where it is hung, what surrounds it, and so on—actually has a significant impact on the way a photo is perceived.

The family pictures shown in the photo at left were carefully mounted and framed, then all were organized into a coherent grouping. Each photo tells its own story, and each photo also contributes to a collective story. By having been carefully planned and executed, the arrangement not only displays the photographs, it enhances them.

There is little point in spending many hours and much money to take and process photographs if you then banish them all to drawers. Outstanding photographs should be seen, appreciated, and even studied. Certainly not every photo deserves display, but some assuredly do.

The way you display your photographs involves both aesthetic and practical decisions. You want your photos to look their best, of course, but sometimes your choice of a mounting or framing technique may be dictated by a practical consideration, such as the fact that very large prints often cannot be mounted or framed using methods that work perfectly well with smaller prints. Similarly, if your primary goal is the long-term preservation of a print, you must reject many of the available mounting methods simply because the chemicals involved can help destroy the image.

Still, if you want to show off your photos to their best advantage even while keeping practical considerations in mind, one approach is to create a consistent style of presentation. For example, a display of a series of your photographs may lend itself well to having all the photos mounted under cardboard mats and then framed. As you become more and more experienced in preparing such mats and frames, your technique will become neater and more professional looking. Eventually, you will probably start composing and printing your photographs with your usual mounting or framing technique in mind. The ultimate result of such a consistent use of one perfected method will be photographs that have been executed in a manner appropriate to the way they are mounted or framed—and mounts or frames that are appropriate to the way the photographs have been executed.

No matter how you present your photographs, the amount of care you take in preparing them for display will influence the respect with which they will be regarded. If you mount or frame your photos thoughtlessly, and with more concern for money saved than aesthetics, then regardless of how good your photos are, viewers will unconsciously think less of them. Mount or frame your photos thoughtfully, carefully, and with proper attention to materials—and viewers will accord your work the respect it deserves.

Of course, for every print you decide to mount or frame, there are usually many more you choose not to display, as well as negatives and slides you decide not to print. If not discarded, these too must be cared for if they are to last. Store them improperly and they will quickly deteriorate; file them haphazardly and you will not be able to find them when you want them. In short, the photographic process is not complete until the fruits of your efforts have been either appropriately displayed or conscientiously stored.

TYPES OF FRAMES AND MOUNTS

FRAME/TYPES

1. Metal strip frame (unassembled)
2. Ready-made wooden strip frame
3. Clear plastic box frame
4. Ready-made metal strip frame
5. Clip frame

HANGING BORDERLESS PRINTS

Often, borderless prints look best if they are separated from the wall by means of wooden strips to give them the appearance of floating.

MOUNTS

The term *mount* indicates that a photo, rather than being framed, is attached to a firm surface, usually by means of an adhesive. "Flush," "box," and "wrap" mountings are all variations on a technique that entails affixing a print onto Masonite or stiff (double-ply) cardboard. All of these methods can be used with prints of any size but are especially effective with larger prints.

Flush mounting. With flush mounting, you trim the edges of your print so that they are even with the edges of the mounting board. You can darken the trimmed white edges of the print with an indelible marker if they are distracting. On the back of the mount you can attach wood strips which will serve both to hold the photo off the wall and to prevent warping.

Box mounting. With box mounting, you glue wood strips flush with the edges all around the back of a mounted print. The wood strips are usually painted flat black to make them less conspicuous. Box-mounted prints are easy to hang on a wall by means of a single nail.

Wrap mounting. With wrap mounting, you mount your print on a board slightly smaller than the print in order to permit you to wrap and glue the print's edges around the board's edges in a manner similar to wrapping a gift. Wrap mounting must be done very carefully to achieve a neat result.

Murals. Very large prints, mounted by means of one of the above techniques or glued directly onto a wall, are called *murals*. The chief problem murals pose is that any irregularities in the underlying surface or any lumps in the mounting adhesive become very noticeable. Executed with care, however, murals can present a striking appearance.

FRAMES

As mentioned earlier, the care you take in displaying a photo can either enhance or detract from its effect on a viewer. However, this is not to imply that you must spend a fortune framing every print you make; rather, it suggests that if you decide to frame your photograph, you should exercise good taste and avoid buying a frame that demeans your work simply to save a few pennies. The difference in price between a good frame and a poor one is not really proportionate to the difference in quality. Some of the framing materials from which you can choose are described below.

Clips and corners. Clips and corners are designed to hold together a sandwich composed of a sheet of glass, a mat, a print, and a sheet of stiff cardboard. The clips and corners are small plastic or metal devices connected by strings that run across the back of the assembly from side to side or corner to corner. This method of mounting is inexpensive and in its simplicity does not distract from the print.

Clear plastic frames. One type of inexpensive, ready-made frame consists of a piece of clear plastic molded in a box configuration with

8. DISPLAYING YOUR PHOTOS

Displaying photos involves much more than simply making them available for viewing. A wide variety of seemingly unimportant factors—the way a photo is mounted or framed, where it is hung, what surrounds it, and so on—actually has a significant impact on the way a photo is perceived.

The family pictures shown in the photo at left were carefully mounted and framed, then all were organized into a coherent grouping. Each photo tells its own story, and each photo also contributes to a collective story. By having been carefully planned and executed, the arrangement not only displays the photographs, it enhances them.

There is little point in spending many hours and much money to take and process photographs if you then banish them all to drawers. Outstanding photographs should be seen, appreciated, and even studied. Certainly not every photo deserves display, but some assuredly do.

The way you display your photographs involves both aesthetic and practical decisions. You want your photos to look their best, of course, but sometimes your choice of a mounting or framing technique may be dictated by a practical consideration, such as the fact that very large prints often cannot be mounted or framed using methods that work perfectly well with smaller prints. Similarly, if your primary goal is the long-term preservation of a print, you must reject many of the available mounting methods simply because the chemicals involved can help destroy the image.

Still, if you want to show off your photos to their best advantage even while keeping practical considerations in mind, one approach is to create a consistent style of presentation. For example, a display of a series of your photographs may lend itself well to having all the photos mounted under cardboard mats and then framed. As you become more and more experienced in preparing such mats and frames, your technique will become neater and more professional looking. Eventually, you will probably start composing and printing your photographs with your usual mounting or framing technique in mind. The ultimate result of such a consistent use of one perfected method will be photographs that have been executed in a manner appropriate to the way they are mounted or framed—and mounts or frames that are appropriate to the way the photographs have been executed.

No matter how you present your photographs, the amount of care you take in preparing them for display will influence the respect with which they will be regarded. If you mount or frame your photos thoughtlessly, and with more concern for money saved than aesthetics, then regardless of how good your photos are, viewers will unconsciously think less of them. Mount or frame your photos thoughtfully, carefully, and with proper attention to materials—and viewers will accord your work the respect it deserves.

Of course, for every print you decide to mount or frame, there are usually many more you choose not to display, as well as negatives and slides you decide not to print. If not discarded, these too must be cared for if they are to last. Store them improperly and they will quickly deteriorate; file them haphazardly and you will not be able to find them when you want them. In short, the photographic process is not complete until the fruits of your efforts have been either appropriately displayed or conscientiously stored.

TYPES OF FRAMES AND MOUNTS

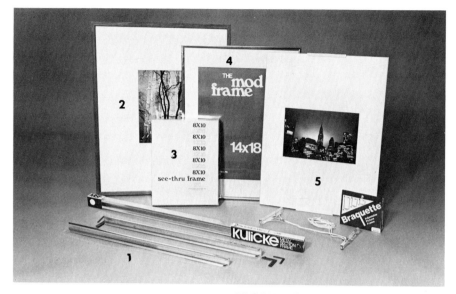

FRAME/TYPES

1. Metal strip frame (unassembled)
2. Ready-made wooden strip frame
3. Clear plastic box frame
4. Ready-made metal strip frame
5. Clip frame

HANGING BORDERLESS PRINTS

Often, borderless prints look best if they are separated from the wall by means of wooden strips to give them the appearance of floating.

MOUNTS

The term *mount* indicates that a photo, rather than being framed, is attached to a firm surface, usually by means of an adhesive. "Flush," "box," and "wrap" mountings are all variations on a technique that entails affixing a print onto Masonite or stiff (double-ply) cardboard. All of these methods can be used with prints of any size but are especially effective with larger prints.

Flush mounting. With flush mounting, you trim the edges of your print so that they are even with the edges of the mounting board. You can darken the trimmed white edges of the print with an indelible marker if they are distracting. On the back of the mount you can attach wood strips which will serve both to hold the photo off the wall and to prevent warping.

Box mounting. With box mounting, you glue wood strips flush with the edges all around the back of a mounted print. The wood strips are usually painted flat black to make them less conspicuous. Box-mounted prints are easy to hang on a wall by means of a single nail.

Wrap mounting. With wrap mounting, you mount your print on a board slightly smaller than the print in order to permit you to wrap and glue the print's edges around the board's edges in a manner similar to wrapping a gift. Wrap mounting must be done very carefully to achieve a neat result.

Murals. Very large prints, mounted by means of one of the above techniques or glued directly onto a wall, are called *murals*. The chief problem murals pose is that any irregularities in the underlying surface or any lumps in the mounting adhesive become very noticeable. Executed with care, however, murals can present a striking appearance.

FRAMES

As mentioned earlier, the care you take in displaying a photo can either enhance or detract from its effect on a viewer. However, this is not to imply that you must spend a fortune framing every print you make; rather, it suggests that if you decide to frame your photograph, you should exercise good taste and avoid buying a frame that demeans your work simply to save a few pennies. The difference in price between a good frame and a poor one is not really proportionate to the difference in quality. Some of the framing materials from which you can choose are described below.

Clips and corners. Clips and corners are designed to hold together a sandwich composed of a sheet of glass, a mat, a print, and a sheet of stiff cardboard. The clips and corners are small plastic or metal devices connected by strings that run across the back of the assembly from side to side or corner to corner. This method of mounting is inexpensive and in its simplicity does not distract from the print.

Clear plastic frames. One type of inexpensive, ready-made frame consists of a piece of clear plastic molded in a box configuration with

a slightly smaller, white cardboard box fitted inside it. To mount your photo, you place it on the inside surface of the cardboard, then slip the plastic box over both. Plastic box frames are very simple to use but can look cheap unless intentionally selected for their minimal interference with the appearance of the print itself.

Ready-made frames. Many stores sell simple, already assembled frames in standard sizes such as 5″ x 7″ (13 x 18 cm), 11″ x 14″ (28 x 36 cm), and 14″ x 18″ (36 x 41 cm). Most of the frames consist of a border of gold or silver strips plus a sheet of glass and a mechanism to hold the photo in place. Frames of this type can be beautiful in their simplicity or startling in their unattractiveness, depending on how well they are made. To avoid shoddy frames, make your purchases at a reputable framing shop or art supply store, rather than a five-and-ten store.

Custom frames. Frames you assemble yourself are similar to the ready-made frames described above, but are sold in 1″ size increments. Assembly is a bit troublesome but not difficult. The primary advantage of using self-assembled, custom frames is that it permits you to construct a frame to fit your print, instead of forcing you to crop your print to fit the frame. In addition, the pieces of the better custom-made frames fit together well and present a neat, sophisticated appearance.

Small table frames. A wide assortment of table frames is available for displaying small prints. These frames are usually constructed of wood, metal, or ceramic, and they are sometimes covered with leather, caning, or fabric. (See the photo that opens this chapter.)

You can present your photos in small table frames either alone or organized into an attractive ar-rangement of individually framed photos. By periodically changing some or all of the photos in the arrangement, you can present visitors with a rotating exhibition of your work.

Traditionally, table frames have been used for displaying family portraits, but there is no reason why table frames cannot be used to display any photo you would like others to appreciate.

TABLE FRAMES

Not every print is best displayed by mounting it on a wall. Small prints especially can be given a feeling of prominence if placed in well-made, carefully chosen table frames.

CLIP FRAMES

By virtue of their simplicity, clip frames allow a viewer's attention to focus on the print rather than on its mounting.

MOUNTING TECHNIQUES

If you expect to dry mount only occasionally, of if you want to avoid the purchase of an expensive dry-mount press, you can mount your prints using an ordinary clothes iron. Hot water will damage your print, so be sure to use the iron on its "dry" rather than "steam" setting. Better yet, empty all water from the iron before turning it on.

Start by preheating your iron to a moderate, dry temperature and trimming the mounting tissue to the size of the print, then follow the procedures described at right.

Small, acid-free tapes are used as hinges to mount a print. Available in most art supply stores, these hinges are easy to remove and make changing a mount a simple task.

MOUNTING PRINTS

The mounting technique you use with a particular print is a matter of personal preference as long as the adhesive involved is appropriate for the materials being joined. However, you should always bear in mind that you may need to strike a balance between the ease of a particular technique and the degree of permanence you are seeking. Many papers, adhesives, and even frames contain acids which will cause the image on a print or the paper itself to deteriorate over the years. If you want to preserve a print for decades—or centuries—you must sacrifice the convenience of some of the easier techniques for the permanence provided by acid-free mounting materials and methods.

Dry mounting. Dry mounting is permanent, clean in that it provides a smooth mount, and time tested. In dry mounting you place a special tissue between the print and the mounting board, then apply heat to form the bond.

Resin-coated (RC) and Ciba-chrome papers can be dry mounted, but you must monitor the temperature carefully to prevent the edges from curling or the print from being completely destroyed. The ideal heat source is a special dry-mount press, but you can also use a household iron, if necessary. If you use a laundry iron, however, you must learn the best temperature by trial and error, and until you do, in all likelihood scorched prints will be an occasional occurrence. Even with a mounting press, temperature control is difficult. SEAL, one of the manufacturers of dry-mounting materials, provides indicator strips that signal when the temperature is correct.

Wet mounting. Wet mounting, a permanent and time-tested, if somewhat messy, process, entails the use of wet glue as the bonding agent between print and mounting board. Wet mounting is the only mounting method practical for use with murals. If executed with care, wet mounting will provide you with a smoothly mounted print and a very permanent bond. For fiber-base paper mounted on porous surfaces such as wood, Masonite, or cardboard, use white glue (such as Elmer's glue) diluted with water to make it smooth and thin enough to apply with a brush. For RC paper, or if the print is to be mounted on a nonporous surface such as metal or plastic, use a contact cement (but beware of fumes).

To make a wet mount:
1. *Prepare mounting board* slightly smaller than the size of the print.
2. *Apply thin, smooth layer of diluted white glue or undiluted contact cement* (as appropriate) with a paintbrush to both the back of the print and the mount surface.
3. *Wait* for the two surfaces to become sticky.
4. *Position print* very carefully above, but not touching, the mounting surface.
5. *Lower print* very carefully onto the mounting surface (no repositioning is possible once the surfaces touch).
6. *Smooth out any bubbles* using a brayer (available from art supply stores), working from the middle of the print toward the outside edges.
7. *Trim print* flush with the edge of the mounting board, or neatly glue and wrap the edge of the print around the edge of the board.

Spray adhesive. Spray adhesives are very fast to use but do not produce a permanent bond. Also, the chemicals in the spray can react with the print and damage it as time passes. Use spray adhesives when

constructing a temporary exhibit, when producing "paste-ups' to be submitted to a printer, or when you know you will need to reposition the prints later. If you want the prints to be easy to remove, allow the adhesive to dry for a while before you mount them. (Solvents are available to facilitate print removal.)

To use a spray adhesive:
1. *Trim print* to size.
2. *Lay print face down on sheet of newspaper.*
3. *Spray back of print* with adhesive.
4. *Lay print in position* on the mounting surface.
5. *Smooth print* with a brayer.

Cold mounting. Two different types of cold mount are available: one that sandwiches an adhesive-coated sheet between the print and the mount (e.g. Perma Mount by Falcon), and another that involves transferring a layer of adhesive from a sheet of special paper onto the back of the print (e.g. Scotch P.M.A. sheets). The latter method has the advantages of not adding to the thickness of the mount and of avoiding any acidity an intermediate sheet might contain; in both methods, however, there may be acids present in the adhesive itself.

To make the type of cold mount that does not leave an intermediate sheet between the print and the mount, see p. 153.

To make a cold mount "sandwich" using an intermediate adhesive sheet:
1. *Position print* on top of the adhesive carrier sheet.
2. *Peel protective paper* carefully away from one side of the adhesive sheet so that the adhesive comes in contact with the print.
3. *Smooth adhesive sheet* with a brayer.
4. *Trim adhesive paper* down to the size of the print.

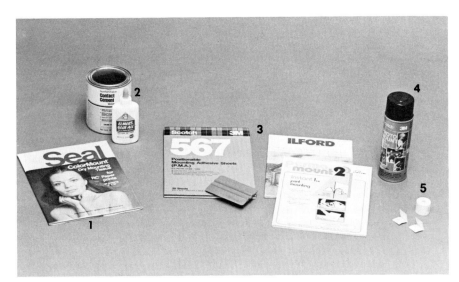

1. **Dry-mounting tissue**
2. **Wet-mounting adhesives**
3. **Cold-mounting adhesive sheets**
4. **Spray-mounting adhesive**
5. **Acid-free tape**

5. *Peel away protective paper* from the other side of the adhesive sheet.
6. *Affix print* to the mounting board.
7. *Smooth print* with a brayer.

Hinge mounting. Small, acid-free tapes (available from art supply stores) that are cut into small strips, folded in half, and used as hinges constitute the safest mounting method of all with respect to print preservation. Hinges are easy to remove, and they make changing a mount a simple task. Aside from being free from acid, they have the additional advantage of bringing the smallest area of mounting surface in contact with the print, compared to other mounting methods.

To make a hinge mount:
1. *Cut mat* with an opening small enough to cover the edges of the print.

2. *Cut at least two 2" or 3" (5 or 8 cm) lengths of acid-free tape.*
3. *Fold tapes* in half, widthwise.
4. *Affix one flap of each "hinge"* onto the back of the print.
5. *Position print* over the mounting board.
6. *Press print* into place on the board.
7. *Secure print* by covering it with the mat prepared in step 1.
8. *Frame* (optional).

Some dry-mounting tissues work by inserting a sheet of paper, coated on both sides with adhesive, between the print and the surface of the mounting material. Peeling away the tissue's protective papers exposes the adhesive.

Hinge mounts consist of small strips of acid-free paper or cloth folded in half and attached to both the back of a print and the surface on which the print is to be mounted. Because hinge mounts are so small, they minimize the amount of adhesive on the print and therefore decrease the likelihood of the print's being damaged by chemicals in the adhesive. Hinge mounts have the added virtue of allowing easy removal of the print, should that later become necessary.

DRY MOUNTING WITH AN IRON

1. *Gather materials.* You will need an iron, a ruler (a center-finding ruler is best), a cutting blade, a pencil, a print to be mounted, dry-mounting tissue cut to the size of the print, and a mounting board cut to whatever size you want.

2. *Position print on mounting board.* Use your eye to locate the print where you want it, then position the print precisely by measuring with the ruler to achieve even borders. Mark the locations of the top edge and one side edge of the print on the mounting board with a light pencil line.

3. *"Tack" mounting tissue to print.* Turn the print face down and place the mounting tissue on top of the print. "Tack" the mounting tissue to the back of the print by tracing an "X" pattern between the corners with the tip of a dry iron set to a medium temperature.

4. *Mount print.* Position the print face up on the mounting board, using the pencil lines as guides. Cover the print with a piece of clean paper, then run the iron across the entire surface of the print. Work from the center outward to prevent scorching.

COLD MOUNTING

The type of cold mount in which a sheet of paper with adhesive on both sides is inserted between a print and its mounting board is described on p. 151. A different type of cold mount that does not add such a sheet between the print and its mount is illustrated at right. Which of the products you use is primarily a matter of personal preference, although the type shown here has the advantage of allowing position adjustments any time before the final burnishing step.

1. *Position print on mounting board.* Referring to the right-hand photo at the top of the previous page, mark the locations of the top edge and one side edge of your print on the mounting board.

2. *Transfer adhesive to print.* Cut the adhesive carrier sheet from a mounting kit such as the one shown above to the same size as your print. Peel away the protective paper from the adhesive carrier sheet, then position the sheet against the back of the print as shown. Next, firmly burnish the entire back surface of the carrier paper using the burnishing tool packaged in the kit.

3. *Expose adhesive.* Remove the adhesive carrier sheet carefully, leaving behind a layer of adhesive on the back of the print.

4. *Mount print.* Position the print face up on the mounting board, using the pencil lines as guides. Cover the print with the protective paper you removed earlier, and firmly burnish the print onto the mounting board.

HOW TO CUT A MAT

One popular mounting technique involves surrounding a print with an attractive border. You produce the border by carefully cutting a window in a special cardboard (available from art supply stores); you then position the cardboard mat so that it surrounds the print and holds it flat. You can either insert the print-mat combination in a frame or mount it on an uncut mat or board using an appropriate technique.

Standard mats. To determine the dimensions of the borders on your mat, you must make an aesthetic decision that will vary from print to print. However, you should pay close attention to the relative widths of the borders if you want your photos to look their best.

In a standard, traditional mat, the two side borders and top border are all equal in width, while the bottom border is approximately one-third wider. However, do not feel forced to use the standard proportions exclusively. Other types of border dimensions you might consider are illustrated on p. 159.

Equipment. Mats look best if the window through which the print is viewed has been cut with an edge beveled at an angle. Art supply stores sell various mat-cutting devices, some of which are quite elaborate and expensive. Fortunately, one of the simplest and least expensive, the Dexter Mat Cutter, is perfectly adequate. To use the cutter most effectively, you will also need a T-square ruler (preferably metal), a C clamp, a push pin, a large sheet of scrap cardboard to place under the mat while you cut, and a firm surface on which to work. Useful, but not absolutely necessary, is a "center-finding" ruler.

CUTTING THE MAT

The first step in cutting a mat is to determine the border proportions

PREPARATIONS

1. *Gather materials.*
Metal T-Square ruler
Center-finding ruler
Mat cutter
Push pin
Mat cardboard
Backing cardboard
Print to be mounted

2. *Determine actual dimensions of window* you will be cutting. (Be certain that the mat will overlap the photo by at least ⅛" (3 mm) on all sides.)

3. *Adjust blade on mat cutter.* Follow the manufacturer's instructions. Set the blade to the angle you want and to the correct depth for the thickness of the mat board you are using.

MARKING THE WINDOW OUTLINE

4. *Center center-finding ruling horizontally* on the face of the mat.

5. *Center print horizontally* underneath the ruler.

6. *Measure distance from left edge of image area to left edge of mat.* (Be sure your measurement includes the amount the mat will overlap the print. Do not make the measurement from the very edge of the printing paper.)

7. *Adjust position of both rulers* as shown above so that they intersect where the measurement on each equals the distance you determined in the previous step.

8. *Mark intersection* with the push pin.

9. *Repeat steps 6 and 7* on the other side of the mat.

10. *Measure straight down* (using the T-square ruler) from both pinholes a distance equal to the vertical dimension of the mat window, and mark with additional pinholes.

CUTTING THE MAT

11. *Double-check angle and depth of cutter blade.*

12. *Push cutter blade firmly into either of two pinholes* nearest you.

13. *Position T square against side of cutter and along line of cut.* Make certain that along the line of cut the distance from both pinholes to the T square is equal.

14. *Clamp T square in place.* (If you try to hand-hold the T square, its position will shift during the cut.)

15. *Position hands as shown above.*

16. *Push cutter firmly* along, from the near hole to the far hole.

17. *Repeat steps 13 through 17* on the remaining sides of the mat.

MOUNTING AND FRAMING

18. *Position print* on the mounting board.

19. *Lay mat over print.* Make certain that the mat borders overlap the print on all sides.

20. *Remove mat* without disturbing the position of the print.

21. *Mark edges of print* on the mounting board with a pencil.

22. *Mount print* on the mounting board. Use whichever of the mounting techniques mentioned earlier in this chapter is appropriate for your materials, the way you want your print to look, and the degree of permanence you want.

you want. Lay the photo to be framed on top of the mat cardboard, and shift the photo around until you locate the position you like best. The instructions at right are written for a mat with the top and side borders all equal in width, but you may decide that for a particular photo you prefer the widths of the top and bottom borders to be different from the width of the side borders.

The photos here illustrate how to measure and cut a mat *using a center-finding ruler.* If you do not have a center-finding ruler, you will have to determine where the corners of the window in the mat will be. Proceed as follows:

1. *Decide on exact dimensions* of the window in the mat, keeping in mind that the mat should overlap the print by at least 1/8" (.3 cm) on each side.

2. *Turn the mat face down.*

3. *Locate mat's center* by drawing diagonal lines between the opposite corners.

4. *Locate and mark right and left edges of window with lines,* making certain that both borders are equal in width.

5. *Locate and mark upper edge of window* with a line. Usually you will want to make the upper border equal in width to the side borders.

6. *Locate and mark lower edge of window with line.* Usually, you will want the lower border to be about one-third wider than the other borders.

7. *Force push pin through mat at each of four corners of window* in order to transfer the location of the corners to the front of the mat.

8. *Continue with procedures outlined at right,* commencing with step 11.

FRAMING THE PRINT

CUSTOM FRAMING

Any time you need a frame of other than standard dimensions, you will have to make your own (or have one made to order, an expensive alternative). Customizing a frame is a relatively easy task, however, if you use the strip frame kits pictured at right.

You will need to buy two separate kits to make one frame, since frame edges are sold two to a package. In deciding what lengths to buy, you must establish the approximate dimensions you want the frame to be, then select packages containing edge strips cut as nearly as possible to those lengths. The hardware for connecting the frame edges is included in the packages, but you will need to separately purchase a sheet of glass or Plexiglas of the proper dimensions. Glass does not scratch as easily as plastic, but it is more difficult to cut, breaks more easily, and is heavier. The choice of which to use is a matter of personal preference.

Usually, you will not need a custom frame unless you have mounted your print in a manner such that it requires a frame of nonstandard dimensions, as when you cover a print with a mat. Even with a mat, you will probably need to back your print with a piece of cardboard to add rigidity and to make sure the print fits snugly in the frame.

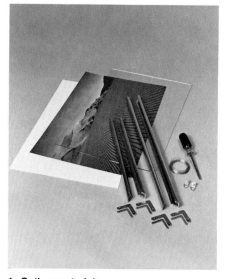

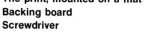

1. *Gather materials.*
 4 frame edges plus hardware
 A sheet of glass or acrylic plastic (Plexiglas)
 Picture-hanging wire with mounting clips
 The print, mounted on a mat
 Backing board
 Screwdriver

2. *Connect three sides via two corners.* Slide the L-shaped connectors into the slots in the edge sections, as shown, and tighten the screws.

3. *Slip glass, matted print, and backing board into frame.* Make certain the combination fits snugly in the frame.

4. *Attach wire mounting clips. Attach fourth edge.* Slide the wire mounting clips into place and secure. Attach the remaining corner hardware to the fourth edge before mounting it. Be sure the wire is securely attached.

Clips such as these hold together a "sandwich" made of glass or Plexiglas, a matted print, and a stiff backing board which adds rigidity and enables the lip to grip the sandwich firmly. To assemble such a frame, you construct the sandwich and then press the clips onto the top and bottom edges as shown. Once you apply tension to the string that links the clips, the assembly will be ready for hanging by means of the slot in the upper clip.

A similar type of frame uses four corner clips instead of two edge clips. Both edge clips and corner clips are available clear or colored, in plastic or metal.

WOOD STRIP BACKINGS

Flush- and wrap-mounted prints often look best if they are hung to stand approximately 1″ (2.5 cm) out from the wall. Two wood strips attached to the back of the mounting board in the manner shown above serve both to create a space between the wall and board and to reinforce the rigidity of the board.

Attach the wood strips parallel to the top and bottom edges of the backing board with glue, but far enough from the edges so that a viewer will not be able to see the strips when the print is hung. Center the strips left to right so their weight will be evenly distributed. To mount the assembly on the wall, simply hook the uppermost wood strip over a nail.

MAT VARIATIONS

You can create an unusual and often pleasing effect by making multiple prints of a subject, then mounting them together. In the photo above, the twelve images are mounted side by side on a sheet of high-quality art paper using a spray adhesive, and the whole assembly is matted together. This technique provides an interesting method for making a small print into a large display.

Some photos are better left unmatted. The photo at left is mounted so that it "bleeds" all the way to the edge of the frame for added impact.

As suggested earlier, mats need not always be cut using traditional measurements and border proportions. For example, sometimes a vertical print will look best on a horizontal board. Or, you may find that the impact of a particularly small print is enhanced by surrounding it with a very large mat. And nowhere is it decreed that the print must always be centered left to right. Use your imagination, but always keep in mind that a nonstandard mat enhances a photo only if it is serving a specific, aesthetic function that provides a reason for deviating from the traditional norms.

One caution about mat variations: if you are planning to display a *collection* of prints, they all should be given the same mat treatment—especially if you are planning to present them as part of a formal exhibition.

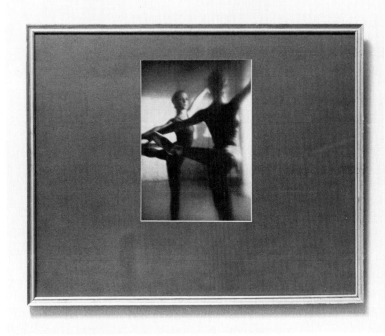

Unusually wide borders can be effective if you want to direct attention to a small print.

The shape of the mat need not necessarily echo the shape of the print it surrounds. Here a vertical print is mounted and framed in a horizontal format.

MAT FORMATS

STORING YOUR SLIDES AND NEGATIVES

Authorities disagree over how long a photographic image will last. Some maintain that a slide will begin to deteriorate after being exposed for as little time as 60 seconds under a 250-watt projector bulb. Others maintain that a carefully processed and stored black-and-white negative will last for 3,000 years. Both contentions may be correct considering that they deal with extreme conditions, but the most common estimates of the ability of an image to survive range from 50 to 100 years. Since some of the earliest photographs taken are still in existence and are therefore about 150 years old, it seems safe to conclude that properly kept black-and-white photographic materials have the potential to at least outlive their creators and survive for the enjoyment of other generations. Color films have not been in existence long enough to arrive at firm conclusions.

In theory, photographs prepared using the newer materials and processes should survive as well as their predecessors. In fact, no one yet knows for certain whether they will.

What *is* known are the factors that contribute to image deterioration. Paper, cardboard, glue, and unsealed wood all give off fumes that react with and tarnish the silver granules on film and paper. Environmental pollutants, especially sulfur compounds, cause images to deteriorate. High temperature, high humidity, and constant exposure to light can encourage mold to grow or an image to fade. Physical abuse can also play a part: pressure on the face of a slide caused by being under a large stack of other slides; oil from fingerprints; and dust or grit all can take a toll.

Conditions. Because prints may contain residual processing chemicals within the paper, or acids may be present in mounting materials, prints are more likely to deteriorate over the years than are slides and negatives. Therefore, fundamental to the preservation of prints are the archival processing methods described in Chapter Four. Beyond that, any storage system you choose for all materials—negatives, slides, and prints—must strike a balance between how much protection you want your photographic materials to enjoy and how accessible you need them to be.

Temperature. For maximum protection, store your negatives at a temperature as close to 70°F (21°C) as you can maintain.

Humidity. Relative humidity should remain in the 15%–40% range.

Light. When not being displayed, protect all materials from light, especially sunlight.

Fumes. All materials should be protected from contact with corrosive fumes to the greatest extent practical.

STORAGE CONTAINERS

Plastic sheets. The plastic sheets in which negatives are stored consist of slots which hold the strips of film. Usually, you can store an entire 36-exposure roll on one sheet. These sheets allow you both to view the negatives and to make a contact print without having to remove the film from the sheet.

The plastic sheets in which slides are stored come in two varieties. The sheets made of polyethylene or cellulose acetate (e.g., Franklin Saf-T-Stor sheets and Vue-all sheets) act as frames for each individual slide, with slots for twenty slides on each sheet. The drawback of these sheets is that they leave the surfaces of the slides unprotected from dust, grit, and fingerprints. If you use overlay sheets for protection, it becomes difficult to retrieve individual slides.

Another type of sheet consists of individual envelopes for each slide which completely enclose the slides, but since these sheets are not made of inert plastic, over the years some harm may come to the slides they hold. Moreover, if the film itself comes into contact with the plastic for a long period of time, the image may be ruined. Therefore, this type of sheet is best used only for slides you will be removing regularly.

Be careful not to store plastic sheets one on top of another in large stacks, or else the negatives or slides on the bottom may be damaged. A better method is to store the sheets vertically in hanging files or loose-leaf notebooks.

Boxes. Negatives, slides, and prints should only be stored in boxes that do not radiate harmful fumes. Only boxes made of specially prepared acid-free cardboard, or wood that has been covered by a layer of thoroughly dried paint, are safe to use. Metal boxes and file cabinets are all usually safe.

Glassine and paper envelopes.
For years, glassine envelopes were the preferred method for storing negatives. More recently, it has been discovered that the glue on the envelopes is harmful. However, acid-free paper envelopes are available and safe.

Plastic slide trays and cubes.
Slides that you want to be able to view easily and often can be safely stored in plastic slide trays and cubes, ready for projection. Remember, however, that repeated or prolonged exposure to the intense light of a projector bulb will cause the image on the slide to fade.

An easy way to store negatives and slides is to insert them in plastic sheets and organize the sheets in loose-leaf folders.

If you make a contact print of each sheet of stored negatives, you can include the print so that it lies facing the negatives from which it was prepared.

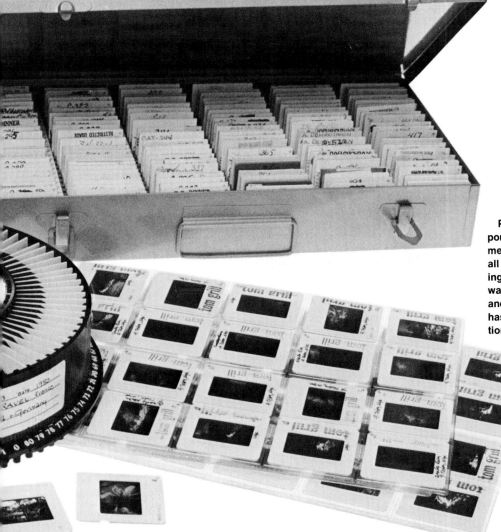

Proper storage of transparencies is important for their preservation. Slide trays, metal storage boxes, and acetate sleeves all meet different organizational and viewing needs, but each is effective in its own way. Note that as an aid to record keeping and slide retrieval, each individual mount has been annotated with pertinent information.

APPENDIX

Liquid and Capacity Measurement

Gallons	Quarts	Pints	Fluid Ounces	Fluid Drams	Milliliters	Centiliters	Liters
1	4	8	128	1024	3785	378.5	3.785
.25	1	2	32	256	946.3	94.63	.9463
.125	.5	1	16	128	473.18	47.31	.4731
.0078	.03125	.0625	1	8	29.57	2.957	.02957
.000976	.0039	.0078	.125	1	3.697	.3697	.003697
.000264	.00106	.002	.03381	.2705	1.	.10	.001
.00264	.0106	.021	.3381	2.705	10	1	.01
.2645	1.057	2.113	33.81	270.5	1000	100	1

Length

Yards	Feet	Inches	Millimeters	Centimeters	Meters
.0011	.0033	.039	1	.1	.001
.011	.033	.394	10	1	.01
.028	.083	1	25.4	2.54	.025
.333	1	12	305	30.5	.305
1	3	36	914	91.4	.914
1.09	3.28	39.4	1000	100	1

Avoirdupois to Metric

Pounds	Ounces	Grains	Grams	Kilograms
1	16	7000	453.60	.45
.0625	1	437.50	28.35	.02835
—	—	1	.06	—
—	.035	15.43	1	.001
2.205	35.27	15432	1000	1

DA-2D Temperature
C = (F–32)x5/9
F = (Cx9/5) + 32

DA-2E
Dry Capacity Measurement
1 pint = 33.60 cubic inches = 550 milliliters = 0.550 liters

DA-2F
Liquid Measure
1 quart = 32 ounces = 946.4 milliliters = .9464 liter
1 ounce = 29.60 milliliters = .0296 liter
1 liter = 1000 milliliters = 33.81 ounces = 1.057 quarts

DA-2G
Surface Areas
80 square inches = surface of one 36-exposure 35mm roll, or one 8″x10″ (20x25cm) sheet

The life and strength of mixed chemicals can be affected by the way they are mixed and replenished and by the temperature at which they are stored. If you notice that your negatives are not showing the density and contrast you expect, depleted chemicals could be the problem. Develop good mixing technique from the start, and you will save yourself aggravation in the future. Maintain accurate records of when chemicals were mixed, how many rolls they have been used to process, and how many times the chemicals have been replenished. With such records you can more easily identify the source of a problem when it occurs. If you follow the procedures outlined below, you will not only extend the life of your chemicals, but you will also develop a skill that is the hallmark of the darkroom expert: the ability to produce predictable results, consistently.

AGITATION

The primary agent in chemical deterioration is oxidation, that is, the action of oxygen on chemicals, especially on developers. The way you mix chemicals can affect the amount of oxygen introduced into a solution. The mixing tools sold in camera stores are specifically designed to prevent excess agitation from occurring at the top of a liquid, where the chemical meets the air. By vigorously agitating the solution only at the bottom, you are mixing the chemicals in a region where no air is present. Your goal is to mix the chemicals sufficiently to dissolve all of the powder into the liquid but without so disturbing the surface that air is introduced.

MIXING TEMPERATURES

When mixing chemicals, be careful to maintain the chemical temperature within the range recommended by the manufacturer. If you mix at too low a temperature, the chemical may not fully dissolve; if you mix at too high a temperature, the chemical may decompose.

Before using a chemical for processing, check to be certain that the temperature has fallen to the proper range.

WATER

Ordinary tap water is suitable for mixing chemicals unless the water has an excessively high sulfur content. Too much sulfur causes fogged negatives. If you suspect sulfur contamination (a rare occurence), you can test for it by mixing a batch of chemicals with distilled or spring water to see if this eliminates the problem. If not, the culprit may be chemical exhaustion or some other contamination.

STORAGE TEMPERATURE

Maintain storage temperatures between 50F (10 C) and 90F (32 C) because the shelf life of mixed chemicals can be altered by excessively high or low storage temperatures. Below 50F, dissolved chemicals may start to crystallize. Above 90F, the rate of oxidation increases substantially, and the life of the chemical may decrease from months or weeks to only days.

REPLENISHING

Some chemicals are used once, usually in diluted form, then discarded. This procedure ensures fresh chemistry and consistent results each time you process, but diluted chemicals do not work as fast as concentrated chemicals, which are more convenient to use. Moreover, you can use full-strength chemistry over and over again by replenishing the depleted chemical after each use. If a chemical (most often a developer) can be replenished, its manufacturer will usually provide replenishment instructions. In some cases, however, a special replenisher is made by a different manufacturer. If you do not have either replenishment instructions or a special replenisher, then follow the procedure below for chemicals designed to be used in concentrated form.

Add to the used chemical 1 oz (29.6 ml) of fresh stock solution for each 80 square inches (2 m)² of film processed (80 square inches = one 36-exposure roll of 35mm film). If 1 oz does not bring the solution back to its original volume, then add additional fresh stock solution. Do not continue replenishing indefinitely, however, since a chemical builds more and more residual silver and sludge each time it is replenished.

Should you notice that film being processed in replenished chemicals is showing reduced density, add more stock solution to the used solution, even if you have to discard some of the used solution to maintain the correct volume. If your negatives start to show increased density, then use less replenisher. If using less replenisher results in an insufficient volume of liquid, dilute the replenisher 1:1 with water. Keep in mind, however, that weak negatives may signal an exhausted solution. When in doubt, replace the chemistry.

TONING

Print *toning* can serve both to alter the color of an image and, by replacing some of the silver in the image with a more chemically inert substance, to help preserve the image. Sepia, brown, blue, red, and other toner shades are primarily intended for altering the color of an image, with protection being a secondary consideration. Selenium and gold toners, on the other hand, are excellent for improving print longevity but have little or no effect on color.

Sepia toner. This toner produces a warm, brownish tone on black paper. It comes in two solutions: bleach and redeveloper.

Kodak brown toner. This produces a browner tone than sepia toner on black and white paper. It comes in one solution.

Gold protective toner. Use this toner for the greatest archival preservation of a photographic image. It has little or no effect on image color.

Selenium toner. This is a less expensive, more commonly used substitute for gold toner in archival printing. It produces a reddish brown color when used on some papers and no noticeable color change on others.

SPOTTING PRINTS

No matter how carefully you clean your negatives, some dust spots will inevitably appear on your prints. To cover the spots you will need to have on hand a variety of high-quality, fine-point artist's brushes, ranging in size from 000 to 1. Also, you should purchase Spotone print retouching colors.

To spot a print, mix the colors according to the general instructions provided by the colors' manufacturer for the type of paper you are using. You will have to experiment to obtain the best mixture of retouching colors to match the tones surrounding the spot you want to retouch.

Apply the colors with a semidry brush in very thin layers rather than in a single, thick layer. To avoid accidentally ending up with a spot that is too dark, mix your first layers a little lighter in tone than you think is correct and keep darkening the tone in subsequent layers until the match is perfect. In the best spotting jobs, the color has been applied as little dots that approximate the grain shown by the image.

If you make a mistake and are using RC paper, you can sometimes wash the entire print in water and start over.

TEST FOR FIXER EXHAUSTION

Periodically you should check to see if your fixer has remained at full working strength. To test a hypo-type fixer, add 2 drops of Edwal Hypo-Chek. If the drops turn white, the fixer should be discarded. If they remain clear, the fixer is still usable. To test a high-speed fixer, take out 1–2 oz (30–59 ml) of the fixer to be tested, add 1 or 2 drops of the Hypo-Chek, and shake the mixture. If the solution turns milky white, the fixer is exhausted and should be discarded. If the solution clears, the fixer is still usable.

TEST FOR HYPO

Because the presence of residual hypo in a finished print can ultimately lead to its deterioration, you may want to test your prints during the wash period to see if all hypo has been eliminated. The procedure is to apply 1 drop of Kodak hypo test solution HT-2 to a test print that has been wiped free of water. By comparing the color produced on the print to the sample colors on the

Kodak Hypo Estimator, you can determine the amount of residual hypo present on the print.

CLEANING

The stains from the developer which form in the bottom of processing trays can easily be removed by using Edwal Tank, Tray, and Rack Cleaner. You dilute the concentrated solution with three parts water, swirl the mixture around in the soiled tray, and then discard the solution. You can repeat the process if necessary to remove stubborn stains. Afterwards, wash the cleaned surface with water. The solution works well on metal, rubber, polyethylene, polystyrene, and porcelain trays, but be careful to rinse porcelain trays promptly to prevent the surface from being etched by the cleaner.

GLOSSARY

Acetic acid—A chemical used to stop the activity of a developer quickly and completely. (See Stop bath.)

Agitation—The process of inducing movement in liquid chemicals for the purpose of insuring that chemical reactions occur at a uniform rate.

Aperture—The adjustable opening in a lens diaphragm through which light passes.

Archival printing—Special procedures designed to forestall print deterioration by removing all harmful residual chemicals from a print.

ASA—A number rating applied to a film to characterize the film's sensitivity to light. (See ISO.)

Bleach—A chemical used in processing to remove silver granules.

Burning-in—A technique used in printing whereby a portion of the light being projected onto the printing paper is allowed to strike the paper for a longer time than the rest of the light. In prints made from negatives (black and white or color), the burnt-in area is darkened. In prints made from slides, the burnt-in area is lightened.

Cassette—The metal or plastic cylinder in which 35mm film is sold and stored, and from which the film must be removed before processing.

Changing bag—A light-tight cloth bag within which light-sensitive materials (unprocessed film or printing paper) can be handled while room lights are on or sunlight is present.

Clearing agent—A chemical that reduces washing time by quickly removing fixer from film or prints.

Cold-light enlarger—An enlarger in which the light source is made of gas-filled tubes that produce far less heat than tungsten bulbs or fluorescent lamps.

Cold mounting—A method that does not require the application of heat to affix a print to a mounting surface. The adhesive is usually layered onto a sheet of paper and either sandwiched, along with the paper, between the print and the mount or transferred from the paper onto the print itself.

Color analyzer—An electronic device that measures the constituent colors in a projected image and indicates the filtration adjustments required to produce correct color balance in a print made from the image.

Color balance—The relationship between colors in a print. When color balance is correct, the colors in a print closely or exactly reproduce the colors in the original scene. Color balance is affected by the colors contained in the light source used to produce or view an image, by the inherent characteristics of the film, and by the characteristics of the particular emulsion batch on which the image is photographically reproduced.

Color calculator—A device containing many combinations of filters and filter densities, through which a color image is projected to make a test print. By studying the test print, it is possible to determine the filter combination that will produce an image with correct color balance. (See Color balance.)

Color developer—A chemical used in color-reversal processing that attaches colored dyes to developing images.

Color mask—A tint or a tinted layer on film that serves to reduce contrast in prints made from the film. The color mask lends color negatives their orangish cast.

Color reversal—The process whereby the negative image initially formed on slide film is changed to a positive image so that the slide can be viewed directly. Color reversal also takes place on color printing paper when a positive print is made from a slide.

Color-reversal film—Film on the surface of which color is changed so that a positive color image is formed. (Color-reversal film is commonly referred to as *slide film*.)

Color temperature—A way of describing the color produced by a light source. Each type of color film responds most accurately to light of a particular color temperature.

Compensating developer—A developer used for processing film exposed to high-contrast subjects. The developer decreases the overall contrast in the negatives but does not significantly affect the separation of tones in highlight and shadow areas.

Complementary colors—The colors resulting from the mixture of equal amounts of any two of the primary colors. Red mixed with green produces yellow; red mixed with blue produces magenta; green mixed with blue produces cyan. These are also called *Secondary colors*. (See Primary colors.)

Contact print—A print made by laying film directly on top of a sheet of printing paper, then projecting white light through the film to produce an image on the paper. Most often, contact prints are made of an entire of negative film at once, to facilitate evaluation of the individual frames on the roll.

Contact printer—A device designed to hold film flat against a sheet of printing paper so that a good contact print can be made.

Condenser enlarger—An enlarger characterized by the inclusion of lenses designed to produce sharp images with high contrast. Condenser enlargers are usually best-suited to black-and-white printing, but they can be adapted to color use.

Contrast—The range of light intensities contained in a scene or a photographic image. Scenes or images showing a narrow range of light intensities are said to be *low contrast*. Scenes or images showing a wide range of light intensities are said to be *high contrast* or *contrasty*.

Contrast grade—A designation of the range of light intensities a particular sheet of printing paper will produce. The grades run from 0 (low contrast) to 6 (high contrast). The #2 paper is considered "normal" and will reproduce more or less exactly the range of light intensities in a negative of average (not extreme) contrast.

Contrasty—See Contrast.

Copy negative—A negative produced by either photographing a print or duplicating another negative.

Cropping—Adjusting the borders of a print to exclude unwanted elements from it.

Cyan—One of the complementary colors that form the foundation to the subtractive method of color production. Cyan filters block red light but allow green light and blue light to pass.

Depth of field—The range of distances in front of a lens that will be rendered in sharp focus by the lens. The depth of field of a lens increases as the size of the aperture to which the lens is set decreases. (See Aperture.)

Developer—Chemicals that convert silver halide crystals that have been exposed to light into metallic silver, thereby converting a latent photographic image into a developed image. (See Latent image.)

Density—An indication of the relative thickness of a developed image on a frame of film. "Dense" negatives appear dark to the eye and require relatively long exposures to form an image on paper. "Weak" negatives appear light to the eye and require relatively short exposures to form an image on paper. An "optimally dense" negative requires moderate exposures and shows better shadow and highlight detail than dense or weak negatives.

Diaphragm—A mechanical device built into photographic lenses which permits the size of the lens aperture to be adjusted. Rotating a ring on the outside of the lens causes the diaphragm to change to a different aperture. (See Aperture.)

Dichroic enlarger—An enlarger characterized by the presence of dichroic filters in the enlarger head. Dichroic enlargers are usually best-suited for color printing or for black-and-white applications where an image is desired that is somewhat less distinct than that produced by a condenser enlarger. (See dichroic filters.)

Dichroic filters—Subtractive color filters which "interfere" with the light coming from an enlarger lamp. The farther a particular filter extends into the light path, the greater the intensity of that color in the light emerging from the enlarger head.

Dodging—A technique whereby light from the enlarger is partially blocked during part of the exposure time of a print. In prints made from negatives (black and white or color) the dodged area is lightened. In prints made from slides, the dodged area is darkened.

Double exposure—A technique whereby two separate images are exposed on a single sheet of printing paper.

Drum processor—A plastic tube in which prints can be processed. Special end caps permit processing chemicals to be introduced and removed without light being admitted.

Dry-mount press—A device that uses heat and pressure to affix a print to a mounting surface.

Dry-mounting tissue—Tissue that is placed between a print and the surface on which it is to be mounted. Heat applied to the print causes an adhesive bond to form.

Dry side—The portions of a darkroom devoted to exposing, but not processing, prints.

Dye couplers—Chemicals contained within the emulsion layers of color films and papers which, in conjunction with color developers, result in the production of color images. (See Color developer.)

Easel—A device that holds printing paper flat below an enlarger head. Some easels hold the print by means of movable blades which permit cropping. (See Cropping.)

Emulsion—The layer or layers on film or printing paper that contain light-sensitive chemicals. After processing, the emulsion layer (or layers, in the case of color materials) contains the developed image.

Emulsion number—A number, applied by the manufacturer of a roll of film or a box of printing paper, that identifies the emulsion batch from which the film or paper was made. The emulsion number is especially important in color processing because each emulsion batch responds somewhat differently to colors.

Enlargement—A print that is larger than the negative or slide from which it was made.

Enlarger—A device having a light source and lens to project the image from a negative or slide onto a sheet of printing paper.

Enlarger head—The portion of an enlarger that contains its light source and to which its lens is attached. (See Enlarger lens.)

Enlarger lens—A lens designed to project a distortion-free, flat image onto a sheet of printing paper. In 35mm photography, the enlarger lens should have a focal length of approximately 50mm.

Enlarging timer—A timer into which an enlarger can be plugged and which automatically turns off the enlarger after a set interval of time.

Exposure—The particular combinations of lens aperture (*f*/stop) and exposure time that will allow the proper amount of light to strike film or printing paper to record the best possible image. (See Aperture; *f*-stop.)

Exposure latitude—The range of exposures, including overexposures and underexposures, that produce at least some detail in the highlights and shadow areas of an image. The exposure latitude of black-and-white film is approximately seven stops; of color film, approximately five stops.

Ferrotyping—A process whereby glossy prints are dried on a sheet of heated chrome-plated steel to increase the amount of gloss shown by the print.

Fiber-base paper—Printing paper that has not been coated by a resin to retard its absorption of moisture.

Film speed—A measurement of a film's sensitivity to light, usually designated by an ASA rating or an ISO rating. The higher the rating, the faster (or the more sensitive to light) the film.

Filter—A clear or translucent piece of glass, gelatin, or acetate which is placed between a source of light and a piece of light-sensitive material to alter the light in a predetermined fashion. Some filters affect color, others absorb unwanted radiation, and still others modify the way an image appears.

Filter, color-compensating (CC)—High-quality but fragile gelatin filters that add controlled amounts of color to light. Because of their high optical purity, CC filters can be placed below the lens of an enlarger without significantly distorting the quality of the image the enlarger projects. (See Filter density).

Filter, color-printing (CP)—Acetate filters that add controlled amounts of color to light. Because CP filters contain optical impurities, they must be placed *above* the negative or slide in an enlarger or else the image projected by the enlarger will be distorted. (See Filter density.)

Filter density—A measurement of the intensity of the color present in a color filter. Color-compensating and color-printing filters are sold in multiples of five density units.

Filter drawer—A compartment of a condenser enlarger designed to accommodate filters. Filter drawers are usually located between the light source and the negative carrier in an enlarger to prevent the filter from distorting the image on the film.

Filter factor—A number used to calculate the effect a particular filter will have on exposure.

Filter pack—The total collection of filters in an enlarger. The filter pack is adjusted by increasing or decreasing the densities of the filters within it.

Fixer—A chemical that prevents the image on film or printing paper from fading by removing undeveloped silver compounds, sometimes called *hypo*.

Focal length—The distance from the optical center of a lens to the point behind the lens where a sharp image forms when the lens is focused on infin-

ity. The focal length of the lens on an enlarger must project an image large enough to cover the paper on which the image is to be printed.

Focusing—The process of adjusting a lens so that it projects the sharpest image of which it is capable onto a sheet of printing paper.

Fog—Reduced contrast on film or printing paper caused either by stray light or by the action of chemicals. Film that is exposed to light before fixing has been completed becomes fogged.

f-stop—(1) A numerical description of the size to which the aperture of a lens is set. The specific number represents the ratio between the diameter of the opening and the focal length of the lens. (2) A description of difference in the intensity of light, as when one light intensity is said to differ from another by a certain number of f-stops.

Glassine envelope—An envelope or sleeve made of translucent paper in which negatives can be stored.

Grade—See Contrast grade.

Grain—Clumps of metallic silver that always form on film or prints. With fine-grained film, the grain is barely discernible to the naked eye. With grainy film, the clumps are readily apparent. Film grain increases with film speed. (See Film speed.)

Hardening fixer—A fixer used to counteract the softness that photographic emulsions develop during processing.

Heat-absorbing glass—A sheet of glass inserted between the light source and the negative carrier in an enlarger to protect color film from the effects of the heat produced by the enlarger bulb.

High contrast—See Contrast.

High-contrast film—Film that converts all tones of gray to either pure black or pure white, depending on the shade of the original tone.

Highlight detail—Discernible features present in the lightest positions of a photograph. (See Shadow detail.)

Hypo—See Fixer.

Hypo eliminator—A chemical used after a hypo clearing agent to remove the last vestiges of processing chemicals from a print.

Intensifier—A chemical used to improve a negative on which density is too weak (i.e., the negative is not dense enough) to print well. (See Density.)

Internegative—A negative, prepared by copying a frame of slide film, that is used to make a positive print.

ISO—A film speed rating which follows the convention introduced by the International Standards Organization. ISO numbers will eventually replace ASA and DIN ratings. (See ASA.)

Latent image—The potential but not yet developed image contained by silver halide crystals that have been exposed to light.

Lens opening—See Aperture.

Light meter—A device that measures the intensity of light and indicates the combinations of lens aperture and exposure time that will result in a correct exposure of a light-sensitive material (film or paper). Camera light meters cannot be used for determining darkroom exposures without the addition of special accessories.

Light-sensitive—A description for materials containing chemicals that change when exposed to light.

Magenta—One of the secondary colors that form the foundation of the subtractive method of color production. Magenta filters block green light but allow red light and blue light to pass.

Multiple exposure—A technique whereby two or more separate images are exposed on a single sheet of printing paper or film.

Negative carrier—A device which holds a negative or slide flat and in the proper position within the enlarger while an exposure is being made.

Negative film—Film containing images which, when projected onto positive (not color-reversal) printing paper, will produce positive images.

Neutral density—The result of combining equal densities of yellow, magenta, and cyan filters. The presence of neutral density decreases light intensity but does not affect color.

Normal lens—A lens of focal length approximately equal to the diagonal of the film size. With 35mm film, normal lenses are about 50mm in focal length.

Orthochromatic—A description for films that do not respond to certain wavelengths of light. Orthochromatic films can be used in the presence of a safelight of the appropriate wavelength. (See Panchromatic.)

Overexposure—A condition wherein more light has reached a frame of film or a sheet of printing paper than the amount required to form the best possible image.

Oxidation—The action of oxygen on a photographic chemical that results in the deterioration of the chemical's strength and ability to function properly.

Panchromatic—A description for films that respond to all wavelengths of light in the visible spectrum. (See Orthochromatic.)

Paper weight—A measurement of a paper's relative thickness. Papers are designated as light (or single) weight, medium weight, and heavy (or double) weight.

Polycontrast paper—See Variable-contrast paper.

Primary colors—The colors blue, green, and red. By mixing the primary colors in various combinations, any color in the visible spectrum can be produced.

Print—A photographic image produced on a sheet of photographic printing paper.

Printing paper—A paper that has been coated with one or more light-sensitive emulsion layers and that will produce an image when properly exposed to light and processed.

Processing drum—See Drum processer.

Pull-processing—A procedure whereby film that has been shot at an ASA lower than its ASA assigned by the manufacturer is developed for a shorter time than normal.

Push-processing—A procedure wereby film that has been shot at an ASA higher than its ASA assigned by the manufacturer is developed for a longer time than normal.

Quartz-halogen lamp—A lamp that produces a high-intensity light characterized by great consistency throughout the life of the lamp.

RC paper—See Resin-coated paper.

Reciprocity effect—A characteristic of film whereby a correct exposure occurs at a variety of easily predictable combinations of lens aperture and exposure time. At very long or very short exposure times, the relationship between lens aperture and shutter speed becomes erratic, a situation referred to as *reciprocity failure*.

Reciprocity failure—See Reciprocity effect.

Reducer—A chemical that improves a negative that is too dense to print well by removing some of the silver that forms the image. (See Density.)

Replenisher—A chemical added to a developer or other processing solution in order to return the solution to full chemical strength so that it can be reused.

R print—A color print produced directly on color reversal paper from a color slide.

Resin-coated (RC) paper—Photographic paper which has been chemically treated to restrict the amount of moisture it will absorb.

Resolving power—(1) A film's ability to produce fine detail in an image. (2) A lens's ability to project a sharp image.

Resolution—See Resolving power.

Reticulation—A wrinkled or cracked effect on film or prints created by exposing a photographic emulsion alternately to hot and cold temperature extremes.

Retouching—Improving or otherwise changing a negative or print by applying paint, ink, pencil, or bleach to portions of the emulsion or by etching the emulsion with a blade.

Safelight—A lamp that produces light of a wavelength to which a particular light-sensitive material does not respond. The safelight therefore provides visible illumination that does not affect the photographic image.

Sandwiching—Placing two or more slides or negatives together, then projecting light through the combination.

Secondary colors—See Complementary colors.

Shadow detail—Discernible features present in the darkest areas of a photograph (See Highlight detail.)

Shelf life—The period of time during which properly cared-for chemicals can be stored without significant deterioration occurring.

Silver halides—Compounds of silver that convert to metallic silver and become black when exposed to light and chemically processed.

Slide—A frame of film, usually color film, that is intended for viewing directly in a projector rather than for being used to make a print. (However, prints can be made from slides.)

Slide copier—A device used to copy a slide onto another frame of film. It can also be used to copy negatives.

Spotting—Retouching small areas of a print to cover defects. (See Retouching.)

Squeegee—A rubber-edged device that removes excess water when passed over the surface of a print and thereby promotes rapid drying.

Squeegee tongs—Tongs with rubber strips attached that can be passed over both sides of a strip of film simultaneously to remove excess water and thereby promote fast drying.

Stabilizer—A chemical used in color processing to improve the stability of the dyes in the emulsion and to act as a wetting agent. (See Wetting agent.)

Stock solution—A reserve quantity of a chemical solution.

Stop bath—A chemical, usually acetic acid, that halts the action of the developer and prevents contamination of subsequent chemicals.

Subtractive colors—The colors yellow, magenta, and cyan. Also called *complementary or secondary colors*.

Subtractive method—A method of producing colors that relies on the ability of yellow, magenta, and cyan filters to block certain colors and pass others. By combining the filters in various patterns, any color in the visible spectrum can be produced from white light. (See Complementary colors.)

Surge marks—Irregularities in development that occur around the sprocket holes in film, caused by developer flowing too rapidly through the holes due to excessive agitation.

Test print—A sample print made for the purpose of determining the correct exposure, paper contrast grade, or filtration to be used to make the final print.

Texture screen—A mesh that is placed in contact with a negative or slide in order to produce a pattern across the surface of the print.

Toning—The process of affecting or replacing the silver image on a black-and-white print in order to add color to the image and/or to prevent it from deteriorating.

Transparency—Usually a color slide, but sometimes a frame of black-and-white film. Transparencies are viewed by transmitted light, as from a projector. (See Slide.)

Tube processor—See Drum processer.

Tungsten light—The light produced by incandescent bulbs.

Type R print—See R print.

Ultraviolet (UV) filter—A filter used in color printing that prevents color shifts induced by Ultraviolet light.

Underexposure—A condition wherein less light has reached a frame of film or a sheet of printing paper than the amount required to form the best possible image.

Variable-contrast filters—Filters designed to be used with variable-contrast paper.

Variable-contrast paper—Black-and-white printing paper, the grade of which is determined by the color of the light used to project an image onto the paper. The color of the light and hence the paper grade is controlled by variable-contrast filters. (See Contrast grade.)

Viewing filters—Devices through which a color print can be viewed and which indicate the color filtration adjustments needed to produce a print with correct color balance. (See Color balance.)

Water bath—A pool of water that has been adjusted to a specific temperature. Chemical containers and processing tanks placed in the water bath adapt to its temperature.

Weak negative—See Density.

Wet mounting—Techniques of affixing prints to mounting surfaces by the use of liquid adhesives.

Wet side—The portions of a darkroom devoted to processes that involve the use of liquids.

Wetting agent—A chemical that decreases the surface tension of water and thereby promotes rapid drying and prevents the formation of water spots. It is usually used on negatives.

White light—Light composed of all wavelengths in the visible spectrum.

Yellow—One of the complementary colors that form the foundation of the subtractive method of color production. Yellow filters block blue light but allow red light and green light to pass.

INDEX